THE ASMP GUIDE TO NEW MARKETS IN PHOTOGRAPHY

Allworth Press books may be purchased
in bulk at special discounts for sales
promotion, corporate gifts, fund-raising,
or educational purposes. Special editions
can also be created to specifications.
For details, contact the Special Sales
Department, Allworth Press, 307 West
36th Street, 11th Floor, New York, NY
10018 or info@skyhorsepublishing.com.

15 14 13 12 11 5 4 3 2 1

Published by Allworth Press, an
imprint of Skyhorse Publishing, Inc.
307 West 36th Street, 11th Floor,
New York, NY 10018.

Allworth Press® is a registered
trademark of Skyhorse Publishing, Inc.®,
a Delaware corporation.

www.allworth.com

Cover and interior design by
The Grillo Group, Chicago

Page composition/typography by
The Grillo Group, Chicago

Cover photograph by
Michael Cooper

Library of Congress Cataloging-in-Publication
Data is available on file.

ISBN: 978-1-58115-921-9

Printed in the United States of America

ALLWORTH PRESS
NEW YORK

THE
ASMP
GUIDE
TO
NEW
MARKETS
IN
PHOTOGRAPHY

EDITED BY SUSAN CARR

CONTENTS

PART I:
MOVING OUT OF AN
ERA OF CONFLICT

CHAPTER 1:
WHERE ARE THE CLIENTS?
BY SUSAN CARR

3

This opening chapter asks the questions nagging on the minds of most independent photographers: Where did those clients go? Is it something I did or did the market change seemingly overnight? The explanations offer insights for moving forward.

CHAPTER 2:
VISUAL COMMUNICATIONS
IN THE NEW ECONOMY
BY TOM KENNEDY

13

Emphasizing how independent content creators are facing both challenges and opportunities, this chapter discusses the dramatic change in the media landscape, including the importance of how media is consumed today, the growing role of the amateur, and where the professional fits into the picture.

CHAPTER 3:
THE ROLE OF TECHNOLOGY
BY PETER KROGH

31

Watching technology and learning how to analyze its impact on your business decisions plays a key role in building a successful career. This chapter provides future technology trends and products to watch as well as tips for honing your trend-watching skills.

CHAPTER 11:
CHANGING YOUR COURSE

BY JUDY HERRMANN

189

Your continued success hinges on managing change effectively. This chapter shows you how to anticipate, prepare for and adapt to the different types of changes you will encounter throughout your career.

PART III:
CASE STUDIES FOR
THE NEW ECONOMY

This final section of the book is comprised of more than thirty interviews with working visual imaging professionals. The chapters indicate the dominant approach used by each photographer adapting to the changes in our industry.

CHAPTER 12:
NEW PRODUCTS AND SERVICES

BY BARRY SCHWARTZ

205

The photographers featured in this chapter expanded by adding new products or services to their business.

ACKNOWLEDGMENTS

This book has been made possible by a generous grant from the ASMP Foundation.

The American Society of Media Photographers, Inc. (ASMP) is built on a foundation of information, education, and advocacy for working imaging professionals. This book, *ASMP's Guide to New Markets in Photography*, is a part of our effort to create awareness of new and emerging opportunities within the rapidly evolving workspace.

Sincerely,
Eugene H. Mopsik
ASMP Executive Director

We wish to thank the following people for their contributions:

**Editor and
Contributing Author**

Susan Carr

Contributing Authors

Blake Discher

Judy Herrmann

Richard Dale Kelly

Tom Kennedy

Peter Krogh

Barry Schwartz

Colleen Wainwright

**Visual Artists
Interviewed for
the Book.**

Timothy Archibald

Teri Campbell

Elizabeth Carmel

James Cavanaugh

Grace Chon

Jenna Close

Wayne DeSelle

Clark Dever

Rebecca Drobis

Robert Durell

Andrew Eccles

Melissa Golden

Lynn Goldsmith

Mark Green

Betsy Hansen

Chris Hollo

Chase Jarvis

Walt Jones

Mark Katzman

Amanda Koster

Claudia Kunin

Spenser Lowell

Ed McDonald

Matthew Millman

Gail Mooney

Ethan Pines

Vanie Poyey

Chad Ress

Yvette Roman

Ian Shive

Saverio Truglia

Nick Vedros

Dan Winters

**Photographers
Whose Photos Appear
in This Book.**

Jake Belvin

Michael Cooper
(cover image)

Kristofer Dan-Bergman

Paul Elledge

Julie Fowells

Jason Griego

Doug Hoeschler

Aaron Ingrao

Caleb Kenna

Michelle F. Mitchell

Mark Mosrie

Vanie Poyey

Lisa Tanner

David Wiegold

Jackie Weisberg

ASMP Board of Directors

Jim Cavanaugh
President

Gail Mooney
1st Vice President

Shawn Henry
2nd Vice President

Richard Dale Kelly
Treasurer

Blake Discher
Secretary

Kate Baldwin

Jenna Close

Mark Green

Chris Hollo

Bruce Katz

Kevin Lock

Ed McDonald

Irene Owsley

Barry Schwartz

Steve Whittaker

INTRODUCTION

BY SUSAN CARR

This new American Society of Media Photographers (ASMP) book is built on the belief that successful photography careers today are endlessly unique. Each image-maker needs to build a career that matches his or her talent to a market or multiple talents to varying markets. There is not just one way to do this or even ten ways. Our goal is to provide you with a pragmatic guide to understanding the new economy, a resource that teaches you how to find the business approach and compensation model that fit not only your needs but your desires as a creative person.

The book is organized in three parts: Part I titled *Moving Out of an Era of Conflict*, Part II, *The Process of Building a Manageable Solution* and Part III, *Case Studies for the New Economy*. The first five chapters that comprise Part I set the stage for under-standing where the industry is today by discussing the disruptive changes of the last few decades. While this section deals largely with conflict such as the digital transition, the Internet economy's impact on our traditional clients, and the continued evolution of technology and copyright, by understanding these complex and intertwined industry issues you will be prepared to move forward in a personally productive fashion.

Part II functions as your essential guide to building a unique career that fits your skills, talents, and the markets you want to pursue. Complete with strategic exercises and marketing and sales techniques, this second section of the book uses a very personal approach allowing you to find your career direction or redirection as the case may be.

Part III offers over thirty concise interviews with working professional photographers representing a broad range of specialties, years in the business, and business models. The interviews are categorized according to the main area of adaptation the particular professional has utilized. Each case study represents both the commonality of characteristics to success and the uniqueness of each professional's business.

We have assembled a talented group of industry experts to concisely yet comprehensively cover this wide range of issues: Blake Discher, Judy Herrmann, Richard Dale Kelly, Tom Kennedy, Peter Krogh, Barry Schwartz and Colleen Wainwright. Each contributor not only authored one or more chapters of this book, but he or she is also providing valuable supplemental materials related to their specific topic. Quick Response (QR) codes and URLs are available at the end of the chapters in part I and II leading you to this additional information. We have intentionally set up this online assistance knowing that changes in the form of challenges and opportunities are forever entering our field. Additionally, the book contains charts to graphically call out specifically relevant research.

ASMP has a long history of producing relevant information and advocacy for photographers and this book is no exception. It comes at a time in our industry and organization's history that demands a reevaluation of the way we do business. As usual, the working independent photographer has a steep hill to climb for success, only this time the rules of the road have dramatically changed. Our goal for this book and its companion resources is sustainable success for you.

GLOSSARY OF TERMS

The new Internet economy and changes specific to the visual imaging industry both yield new terminology. While this list in no way attempts to be comprehensive, it does facilitate a better understanding to put the readers and contributors on the same page with the most commonly used language.

Collaboration
The act of working with others in the production of a creative product. By utilizing the expertise of a variety of creative professionals, a complex visual communications piece can usually have a higher level of quality than one developed by a single individual.

Convergence
In the broadest use, convergence is the blurring of roles in the visual communications industry. Various roles can be played by a variety of people. Who does what is no longer clearly defined. Examples include the process of still and motion photography being created by the same tools and creators, as well as the ability for individuals to distribute their own work via the Internet rather than solicit a publisher to do so.

Media
The act of publishing information via words and visual forms of communication.

Motion
Another way to describe working in the video medium.

New Economy
The economy in the Internet age. The Internet is the great economic leveler. Large branding and marketing budgets no longer rule in a world where the customer is in control. The Internet allows the buyer infinite choices of an infinite number of products and services.

New Media
The publishing of information via the Internet. New media is often specifically used to describe new forms of communication such as multimedia, video, and interactive commentary. These formats were previously unavailable in the traditional print or television publishing world.

Photography
The craft of producing imagery, still or moving, through the lens based capturing of light.

Producer
The person in charge of every facet of a video production, from the general concept of the project through the finances and scheduling of how things get done. For smaller projects, the producer and the director are effectively one person who has a vision for how the end product looks and what it's going to say to the audience. The producer is usually the owner of the copyright to the finished piece of work.

Rich Media
The art of visual communications that utilizes multiple mediums to create a new product, such as a slide show of still imagery with audio included, creating a single video piece.

Social Media
The practice of engaging in online interactive communities such as blogs, Facebook, LinkedIn, and Twitter.

Video
The specific art of producing moving imagery. Also referred to as working in "motion" rather than "still" photography.

CONTRIBUTORS

SUSAN CARR

Susan Carr is a Chicago-based photographer. Her photographs are included in corporate and private collections, most notably the Pfizer Corporation and the Museum of Contemporary Photography.

A past president of the American Society of Media Photographers (ASMP), Susan has long been dedicated to the advocacy and education of fellow photographers. Susan organizes and manages the highly successful ASMP Strictly Business conferences and currently serves as Education Director at ASMP. Susan is the editor of the latest *ASMP Professional Business Practices in Photography* (2008) and author of her own book, *The Art and Business of Photography*, released in February 2011, both published by Allworth Press, an imprint of Skyhorse Publishing.

BLAKE DISCHER

Detroit photographer, SEO expert, and educator Blake J. Discher specializes in people photography used in brochures and annual reports for major companies throughout the world. His clients include General Motors, Chrysler, Ally Bank, and Oracle. Blake also consults for small businesses on search engine optimization. He shares his knowledge with students and other photographers through his involvement with the American Society of Media Photographers (ASMP), most recently as an educator in ASMP's successful Strictly Business series of conferences. Blake currently serves as secretary on the National Board of Directors of ASMP. A professional photographer for twenty-five years, he shares his home with his wife and eight-year-old son. When not working, he's usually tinkering with one of his British-made, vintage Triumph automobiles.

JUDY HERRMANN

Judy Herrmann of Herrmann + Starke, www.HSstudio.com, creates distinctive imagery for advertising, editorial and corporate clients. Her work has won recognition from *Graphis*, *Communication Arts*,

Lurzer's Archive and numerous award annuals. A past ASMP national president, Olympus Visionary, and recipient of the United Nations' IPC Leadership Award, she was recently named one of *Rangefinder Magazine*'s "11 Photographers You Should Know."

Since 1995, her energetic and inspiring seminars on digital photography and smart business practices have helped thousands of photographers compete more effectively. Through one-on-one consultations and her blog, 2goodthings.com, she helps people grow creatively satisfying and financially rewarding businesses.

RICHARD KELLY

Photograph © 2010 Shawn G. Henry

Richard Dale Kelly is a Pittsburgh-based photographer, producer and consultant at Indigo Factory Inc. Kelly received the 2011 United Nations' International Photographic Council's Leadership Award and in 2009 a fellowship from the Pennsylvania Council on the Arts. Currently he is Associate Professor of Photography at the Pittsburgh Filmmakers and a Program Associate at the Silver Eye Center for Photography. From 2003–2007 Richard was the Director of Photography for WQED Multimedia. A past president of the American Society of Media Photographers (ASMP), Kelly is currently serving as a director.

Beginning his career in New York City in 1988, he continues to focus his lens on documentary projects of creative and innovative subjects; his "Light + Words," portraits of Pittsburgh Writers was exhibited at the Carnegie Library in 2008. Kelly and nine other photographers exhibited "Picturing the City—Documenting Downtown Pittsburgh, 2007–2010" at the Carnegie Museum of Art from October 2011–March 2012.

TOM
KENNEDY

Photograph © Stanley Leary

Tom Kennedy is an internationally known visual journalist with extensive print and online experience, including positions as Managing Editor for Multimedia at washingtonpost.com and Director of Photography at the National Geographic Society. He has created, directed, and edited visual journalism projects that have earned Pulitzer Prizes, as well as EMMY, Peabody, and Edward R. Murrow awards.

Kennedy is currently the Managing Editor/Digital News for the PBS NewsHour after a two-year teaching appointment as the Alexia Chair Professor of Documentary Photography in the S.I. Newhouse School of Public Communications at Syracuse University.

Kennedy has been a featured speaker at some of the most prestigious journalism conferences and media workshops around the world, while also consulting to various academic institutions and media companies on topics ranging from media management to multimedia storytelling. In 2011, he was the keynote speaker at ASMP's Strictly Business 3 conference.

PETER KROGH

Photograph © 2010 Kelly Castro

Peter Krogh has been a photographer for nearly thirty years, working for publications, agencies, corporations and NGOs worldwide. He loves to tell stories with words, still photos and motion imagery. He served on ASMP's national Board of Directors for six years, and founded its Digital Standards and Practices Committee.

A widely recognized industry thought leader, Peter is the Director of the dpBestflow.org project, and the author of *The DAM Book, Digital Asset Management for Photographers* (O'Reilly, 2009), the best-selling book on digital photo management. He has created instructional material for the Library of Congress, World Press Photo, Microsoft and Adobe, to name a few. He spends much of his time spreading the gospel of good image management and effective workflow worldwide.

BARRY SCHWARTZ

Photograph © 2012 Barry Schwartz

Barry Schwartz is a photographer, writer, and occasional designer in Los Angeles. His photography specialties are architecture, interiors, portraits, and documentary work. Making photos of people working

is a particular interest, coming out of a background that includes construction and graphics and architectural design. His writing includes journalism, blogs, and copy.

He teaches workshops for photography students, emerging professionals, and advanced amateurs on Digital Workflow and Basic Business Practices. At one time, he had a three-octave range (tenor-baritone), but it's all phrasing now. He freely gives into long-term obsessions with design, good writing, science, music, and trying to figure out what is going on in the mind of his Wheaten Terrier.

www.barryschwartzphotography.com

COLLEEN WAINWRIGHT

Photograph © Josh Rosh Creative

Colleen Wainwright is a writer-speaker-layabout who started calling herself "the communicatrix" when she hit three hyphens. She spent ten years as a copywriter crafting TV commercials for brands like Wheaties,® Gatorade® and Jell-O,® and another ten acting in them for cash money. Since deciding she'd blow her brains out if she had to sit through one more meeting about which way the bears danced around the cereal box, Colleen has spent her time helping fellow creatives learn to talk about themselves in a way that wins them attention, work, and satisfaction. In 2011, Colleen used herself as a guinea pig for her theories on social media marketing, raising over $100,000 in fifty days for a nonprofit benefitting high-school girls. Eventually, she will learn to take a decent photograph.

PART I

MOVING OUT OF AN ERA OF CONFLICT

CHAPTER 1

WHERE ARE THE CLIENTS?

BY SUSAN CARR

It is thrilling to create something and to have the passion to create as your driving force is even more amazing, but for those of us who want a career creating images, some kind of income is critical to the equation. The money and time to do the work has to come from somewhere. So, who are the clients in this new economy?

First, let's put this conversation in perspective by looking at the recent history of the professional photography industry. For those of you who are new to this field, it is necessary to understand our not so distant past to appropriately navigate the current landscape. If you have worked in this industry for a while, a clearer under- standing of the last two decades will hopefully help you accept and adapt to the changed business landscape. I hear many photographers say, "What happened here? Where did the clients go?" Well, a sort of perfect storm is what happened and things are still shaking out. The impact of the World Wide Web and technologies developed to use it cannot be emphasized enough. The ease and low cost of distributing information that the Internet provides has affected every industry, and photography is no exception.

The expansion of stock photography businesses, which license existing art for much less than the cost to produce custom work, hit every assignment photographer hard. Corbis Corporation was

Photograph © Paul Elledge

founded in 1989 and Getty Images in 1995. Both companies actively bought up many small stock agencies and image collections, consolidating the stock photography business and driving prices downward in the process. By 1996, I no longer produced any images for clients unless they were people, product, or place specific. From that time forward, if the client's needs are generic, they purchase the much less expensive commodity option that stock photography offers. In addition to the explosion of cheap, available stock photographs, the era of corporate consolidations worldwide was having an effect. Fewer companies meant fewer marketing departments and fewer advertisers. Simultaneously with all this, the industry moved from film to digital imaging and photographers had to face a huge technology hurdle. The transition is now complete and the industry standard is digital image delivery, but the cost to our distinctiveness as professionals is high and the list of collateral damage is long; gone is the need to gel lights for color accuracy, in some cases gone is the need to even use a supplemental light at all, gone is the need to get the exposure perfect on set, gone is the need to avoid retouching by carefully orchestrating all elements of the photograph, gone is the business of making prints for clients, gone is the high financial bar to enter the field, and the list goes on. Many of the services we relied on to sell our clients on the cost of professional photography are no longer services they want or need. While cheap stock photography, business consolidation, and the digital revolution had many assignment photographers struggling to maintain good profit margins, the real game changer was rolling down the tracks and most of us had no idea it was coming.

While attending Photo Plus Expo 2004 in New York City, I had the good fortune of attending a lecture by marketing expert Seth Godin. His topic was his newly published book *Free Prize Inside*. Godin's presentation illustrated the new explosion of consumer choice through images of his local grocery store; a view of the cheese counter graphically communicated how difficult it is for a product to stand out in our new world of many options. In *Free Prize Inside*, Godin describes clearly how traditional marketing and advertising no longer work. "There are plenty of products that used to be right there in the middle of our radar screen." This is the world I grew up in, where decent products wrapped in nicely designed packaging were promoted to

us in carefully crafted and clever advertising. Most of us can still sing jingles from this era (plop, plop, fizz, fizz...) and still use brand names to describe products (Kleenex when we mean tissue). There was nothing extraordinarily special about these products, we purchased these products because given minimal options we picked the one that had name recognition. The advertising these businesses engaged in built brand name identity and purchasing these products felt like the safe, even the best, choice. Godin continues, "Every time the brand marketers spent $100 on advertising and other forms of interruption, they made $200 in profit. ...They were able to charge non-commodity prices because they'd created a brand. Today, twenty years later, it's easy for a marketer to get nostalgic about this. One product after another is fading away, for a simple reason: The ads can't pay for themselves anymore... In an era of too much noise and too much clutter and too many choices and too many channels and too much spam, you can't make a good living by interrupting people over and over."[1]

A lightbulb went off for me. The downward pressure on my pricing and requests for all rights to my images was not being primarily driven by stock photography or the shift to digital imaging over film as I frequently complained, but rather by the simple fact that the old ways of marketing that my clients relied on to increase their profits were no longer working. The investments they were making in photography, graphic design, advertising agencies, printing, and paid media space were now an expense that had no guaranteed return. The economic model I built my entire business on was falling apart.

When advertising campaigns could virtually promise a certain return on each dollar invested, photographers had the leverage to license per use. Run another ad, the client is going to make more money and the photographer, whose work is illustrating the ad, gets a piece of that pie. Advertising agencies could sell this practical approach to clients because everyone in the chain of production was making a profit. When the consistency of the returns on advertising investments started to waver, the old way of licensing photography was drawn into question.

I have a vague memory of Amazon's decision to stop advertising and offer free shipping instead, but I had no idea that the result would impact my business beyond the obvious selfish benefit of buying books cheaper and getting free delivery. Godin describes what happened:

> A year ago, Amazon.com announced that they were going to stop advertising altogether. No more TV. No more magazine ads. Instead, the company decided to put the money it was spending on ads into free shipping instead. Marketers were aghast. The idea of investing your ad dollars into actually making the product better was heresy. Pundits once again proclaimed the death of Amazon. After twelve months, the results were in. Sales for the year were up 37 percent. International growth was an astonishing 81 percent.[2]

Amazon took this move in 2003. They strategically stopped using the traditional system of advertising and decided to put those resources toward making their service better and other businesses soon followed. Think about your clients; while their reduction in marketing dollars may be more reactionary than strategic, they likely have and continue to steadily reduce their budgets on things like professional photography. The ripple effect on small and large businesses is huge. Think about this the next time you pass an unused billboard, look at the lack of extravagance in a current annual report, notice the shrinking size of your favorite magazine, or the demise of your local newspaper, printer, or ad agency. The evidence is everywhere telling us that we have to throw out all we thought to be true about how to make money as a creative producer because the users of our "product" have changed how they communicate to their customers. And, to further complicate things, the number of people using nonprofessional photography to sell something explodes, like eBay and Craigslist. The growth of personal choice made possible by the new ease of information distribution via the Internet is crashing down on both our traditional clients and us. Average products in slick packaging no longer works for anyone. There are simply too many readily available choices. If something isn't exactly what you want, whether it is the music you listen to, the shampoo you buy,

where you grocery shop, or the photographer you hire, there are many other options at your fingertips.

Chris Anderson, editor-in-chief of *Wired* magazine, published *The Long Tail* in 2006 and defined how technology was changing the way business gets done.

> *The theory of the Long Tail can be boiled down to this: Our culture and economy are increasingly shifting away from a focus on a relatively small number of hits (mainstream products and markets) at the head of the demand curve, and moving toward a huge number of niches in the tail. In an era without the constraints of physical shelf space and other bottlenecks of distribution, narrowly targeted goods and services can be as economically attractive as mainstream fare.*[3]

The irony of the long tail Anderson defines is that this phenomenon both undercuts the traditional markets for professional photography and presents photographers with more affordable ways to reach new clients and markets. The *New York Times* on March 29, 2010, reported that ad pages in magazines declined by 41 percent from 2001 to 2009 and in 2009 alone, 428 magazines closed.[4] This advertising demise hurt printed magazines, so they cut down on editorial content to save costs. That translates to lower budgets and fewer photographers being hired to cover stories. Classified ads are no longer a large profit center for newspapers and paid subscriptions are diminished by free online access and many other news options, so staff photojournalists are losing jobs in droves. Advertising agencies no longer generate high profits from commissions on securing paid media advertising space and are pressured to account for every penny spent on services like photography. The big budget campaigns of recent decades are gone.

On the flip side, photographers no longer need to pay for expensive source book ads to get their work in front of clients. Direct mail is expensive, but email promotions are not. Websites can be updated and tailored for specific markets with ease and little expense. Social media sites can be used to build a brand and find new contacts. It takes time, energy, and persistence, but it doesn't take a large financial investment. The photographer who previously was held back by

a lack of resources can now find marketing opportunities like never before. The ease and low cost of publishing online, however, democratizes the showcasing of images. These new tools are readily available to all, not just the professional.

The professional photographer has always battled the fact that their chosen vocation is an avocation for many others. In 1946, Chris Abel articulated this in his book *Professional Photography For Profit*:

> *Are you sold on photography? It would not be necessary to ask this question or to devote a full chapter to its discussion were it not for the mistaken impression held by many people that photography is a very easy method of making a living. This misapprehension is fostered by the simplicity with which almost anyone who owns a box camera can occasionally produce a good landscape or interior, or even an excellent portrait likeness... it is important for you to bear in mind that your competitors will not only be your brother photographers in your own and nearby communities, but the amateurs as well.*[5]

The presence of the amateur in the professional marketplace is not new, but an increased amateur access to our clients is. In 2008, Getty Images (licensor of photography) and Flickr (photo sharing community) signed an exclusive partnership. This collaboration directly and deliberately connects the photo-enthusiasts with commercial buyers by establishing a Flickr branded collection in the online image licensing machine of Getty Images.[6] A smart move for both businesses offering buyers more choice and offering a little "extra" cash to the hobbyist who originally created the images with no monetary objective. After a little over a year this stock photography offering contained 100,000 images. Based on the success of this vetted Flickr collection on Getty Images, the two companies expanded their business venture with "Request to License," an option for all members of Flickr. Any Flickr participant can mark their images as available to license; if a potential customer clicks on the licensing link, they are connected with a Getty sales representative who in turn contacts the photographer with details on the potential sale. These new Flickr features mean this Yahoo-owned sharing service is now clearly participating in the commerce side of photography. The

blurring of the line between the amateur and the professional continues, signaling the need to drop preconceived notions of what we do and who we do business with.

Chris Anderson's controversial book, *Free*, created quite a buzz in the professional photographic community when it was released in 2009. The gut reaction by many photographers was negative, surmising that Anderson was pitting free against paid to the detriment of the professional in any field. Anderson actually does a masterful job of outlining a history of how businesses have used the "free economy" to build products and services people will pay for. Anderson writes,

> *The way to compete with Free is to move past the abundance to find the adjacent scarcity. If software is free, sell support. If phone calls are free, sell distant labor and talent that can be reached by those free calls (the Indian outsourcing model in a nutshell). If your skills are being turned into a commodity that can be done by software (hello, travel agents, stockbrokers and realtors), then move upstream to more complicated problems that still require the human touch. Not only can you compete with Free in that instance, but the people who need these custom solutions are often the ones most willing to pay highly for them.*[7]

Like it or not, the photographs licensed every day and, in many cases, even the service of photography are now commodities. Generic photographic subject matter will no longer produce substantial financial rewards nor will it be possible to build a career taking corporate headshots. I return to Godin who always seems to concisely hit the nail on the head: "Your organization is based on exploiting scarcity. Create and sell something scarce and you can earn a profit. But when scarce things become common, and common things become scarce, you need to alter what you do all day."[8] Godin further offers that spare time, trust, and attention are things that used to be abundant and are now scarce. Remember these when formulating your business strategy; potential clients do not have extra time, do have trouble giving things attention, and are skeptical as a default. Turn those challenges into assets by saving clients time, being easy to do business with, and building trust through quality and professionalism.

Photographs in general are definitely not scarce. We cannot compete on price when seemingly endless images are available for free or nearly free. We cannot compete with mediocre imagery when there are loads of one-click options for obtaining mediocre photographs. Photographers must define what they can bring to the table that is rare and that brings us back to creativity. A specific vision, style, or point of view directed toward a particular passion or interest is our one true unique offering. As a photographer, you need to develop a vision in your imagery, but that same creative thinking needs to be applied to how you run your business. Make it a package, so that all components speak to the same core message of genuine quality and value.

Once you clarify your uniqueness, you need to define your target audience, but consider the changes discussed here and think differently. If you are interested in editorial work, consider becoming your own publisher. Figure out how to leverage new technologies to affordably tell the stories you want told. If your goal is helping businesses refine their communications, consider targeting a specific industry, preferably one you believe in. Educate yourself on their business idiosyncrasies and offer solutions specific to their needs. If wedding photography is your passion, pick a target demographic and focus your business strategy on the unique desires of this group. If your business focus is working in your local community, get involved in that community. Find out what the economic concerns are and build a business that directly addresses those issues.

Photographer, educator, and business consultant Judy Herrmann posted the following on the ASMP *Strictly Business Blog*:

> How many clients do you need? No, really—1,000? 500? 50? 10? If you're like me, the number's a lot closer to the right than the left. In fact, what I really need, what I really want is a core group of repeat clients who I like and respect and who like and respect my work.
>
> If you're dying to be EVERYBODY's photographer, read no further. But if you, like me, are looking to build relationships with like-minded people with whom you can produce creatively satisfying work then I've got a crazy idea for you.

What if we stop scattering seeds to the wind in the hopes they'll land on fertile ground? What if we stop the mass mailings and emailers and broadcast marketing blasts that go to faceless, anonymous people who are already receiving thousands of these things from a multitude of faceless, anonymous photographers?

What if we take the time to find those individuals whose aesthetics and visual communications needs really resonate with what we love to do. What if we took that common ground, mixed it with a little creativity, ingenuity and good-old fashioned chutzpah and used it to build relationships with those individuals instead of marketing to them?

Maybe, just maybe, we'd actually get what we want.[9]

The reality is that most independent working photographers only need a handful of customers to make a good living. What we need are loyal clients who value our unique product and compensate us fairly for it. Everyone does not have to think you or your work is extraordinary (and everyone won't). The goal is to find the good matches and nurture them with good work and exemplary service. This is the beauty of the Long Tail; we now all have access to inexpensive distribution channels for our images and our message and it is simply up to each of us to exploit these new opportunities to find our specific niche market.

This chapter excerpted from *The Art and Business of Photography*, by Susan Carr, Allworth Press, 2011.

For supplemental information and resources on this chapter go to www.asmp.org/carr1 or scan this QR code with your smartphone.

VISUAL COMMUNICATIONS IN THE NEW ECONOMY

BY TOM KENNEDY

WHERE ARE WE AND HOW DID WE GET HERE?

In 1988, both the National Geographic Society and Eastman-Kodak celebrated significant anniversaries. As director of photography at National Geographic, I had the opportunity to join in these milestone celebrations in both companies. The National Geographic Society was at its absolute height with 11.5 million members, celebrating its centennial year with a traveling photo exhibition entitled "Odyssey: The Art of Photography at National Geographic." At the same time, Kodak was celebrating the 100th anniversary of its introduction of the snapshot camera that made photography accessible to the masses. Throughout the twentieth century, both organizations had shared a strong relationship and successes in promoting photography as an art form and means of understanding the world. Both were riding high in terms of company performance, profits, and the support

of a loyal audience for their products. The future seemed assured and there would be no need to do anything more than continue business as usual.

In that same year, I traveled to the MIT Media Lab on a research trip. While there, host Walter Bender showed their work on high-definition television among other things. I was dazzled by the image quality and understood quickly that the image capture might soon be sufficient to enable still photographs to be pulled from their cameras. It was clear that powerful developments were unfolding in the labs that might impact the future of image technology.

It is hard to describe my feelings upon returning to Washington, DC, from that trip. I felt that I had glimpsed a future that might be very different from the current reality and yet it was very hard to know how we could transform ourselves to take advantage of what was coming. I returned to the world of Kodachrome and film editing and the impressions of the trip faded into the background of business as usual.

Five years later in 1993, a unique opportunity beckoned when my National Geographic colleague Bob Madden and I were invited to come to New York and participate in a grand experiment playing out in the basement of the Time-Life Building in Manhattan. Under the auspices of Time-Warner, we were going to work with colleagues from across the magazine industry to create the first print magazine and CD-ROM to be executed entirely with digital tools. It was an intense, exhausting week, filled with challenges. But in the end, we succeeded in creating a print version of the magazine dubbed *Open*, and a CD-ROM entitled "Open Wider."

That same year, the National Center for Supercomputing Applications (NCSA) at the University of Illinois Urbana-Champaign released the first web browser that could display graphical elements, thus opening up the ability to show images as part of what was being presented on the World Wide Web. The Internet was emerging as a content distribution platform and few in mainstream media understood fully its fast paced and direct implications.

As I looked at these developments, I saw in a whole new light the impact of the digital tools we had just worked with in New York. It became immediately clear this new technology could create a communications landscape that would level the playing field between the individual professional and corporate media giants. An audience could be gathered and connected via electronic means, and the time frame within which media could be created and distributed could be vastly sped up. I stood on the cusp of leaping from a secure position in the known landscape of print media into something brand new that was being birthed all around me. That creative challenge was a siren song, too tempting not to heed. So in 1998, I joyfully made the leap into the world of digital publishing.

Fast-forward to 2012, and the full blessings and challenges of working in a digital age are with us. While at first blush this may seem a scary time to be a professional visual communicator, technology is also blessing us with great gifts that allow us to publish and distribute content with ease unimaginable just twenty-five years ago. We have the chance literally to reinvent ourselves and our businesses at a time when visual communication is a language needed by all companies, organizations, and even governments to reach target audiences. Rather than bemoan a lost golden age, as professional visual communicators we need to find a way forward that takes advantage of the opportunities at our doorstep.

Today, our new media landscape is moving us powerfully away from print and into a world of screen-based content delivery platforms. Mass media forms in print and broadcast have been augmented, if not replaced, by forms of rich media (mixes of still photography, audio, video, information graphics, and text) published either as websites or as new forms of content on portable screen displays, leveling the playing field between huge publishing conglomerates and individuals. At the same time, our world is awash in a ceaseless tidal flow of images circulating daily, with most made by nonprofessionals for highly personal reasons and shared publicly through various social media networks like Facebook and Twitter. Their presence is adding to the visual and aural/oral languages being spoken around the globe.

In thinking about all this, I am struck by how eerily similar it all is to 1888 when Kodak first saw the possibility of making photography into an art form available to all and National Geographic made a conscious decision to use photography as its main publishing tool to "increase and diffuse geographic knowledge" to a mass audience.[10]

Those two separate decisions intertwined throughout most of the first half of the twentieth century, pointing the way to the use of photography in magazines as a means of supporting advertising messages as well as communicating about news, celebrities, culture, politics, and sports. The flourishing of weekly picture magazines around the world created the first opportunities for photographers to become "professional" visual communicators.

In looking back on this era, it seems obvious that professionals benefited from the economics of "scarcity" as the engine behind the business model. Access to remote places, key personalities, and epic events required the logistical support of large publications. In addition, the photographic technology itself required a craft mastery that could only be achieved through years of practice and the availability of specialized equipment, well beyond the reach of most amateurs.

Uniqueness of image aesthetics often overlapped with uniqueness of the situations being documented so that both came together to set publications apart from rivals. Photographers could trade on the scarcities to bid up the value of their work. At the same time, publications could sell uniqueness to a mass audience, which in turn made their publications satisfying to commercial enterprises trying to sell a product or service.

Think of it as the perfect equilateral triangle, with publishers, advertisers, and audience as the sides. The symmetry yielded positive results on every side. Publishers harnessed the attention of audiences and sold it to advertisers. Advertisers paid happily to reach the audiences with their messages. And consumers (the audience) were happy to be receiving a stimulating view of the world each week that informed as it also entertained. And photographers were rewarded for their efforts by using scarcity as a lever

to drive value. In fact it wasn't uncommon for newsweeklies to engage in bidding wars for the most unique images each week from far-flung quarters of the globe.

By the 1960s, print weekly magazines had a new rival in television for the production and distribution of the same news, sports, and celebrity content and that changed the game completely. Moving images changed how people viewed the world and the advent of new technology such as communications satellites meant the capacity to move images across the world easily in something close to real-time. That power was new and became formidable within a decade, to the point that picture weekly magazines such as *Life* and *Look* folded in the early 1970s under the pressure of declining advertising revenue and circulation as well as rising distribution costs.

Watching this transformation with great interest was Marshall McLuhan, a Canadian literature professor turned media critic. As McLuhan saw it, broadcasting was the emergence of a new media technology helping to transform society. He saw it creating a "global village," while simultaneously reviving the long-dormant language that mixed moving images and oral storytelling tradition.[11]

In the last twenty-five years of the twentieth century, we were treated to the emergence of the 500-channel television universe thanks to full implementation of cable television. While some of us may still have our frustrations with cable companies, their arrival signaled an important change in the "electronic hearth." Along with channel choice itself, accompanying technologies like VCRs emerged to permanently alter viewing habits. Now, audiences had the choice to self-select into narrower affinity groups. No longer was television broadcasting solely a mass medium where people had the choice of watching a limited set of programs at predefined times.

At the same time, in the 1990s, as noted earlier, the Internet arose as another means of enabling access to news, information, and entertainment. It too facilitated the shift away from the landscape of "limited choice" mass media to a media landscape of niche audiences with specific interests. People could self-

identify their interests and gain immediate access to deep pools of information about very specific topics. Internet access could also facilitate endless browsing across entire ecosystems of content, built by all manner of content providers. Simultaneously, personal computers and cell phone advances created a revolution in personal communications, connecting people to each other and offering the possibility of instantaneous information-sharing across the globe as the new millennium dawned.

TODAY AND THE START OF TOMORROW

The emergence of the Internet in the first decade of the twenty-first century as a dominant technology supporting all new screen-based delivery platforms has changed the nature of shared communications and information in the public arena. Clay Shirky, New York University professor and author, has described this change in his book *Cognitive Surplus*, by offering a new definition of media. "Media is the connective tissue of society... Media is how you know about anything more than ten yards away... All these things used to be separated into public media (like visual or print communications made by a small group of professionals) and personal communications (like letters and phone calls made by ordinary citizens). Now those two modes have fused."[12]

Other technological advances, making the act of content creation and dissemination via the Internet much easier, have supported this fusion of public and private communication. This is blurring the lines between work done by amateurs and professionals, with profound consequences for professional photographers.

By enabling the rise of an amateur do-it-yourself (DIY) class of content producers, technology has helped unleash a torrent of amateur photography that washes over the world on a daily basis. Digital cameras and the move away from film have been obvious drivers, along with the inclusion of cameras as part of smartphone technology. Flickr was the first Internet-based digital photo sharing service to enable photo sharing on a mass scale by amateurs. It launched in

2004, and was acquired by Yahoo! in 2005 and by August 2011 it was hosting about 6 billion images.[13]

While many recent Flickr contributors have been providing images through smartphone technology, principally iPhones, other image collections have emerged on the Internet to challenge Flickr as an image repository. For example, Instagram, an iPhone photo app that launched in October 2010 hit two big milestones within the first nine months of its existence; more than 7 million users and 150 million photos on their servers.[14] As a point of comparison, it took Flickr nearly two years to reach 100 million photos on their service.

On April 9, 2012, Facebook announced its purchase of Instagram for $1 billion dollars. According to Facebook founder Mark Zuckerberg, the primary draw was enabling Facebook's popular photo-sharing features to be extended to the mobile space where Instagram has had such success. Photo sharing as a social experience has become a big part of the amateur photography universe, with smartphones being a primary mechanism of image capture and delivery. It also has helped underpin other geolocation services such as foursquare, where users are able to add photos as information when they check in at a particular location. The use of photos as information about real life, shared via smartphones, suggests that the visual image is augmenting, if not replacing, some forms of text-based communication as an expression of personal experience.

As these networks become dominant as pools of imagery, it raises the question of how professionals should regard them and what professional photographers can do to maintain or increase the value of their work in the face of such a flood tide of images.

Viewed from one perspective, this might all seem overwhelming and point to a depressing reality—namely that a continual oversupply of images is continuously exerting downward pressure on the market price of photography and ensuring it is viewed by end users as a commodity product.

However, a more nuanced view might suggest a very different possibility. The flood of amateur photography activity is creating a

heightened awareness of the value of images as a medium, fulfilling some of McLuhan's futurist vision that described how today might look, with visual images being a primary form of communication rivaling text. The current image-making activity, so clearly driven by smartphones, has the potential to help foster amateur creativity and promote an increased visual literacy across the world. Further, professional image-makers now have the opportunity to easily create global markets for their work. They can use the commerce and marketing tools available on the Internet to answer the demand for high quality visual communication as a key part of brand expression by major companies. In fact, I would strongly argue this position, partly because of several other changes that are creating opportunity and new realities in media usage today.

Much of the change in media consumption in the first decade of the twenty-first century can be attributed to three factors: 1) the emergence of greatly more sophisticated digital devices for media consumption, 2) the emergence of social media connectivity platforms, and 3) the ability of consumers to self-select multimedia content from many digital and broadcast sources and to time-shift their consumption thanks principally to the websites, iPods, and DVRs.

Taking the last point first, this past decade has seen visual media consumption move dramatically away from timing once dictated by the media companies. The idea of "appointment viewing," once a necessity for consuming broadcast media, has been altered fundamentally and perhaps irrevocably. Instead, consumers are free to select when, where, and how they will watch visual media. In exercising this choice, they are able to select specific digital platforms that each carry a "signature DNA." This DNA optimizes the device for a particular form of content as it also maps to satisfying a specific set of needs by the consumer.

I first became aware of this reality after the launch of iPods in the early part of the decade. After a couple of iterations of the device and the accompanying evolution of the iTunes store, it became clear that niche audiences were creating "podcasts" on a variety of topics that mapped to niche interests unleashed by the Internet.

Taking the Metro to work regularly, I saw the market penetration occurring as more and more individual riders chose to listen to an iPod rather than read the daily newspaper. As I watched over a period of months, the percentage grew from one in ten people in a Metro train car or on the street to a situation where it was more like four in ten people.

At the same time, the new iPod version was also enabling amateur video to be served up as a media type. At that point, I realized that iPods were acting as alternative to print for consumers taking public transportation and as an alternative to radio for those commuting to work in cars. The power of the portability was so strong that people were using it too as an entertainment source to relieve the tedium of waiting in places where such waiting was inevitable on a daily basis (like waiting in the checkout line at the grocery store or on a subway platform for the next train).

These personal observations led me to an inescapable conclusion in my role as the managing editor for multimedia at the *Washington Post*'s website. We needed to have our video content available on the iPod to extend our brand and meet the potential demand for news-based visual content occurring on this device.

Other equally compelling patterns of media consumption played out early in the first decade of the twenty-first century, leading me to formulate the hypothesis that time was the new scarcity that would drive the economics of media production, distribution, and consumption going forward.

Instead of the content itself being the rare and valuable thing that would drive marketplace price valuations, it is the consumer's time for media consumption that is the scarcity that drives the value chain. In order for a media company to succeed, it would have to understand the distinctive DNAs of various digital platforms and how those might be influencing both the presentation of content and delivery, as well as the rationale for consumption by the end user. It also needed to be in continuous contact with the consumer on a 24-hour basis.

Continuously available 24/7 connections to the audience are crucial if media companies are to have a chance at competing successfully for scarce audience time and attention. To be fully successful, media companies must also now deliver content in the way that people want it, when they want it, on the devices they are using for specific purposes, at a particular point in each day in a form that is optimal for that device. This may seem like a simple formula, but it is hard for media companies to execute in practice.

To put it another way, why will a consumer choose a particular device at a particular time and what is the presentation that can best satisfy that person in the moment? For example, people about to be in transit might have a very strong interest in using mobile phones to access information about traffic and weather when they are about to leave home for work, or leave from the office to make the journey home. During lunch hours, these same commuters may have an interest in taking a break to catch the latest news headlines, or to see if new information about situations impacting their work might be occurring. For desk-bound workers, accessing a website on a computer is the best alternative to cable news on a television set.

At the same time now, there is strong evidence in the latest "State of the News Media" report by the Pew Foundation that more people are turning away from print and toward the digital platforms, with more people now getting their news on the web than from print, and nearly half (47 percent) of Americans getting some form of local news on a mobile device, with a particular focus on immediate needs like traffic or weather information or information about restaurants and other local businesses.[15]

Recent evidence suggests tablets have also taken off as a digital delivery platform, displacing personal computers for some patterns of media consumption. By the end of 2010 (the first year of availability for the iPad), Apple said it had sold 14.8 million iPads worldwide, representing 75 percent of tablet sales at the end of 2010.[16] By January 2011, 7 percent of all Americans owned an electronic tablet according to Pew research and that number was expected to grow to 23 percent by early 2012. And the good news for our profession is

that more than half the tablet owners were using it as a "lean-back" entertainment device to watch broadcast television shows and full-length films.[17] Advertisers have been tuning in to this use and looking to support further development as a way to reach consumers.

Finally, another area of huge change in this past decade has been the explosion in the use of social media. Facebook and Twitter, in particular, have enabled consumers to share information and recommendations in a way that fundamentally alters the brand messaging landscape for businesses offering goods and services. Traditional marketing and advertising techniques are being upended, and it is now essential that businesses engage in continuous conversations with their customers to be part of this new media ecosystem. Look no further than the consumer revolts launched on Facebook late in 2011 against Verizon and Bank of America over the attempts to impose new service fees to sense how the balance of power is tilting more toward the consumer.

This all harkens back to the prophetic vision of McLuhan, as we are now in a world where visual communication is essential to expressing brand promise for goods and services. High quality video and still photos convey essential information and act as vehicles to gain the scarce attention of consumers. Consumers get a sense of specificity and concreteness from seeing images, whether to understand the world (as in news), or for more prosaic reasons to evaluate the value of a commercial transaction. We are living in an age where the rich media language (a mix of still photography, video, audio, and various forms of graphical information) is emerging alongside text, and people are using rich media to communicate with the same frequency and ease as text.

In this new media landscape, the storytelling is being consumed in a variety of ways on a variety of platforms. Quality is crucial to gaining consumer attention and matters as consumers seek to distinguish signal from noise in the daily torrent of media messaging. Rather than lamenting the death of our profession, we stand at the dawn of an era where our skills and output will be even more in demand as the currency that buys consumer attention. Our skills

and craft mastery are essential, even as a sea of amateur-generated content on a daily basis surrounds our work product.

However, to fully capitalize on the opportunity, I believe it is equally important to understand the changes in corporate organizational structures, work flow systems, and office cultures that have also been unleashed by the technology disruptions of the past quarter century. Recently, authors John Seely Brown, John Hagel III, and Lang Davison collaborated on a book entitled *The Power of Pull: How Small Moves, Smartly Made, Can Set Big Things in Motion* that powerfully makes this case. They suggest that many of the practices and values built into successful twentieth-century businesses were really set up to enable economies of scale and production efficiency. While those attributes may still have a place, we're now in a place where collaboration, individual passion, and the ability to engage with others to create new knowledge flows are more important than working in closed silos, with a strong command and control, top-down modes of organization. To quote the authors:

> We need to marry our passions with our professions in order to reach our potential... Passion in this context refers to a sustained deep commitment to achieving our full potential and greater capacity for self-expression in a domain that engages us on a personal level. We often develop and explore passions in areas such as sports or the arts outside of work, but we rarely integrate our passions with our professions. As we make our passions of our professions, we may find our dispositions shifting too. Rather than dealing change as a threat and something to be feared we will find ourselves embracing change, recognizing its potential to drive us to even higher levels of performance.[18]

The new efficiency should be about releasing creative energy to reimagine and remake the world. To do it effectively, the authors are arguing for a landscape in which individuals are encouraged to work from wellsprings of personal passion within communities of practice that utilize changing technologies to build and share new knowledge as rapidly as possible.

Further, they comment repeatedly on the value of building tacit knowledge "flows" through the power of storytelling that engages the imagination and intellect of those it reaches. That sounds to me like a huge opportunity for our profession. We are the professional storytellers who know how to combine media assets to convey information in a way that moves hearts and minds.

In doing this work, we need to be aware of the difference between working alone and working collaboratively within a community. My generation was trained to think of visual communication, in the context of still photography, as principally being carried out as an act of solo practice, resting on a certain craft mastery that developed over time and that was unique to each individual. The authors of *The Power of Pull* would probably take issue with that idea as a wise course of action for building a career. In part, they contend it would be very difficult to build a sufficient body of knowledge in the future to be fully self-sufficient, and to be able to build such knowledge as a sustainable competitive advantage.

Instead, they would advocate the idea of collaboration with others engaged in aspects of visual communication to build "virtual teams" that could provide visual content solutions to those seeking to use visual communication to communicate about a good or service as part of brand messaging. They would underscore the economic advantage to be gained by providing a service rather than a commoditized product.

This crucial idea is essential for all image-makers to grasp. It is fine not to be able to do all aspects of visual content creation as a solo practitioner. However, it is not fine to try to always go it alone, assuming that one can amass the full range of knowledge and skills necessary to be totally self-sufficient as a small businessperson. Instead, it makes more sense to try to build one's business on the premise of collaboration within a community that can help provide resources to enable your visual solutions that address the current needs and problems of your clients.

It is essential that you learn how to position yourself as a partner in creative problem solving that fully taps your ability to leverage relationships with other visual communications specialists. Working in this way, we can take advantage of new knowledge flows, flexible and porous social network boundaries, and serendipitous encounters with other people to create new visions and possibilities for our own efforts.

I like the fundamental sense of optimism that the authors express and their view that fundamental changes being wrought by technology disruption actually can help rather than harm professional visual communicators.

PROVIDING VISUAL CONTENT IN THIS NEW MEDIA LANDSCAPE

Mainstream media is starting to shift significantly from print in the direction of screen-based digital devices. Mobile platforms that enable both information acquisition and entertainment as fused outcomes are the hot new thing. Convergence is clearly happening, but it is sometimes unclear as to what exactly that means for individual visual content creators.

Henry Jenkins, a professor of communication, journalism, and cinematic arts at the University of Southern California, in his 2006 book *Convergence Culture: Where Old and New Media Collide,* noted the two contradictory trends of the current media landscape. At one level, new technology is enabling individual production and distribution with greatly lowered costs, and enabling greatly increased channels of distribution. This has meant that all Americans can be content creators, "The story of American arts in the 21st century might be told in terms of the public reemergence of grassroots creativity as everyday people take advantage of new technologies that enable them to archive, annotate, appropriate and recirculate media content," he wrote.[19]

At the same time, there has been an alarming concentration of the ownership of mainstream commercial media, with a small handful of multinational media conglomerates dominating all sectors of the entertainment industry. No one seems capable of describing both sets of changes at the same time, let alone show how they impact each other. Some fear that media is out of control, others that it is too controlled. Some see a world without gatekeepers, others a world where gatekeepers have unprecedented power. Again the truth lies somewhere in between.[20]

According to Jenkins, "Delivery systems are technology platforms—media are cultural expressions (systems)—delivery systems come and go, but media persists, evolving and growing ever more complex, as it exists in information and entertainment spaces."[21]

For me, these books raise key new questions as the pace of technological change continues to quicken. To begin, as visual communicators and operators of small businesses how are we to handle the waves of fast change continuously reshaping our media environment today?

Another key question coming from old ideas about scarcity also looms. Will it be necessary to continue to hitch our individual efforts to the "big wagons" of mainstream media companies in order to have a successful career or to build a successful business? Or is it better to try finding a new path to reaching our target audience and the business profits that might flow from capturing that attention?

Other relevant questions to consider in this new media landscape:

How will the current consolidation of media companies, being carried out in the name of media convergence, cut against the trend that favors the release of creativity by independent visual content producers? How will the audiences evolve in their tastes and desires for visual media?

How will visual communicators take advantage of collaboration possibilities to build new business models that address visual

communication needs by media companies, corporations, nonprofits, governmental agencies, and others?

And how will technology affect aesthetic expression in the future, particularly as to how it might enable the more expansive develop-ment of rich media as the valuable language envisioned by Marshall McLuhan?

This last question seems particularly relevant since some media companies with newspapers are already embracing a "digital first" strategy and envisioning a future that is not based on the distribution of a print product.

As we move forward, it seems clear to me that we have the ability to recalibrate our own sets of relationships and to act collaboratively to discover ways to make our creative output ever more valuable to the world. This is perhaps the best way to move forward into this new media landscape that is constantly being reshaped by technological change and globalization, among other forces.

For supplemental information and resources on this chapter go to www.asmp.org/kennedy2 or scan this QR code with your smartphone.

THE ROLE OF TECHNOLOGY

BY PETER KROGH

For most of us, watching the evolution of technology is like watching a magic show. We sit back and wait for the next trick. Sometimes we are amazed and delighted, and sometimes we are horrified. We may have a vague understanding of how the trick is performed, but it mostly remains a mystery.

In both magic and technology, a skilled practitioner uses a disciplined methodology to accomplish the seemingly impossible. Current practice, in both cases, is built on the earlier achievements of others. And in both cases, while it may seem otherwise, it's not really magic. Let's leave magic behind and take a look at some of the structure and implications of real technological development.

Once we've outlined how technology develops, we'll look at some of the development that will be most important for photographers to keep an eye on. And finally, we'll present some strategies for keeping up-to-date in ways that are appropriate for you and your business.

Photograph © Aaron Ingrao

HOW DOES TECHNOLOGY EVOLVE?

To start this discussion, let's outline some of the important components of technological development.

Common Standards

One of the most important prerequisites for the development of technology is the creation of standards. This allows developments created by one person or company to be combined with those of another. At its core, think of standard bolt sizes. How hard would it be to build anything if each manufacturer needed to design and build each widget.

In our current world, the common standards for media and communication are pretty mature, although they continue to evolve. These include HTML, which powers the web, and image file formats, which enable interchange between users, computers, and applications. It also includes telecom standards that work around the world, SMS texting standards and more.

At the end of 2011, there were more than six billion mobile phone subscriptions, which means that more than 80 percent of the world is connected in the same communications network.[22] Internet slightly under half of that, according to some studies.[23] This is arguably one of the most important developments in the history of mankind, and we are just starting to see where it goes.

While there are still some areas of technology that are in need of better common standards, the real action is not in standards, it's all about platform.

Platform Development

In many ways, the most critical objective of any technology company is to become a platform: a foundation that others will build upon.

Mac and Windows are OS platforms, Photoshop is an application platform, Amazon is a retail platform, and Facebook is a social media platform. If you build your business on one of these platforms, then their technology may become part of the very DNA of your company.

Platform dominance can be a path to untold riches in the new economy. This is true for any level of platform that is owned by a private company, even ones who currently offer their platform for free. I believe that understanding this struggle is an important key to understanding technological development, and for forming a strategy for all your relationships with technology.

In many ways, the platforms that you use become your partners in business and in creative enterprise. The Facebook platform has become the social media instrument for vast numbers of companies, and it becomes more intertwined with their businesses with each new member. If you sell through the iTunes store, Apple demands a chunk of revenue. More importantly, Apple requires that you suborn your customer relationship to the one Apple has with the customer.

In the above two examples, we see two approaches to platform dominance. Facebook has adopted a "freemium" concept. Valuable services are given away in hopes that the platform develops critical mass and market dominance. (Hint: it's working.) You can see the success of Facebook's strategy everywhere. A large percentage of businesses, institutions, and government agencies use Facebook as an integral part of their customer relationship management.

Apple is working with an older paradigm—one that Microsoft used to pursue before Justice Department action. Apple sets up terms that require deep partnership with their platform and don't allow for any negotiation. (That one's working too.) This is evident in the terms Apple requires for App store participation as well as for content distributed through the iTunes store.

As you consider the adoption of any technology into your business, you would be wise to evaluate the extent of lock-in that any platform requires.

Disruptive Technology

A *disruptive technology* is one that changes in a great leap, rather than in small increments. It has the ability to change the value proposition of many different stakeholders. Established companies can go out of business if they can't navigate the change, and new businesses can achieve incredible market share seemingly overnight.

Digital Photography is, in fact, one of the textbook examples of disruptive technology. It changed the art of photography and radically restructured the market for nearly anything having to do with photography, from camera makers to film and processing, to the way we work as photographers, to the way our clients work with us and our products.

We are still in the middle—or maybe only the beginning—of the disruptive change that digital photography has initiated. There are still a great number of businesses and individuals that came of age in the film era. Eventually, the market will be filled with people who never practiced film photography, and that will create an entirely new frame of reference.

When faced with a disruptive technology, it's very important to accept your situation, and to plan accordingly. That means you need to be careful of the emotional attachment you have to the outdated technology (such as film). Once you begin to let go of that, you can start to do some planning for the future. Try and evaluate what effect the technology will have on your clients and how they do business. And how will those changes affect your business?

One of the most useful parts of this evaluation is self-knowledge. What is your relationship to technological change? The next section offers some methodology for evaluating that.

Crossing the Chasm

One of the most important books that describes the adoption of disruptive technology is *Crossing the Chasm* by Geoffrey A. Moore.[24] He describes the typical path of a technology from unknown and esoteric, through early adoption, and onto universality (if the makers are that lucky).

Here's the rough outline of how it works. Emerging technology needs to be picked up by a small group of "early adopters" who have sufficient incentive to go through the pain of development and troubleshooting. Once a technology has been proven to work, the "early majority" begins to make widespread use of it. The Late Majority and Laggards only adopt technology when it is clearly here to stay, and there is little way to avoid change.

The chasm is the gap between the early adopters and the early majority. There are many promising technologies (or companies) that don't make the jump from difficult and very expensive to cheap and easy.

Again, looking at digital photography in general, it started with the digital cameras of the '80s and '90s. These were often bought by news organizations that had tech support on staff and an overwhelming need to shorten the production cycle. In the early 2000s, we began to see the early majority, as more affordable production of cameras geared up. Now, in 2012, digital cameras are nearly universal.

The most important point is to know where you lie on the spectrum. There are both advantages and disadvantages to each part of the scale. Early adopters get a chance to incorporate new technologies and services into their businesses, but they do so at a greater risk. Emerging technologies tend to be expensive to implement, and there's no guarantee that they will take hold or remain viable. On the other hand, if you wait too long, you may not make the change to a new technology until your competition has already started to take away your clients.

The APIfication of Everything—
Accelerating Change

In order to understand the march of technology, I believe that it's important to know the role of the Application Program Interface, or API. An API is a set of "hooks" that an operating system, program, web service or device makes available in order to connect with another OS, program, service, or device. These show up in a number of places.

- The APP store is entirely powered by APIs, which Apple makes available for developers.

- The reason that Facebook shows up on so many web pages is that it makes APIs free and easy for web designers to use.

- When you start your GM car with your phone, that's also APIs at work.

- When your new TV plugs in to the Internet and allows direct viewing of Internet movies, it's being done through APIs.

- And when you are forced to upgrade your OS because you upgraded Photoshop, that's because Photoshop is dependent on APIs for many functions.

APIs enable technological development to proceed at an unheard-of rate. Programs are created faster because new code does not have to be written for every function—programs can pick up much of their functionality from APIs. Instead of making a dedicated remote control, a manufacturer uses API hooks to connect your phone to any wireless-enabled device. And when a big company wants to personalize their website *for you*, the fastest and easiest way to do it is through the Facebook API, rather than trying to build its own social network from scratch.

The connectivity and functionality that APIs offer is unprecedented. They dramatically shorten development cycles and reduce costs. But there is a downside as well. When you depend upon the APIs from another company, you are no longer master of your own domain. If

all of your client contact moves through Facebook, the social media site becomes your partner, to some extent. It's certainly possible that they may one day adopt usage terms that you object to. At that point, it may be messy to untangle yourself from the relationship.

This is a different sort of technological dependency than we are used to. Switching your camera system, for example, may entail some painful expenses as you purchase new bodies, lenses, and flashes. But switching out an API-driven social media platform can be even more complex, since it may lie at the heart of your customer relationship strategy. And this issue affects not only us as business owners, but it affects our suppliers and our clients.

Winner-Take-All Economics

The term "winner-take-all economics" refers to advantages that market leaders have which let them accelerate their lead over the competition. In retailing, the concept is at the heart of the Walmart strategy. The sheer size of the company enables it to buy at a lower price than its competition. This lower purchase price allows Walmart to sell at a lower price, eventually driving many competitors out of business. This increases the market share, allowing Walmart to negotiate an even lower price from suppliers.

In technology, we see winner-take-all economics in Google's success on several levels. It was first used to make the search tools better. And now it's a fundamental part of how they grow the company into new areas.

User feedback is one of the most powerful tools that Google uses to improve its algorithm. Google knows when you return to your search after clicking a result. If you never return, Google assumes that you found what you were looking for. If you come back and keep working through the results list, it assumes that it is not providing you with the result you were looking for, and it tries to figure out how it can do better.

The more users Google has, the better it can tune their algorithm for all kinds of searches. The better the search, the less likely you are to use a competitor. Which brings more users and, yet again, improves Google's search results.

Google has also leveraged winner-take-all in Internet search to move into new areas, such as GPS integration. The company has leveraged its lead in text search—along with all the money it has made from that service—to provide new functionality tied to your movements in the real physical world. And that new functionality ties your searches to real-time information about how you act on those searches. This provides the company with vastly more information about you, about how their searches perform. This gives the company exponentially more ways to monetize their relationship with you.

We can also see winner-take-all economics in how software applications achieve market dominance. Once a program has achieved critical mass, it has the ability to accelerate its lead. Sometimes this is simply a function of market awareness. "Everybody uses X program, so I will too." Sometimes this is because it's much easier to collaborate with people using the same project. "Send me the Final Cut Pro project file."

Sometimes critical mass enables ecosystems to spring up, such as the plug-in market for Photoshop. One of the most important things Adobe did with Photoshop was to open the program's APIs so that third-party developers could create useful tools that perform some function. These plug-ins are separate products that may guide you through image sharpening, or some kind of targeted image adjustment. This adds lots of additional functionality at little development cost to Adobe, and it creates a lot more companies invested in the success of the platform.

Note that while winner-take-all does provide an advantage to the big players, it does not ensure permanent market dominance.

- Companies might get out-engineered. Yahoo! was the search leader before Google came up with a better solution.

- Companies can also get lazy. Adobe InDesign knocked QuarkXPress out of its leadership in the design market because Quark did not see the urgency to move to Mac OSX.

- And when companies get too big, the federal government might step in. Microsoft's winner-take-all behavior was significantly altered by the Justice Department's antitrust action of the late '90s.

Technology and the Art of Photography

And finally, we can't have this discussion without outlining how technology has changed the practice of the photographic art itself. Photography has always stood at the intersection of art and technology, so it's not surprising that advancements in technology would have profound implications on how the craft is practiced. Let's take a look at an example of this change, HDR imaging.

The technology behind High Dynamic Range (HDR) imaging is simple in concept. Images are captured with an extended range from highlight to deep shadow. Generally, this is done by shooting a sequence of images that are exposure bracketed. The images are then stitched together in software and further manipulated.

Originally, HDR tools were designed to mimic a traditional filmic look. As with any new tool, however, photographers started misusing the capabilities to find interesting new visual style. Before long, the term HDR became synonymous with an oversaturated, "fake" look with lots of grungy detail enhancement that made a big splash among the photography enthusiasts posting on Flickr.

Eventually, scaled back versions of the "HDR look" started to make appearances in professional images. These showed up first in advertisements, and have spread to editorial content, fine art, and nearly every usage class of photography. As of this writing, the technique is generally considered a mainstream tool. (Like any creative tool, it can be used to make both good and bad works.)

The development of HDR travels a familiar road for many new photographic techniques. It starts as a gimmick, then it starts gaining acceptance as people figure out how to use it effectively, and eventually it simply becomes another photographic tool.

TECHNOLOGIES TO WATCH

You need to be attuned to the development of new tools. This can often be a difficult balancing act. On one hand, you don't want to spend all your time buying and learning new software and hardware. On the other hand, if you ignore developments, you might find yourself passed by. The following topics represent some of the most important areas of technology to watch.

Cloud Tools

The term *cloud* is one of the hot buzzwords in emerging technologies, but there is a tremendous variability in what people mean by cloud. In general, the term cloud refers to a service or function that is performed by multiple networked computers. In most common uses, the networked computers are not your own computers, but are ones that are scattered around various points on the Internet.

I have found it useful to break analysis of cloud computing into smaller chunks. There are four general uses of the term, and they may not have anything at all to do with each other.

Cloud Processing

This is probably the oldest true cloud service, dating back to the very beginning of the Internet. In cloud processing, a large task is spread out among many different computers in order to speed things up. This is useful for projects such as those that look through radio telescope data for signs of extra-terrestrial life, but it's not particularly relevant for most photographers.

Cloud Storage

This term refers to Internet accessible storage. This can be simple storage which mostly serves as a place to put stuff, or it can be part of some kind of cloud service as defined below. Cloud storage is generally not suitable as the primary storage for a photographer's archive, but it's very useful for targeted groups of files. You can use cloud storage to share and collaborate with clients, and to have access to your own digital files when you are away from your home or studio.

Cloud storage services range from free ones that offer modest storage, through consumer backup services like Backblaze or Carbonite, up to enterprise services like Amazon S3.

Cloud Applications

Cloud applications are ones that reside on the Internet rather than in your computer. The Google Docs suite of applications is a great example of cloud applications. As smartphones and other touch devices become more integrated into our computing experience, we'll see more cloud apps become available. These applications can offer seamless integration between multiple computers and devices.

Cloud applications offer the promise of multiuser work-group collaboration, either from the same office or spread anywhere in the world.

Cloud Services

The real game-changer, however, are cloud services, which typically combine some functionality from all of the categories above. Cloud services can typically store data, provide application functionality, enable connectivity, and have their own platform interface. Facebook is a type of cloud services application. The photo hosting company Photoshelter is also a cloud service—it has storage, image-smart functionality, the ability to integrate with multiple computers, and its own background processing.

Cloud service is the most interesting area of development because it provides the most transformative functionality. As a user, you may tend to think of Facebook as a social connection tool. Large companies, however, see that Facebook provides them a way to profile and connect with their customers in a way that would simply be impossible otherwise.

New Expression Driven by New Tools

As I outlined with HDR imaging earlier, new technology will continue to create new styles and new methods of photographic expression. Undoubtedly, some of these will seem strange and "un-photographic." And eventually, many of these will find a home in the marketplace where they can help with visual storytelling. I suggest that you keep your eyes and your mind open to these new styles and expressions, and don't be afraid to try them out. These tools may lead to personal artistic breakthroughs that refine your unique visual offering.

Here are some areas where you will see changes as technology evolves:

New Photographic Styles

We saw it with HDR, which was driven in large part by a single program, Photomatix, which offered a strange and compelling rendering. There's no reason to expect that this won't repeat itself sometime soon, when some other new tool enables a style that shatters conceptions of what a photograph looks like.

Still/Video Hybrids

The Digital Single Lens Reflex (DSLR) camera that shoots video is just the beginning. Flat panel displays and smartphones demand animation to attract attention and support storytelling. The new HTML 5 standard allows for hybrid image files that are somewhere between the two imaging types. HTML 5 also allows for extended capabilities for video files. Individuals and companies are working on this at all levels, from development companies to content companies to individual creators.

CGI and 3-D Imaging

The large number of 3-D viewing devices and theaters are hungry for content. And anytime you have a market needing content, there's an opportunity. In addition to the traditional two-lens 3-D photography, it's also possible to produce dimensional images with wireframe models that get rendered out to 3-D formats. Computer-Generated Imaging (CGI) is already having a profound impact on automobile photographers, as many ads are now simply created using 3-D models made from design specifications. These techniques have nearly eliminated traditional automobile photography.

Content Platform Development

Our work as photographers is inextricably linked with content platforms. At one time, there were a handful of options: books, magazines, movies, TV, and prints. More importantly, these platforms were relatively easy to understand, and they were owned by a relatively few companies. In our new economy, none of these lines is clear.

The race for success in media is, in many ways, the race to become a new dominant platform. You can see this when magazines start to produce streaming video content on their websites. And we see this when the *Huffington Post* sidesteps big media in its growth— starting first with news story aggregation, and adding original reporting as they mature.

Content as App

Instead of publishing to a book, magazine or website, we're now seeing a lot of content that is distributed as a smartphone app. This offers a number of important functions. It's easier to launch an app than to launch your web browser and surf to a page. The content can be formatted in for a better experience. And the app can take advantage of additional smartphone functions, such as geolocation, that are harder to build in to a website.

Media Convergence

The convergence of media types is an important part of platform development. One part of this is inescapable. Many photographers are testing the new motion imaging capabilities of their DSLR cameras as they search for new markets. And these markets are exploding. Companies that had previously used print for their most important communications are now in need of streaming content instead.

Another technical aspect of convergence involves television sets. It's now common for TVs to include some kind of built-in Internet access. This has the potential to be a revolutionary development as it enables a "standard" TV experience with Internet-delivered content. Google, through its YouTube service, is making a play to become a new super network with an entirely new access and revenue proposition.

There are plenty of others who are also working to become the Internet TV portal, and this promises a new opportunity to reach audiences outside of the current structure of network television. Independent creators may find themselves in an interesting position as these new business models are born. Any time there is a big shakeup in an industry, there is lots of new opportunity for innovation and rapid success.

Device-Based Content

I like to say that the touch screen is the new paper. I use my phone to read and write letters, make notes, read the news and more. Your smartphone is becoming the most important channel for information dissemination and marketing. Your smartphone does not sit at home while you travel, shop, do errands, or commute. It goes with you, it knows where you are, and it provides a way for you to be constantly connected to the entire Internet in a two-way conversation as you go.

As your smartphone becomes ever more integrated in all aspects of your life, the content on that phone becomes even more important. Publishers and advertisers need content that fits on the small screen

and that works with the suboptimal viewing conditions that people normally encounter with the device. The opportunities in this space are not just for image production, but for motion, audio, and even for new content structures that have not yet been invented.

STRATEGIC PLANNING

Technology moves forward at its own pace. There's not much we can do to slow it down, even if we wanted to. As a business owner, your survival strategy needs to be rooted in a good evaluation of where we're going, and how inevitable changes will affect the practice of your craft and the shape of the marketplace. And of course this evaluation needs to take into account your strengths and weaknesses, and your areas of interest. In Part II of this book you'll find tools to help you make these evaluations and to act on them.

What is your methodology for learning new technology? The first step in developing a strategy is to know yourself. The Crossing the Chasm spectrum is really helpful here.

Are you an early adopter who enjoys and is good at implementing new technologies? If so then it should help to inform your business and marketing strategy. But you also need to be careful that you don't adopt *too* early, and waste a lot of time on technologies that fall into the chasm and never take hold.

The early majority is probably the best place to be, picking up new technology as it is adopted on a wide basis and becomes standard. When you see new technology being picked up by your kids and your technophile friends, it's time to start paying attention. And as soon as you see any of your clients picking up on techniques, it's time for you to get in gear.

If you are a late adopter or a laggard, you may be putting yourself at risk. While there are some photographers who are able to keep doing things exactly as they have for the last decade, that is a pretty

rare exception. Almost everyone has gone digital because that's what the market demands. If you know you are a very late adopter, you'll probably want to put some extra effort into understanding new technologies.

Upping Your Game

If you feel like your techno savvy is putting your business at risk, here are some suggestions for filling in the gaps.

Pay Attention to What Kids Are Doing

Each successive generation grows up with more technology at its access, and they will create new relationships with that technology. Those new relationships include stuff that's new, as well as existing technology. For example, when texting became popular in the United States, it not only created a new way to communicate, but it also had an effect on how existing email and telephone are used. And the rise of the MP3 music file will forever change new generations' relationship to recorded music.

Pay attention to how young people are using technology, and try to resist your inner curmudgeon. One of the best ways to get this interaction going (assuming you don't have any young people in your house) is to teach or mentor teens, young adults, or emerging professionals. Not only is it rewarding, but you'll get a chance to understand what technology they are using and how.

Examine How Your Clients' Industries Are Using Technology

If your work is concentrated in particular industries, it's advisable to spend some time understanding what the new developments are, and how your clients may be using them.

The most directly relevant technologies will be the communications platforms that are used by marketing people who might hire you. You

may do print work for a company and find that they are starting to put video case studies on their website. Or perhaps they have developed a smartphone app. These new ventures may present opportunities for you to get additional work from the company.

If a company starts a social media strategy that includes Twitter, Facebook and/or blogging, there may also be a need for a new set of portraits. These images tend to be less formal than traditional business photos, and need to work as small square images.

If you are, for instance, an architectural photographer, you would be wise to understand your client's use of CGI technology, as it may be used in the same way as automotive CGI. CGI can be combined with "real" photography in ways that may become standard practice in this market segment.

And finally, understanding the technology that a company uses can help you tell the company's story better.

Examine What Your Competitors Are Doing

It's important to know what your clients do and what they want, but it's also important to know what your business's competition is offering. Clients can get used to new levels of service very easily, and not having that service capability can put you at a significant disadvantage.

Some of the capabilities are easy to measure. Improved turnaround times enabled by improved software capabilities or new hardware are one obvious example. Offering still and video imaging is another one. And new image techniques, such as HDR or Panorama stitching might also be offered by competitors. You might want to spend a bit of time asking your favorite clients what new services or technology they have heard about that is of interest to them.

Set Up a Regular Meeting with Technophile Friends

If new technology is not one of your strong suits, perhaps your friends can come to your assistance. See if you can make some time on a regular basis to discuss new technologies that are of interest to your friends or colleagues who love that stuff. (You know who they are. And you also know they love to talk about it.) The objective here is not to learn all the nuts and bolts of everything new coming down the pike. The real objective is to figure out what to pay attention to, and when to get serious about it.

Take Advantage of ASMP's Resources

There are endless places to get information about technological developments. If you want to learn about digital photography, or if you want to learn how a piece of software works, you have a lot of choices. There are books, videos, and classes of every scope and cost profile. The vast majority of these, however, are focused on the practice of the craft, and not the practice of the trade.

ASMP provides a different perspective for technical education. The focus of the association's efforts is to fill the gap between existing resources. In our case, that means analyzing the technologies that relate directly to digital photography business practice. ASMP has done a good job bringing this kind of information to the entire photographic industry.

ASMP resources include many published tutorials on the ASMP website, the technical information on dpBestflow.org (which outlines digital photography best practices and workflow) Cameracake.com is a resource sharing site, the national programs, and the chapter programs as well. While these resources do not provide everything you need to know about technological developments, they do provide an excellent overview of developments you should pay attention to and research further.

Try to Use Some New Technology for a Limited and Achievable Project

I have found that the best way to learn about some new technology is to put it into practice in service of a particular goal. It's simply too large and difficult to "learn Photoshop" or "learn digital filmmaking." It's much easier to learn some chunk of this new technology working on a particular project. I suggest finding a modest and achievable project to be your case study.

In many cases, the best way forward is to start with a project to do for love rather than money. You could do something for your kids' school, your church or some other volunteer group. Or you could create a personal project that helps you stretch out beyond your normal comfort zone.

I've been working on a personal project photographing Halloween across the United States since 1982, and it has always provided a good proving ground for new technology. In the early days, that included tricky stuff with flashes, and then for digital photography experimentation, and more recently video and audio techniques.

Get a Lynda.com Account

If the new technology you need to learn involves some kind of new software, one of the best ways to jump-start the process is with a Lynda.com account. Lynda provides video training for an extremely broad range of software applications, with a concentration on creative services applications. They do a good job recruiting expert trainers, and they create comprehensive and well-produced curricula. I have most recently found this to be valuable as I have learned to edit digital video.

FINAL THOUGHTS

Technology presents a great challenge and a great opportunity for photography. This is evident in both the art and commerce of our profession. To navigate these changes, it's important for you to understand your own relationship to technology, and for you to be able to recognize how things are changing around you. Armed with this knowledge, you can create an action plan that capitalizes on your strengths, and addresses your areas that need improvement.

For supplemental information and resources on this chapter go to www.asmp.org/krogh3 or scan this QR code with your smartphone.

THE ONGOING TUG OF WAR BETWEEN COPYRIGHT LAW AND TECHNOLOGY

BY RICHARD DALE KELLY

"Everyone is a copyright infringer… we infringe copyright everyday."
—*David Carson*[25]

Photography in the predigital world was all atoms. It had mass, moving it from one place to another required real effort and cost. There were serious investments in time, money, and human

resources to take a photograph and publish it. There was value from image capture to distribution. If you were a photographer with a unique skill or reputation, that was all added value. Digital photography and distribution changed all that when making a copy became easy with no impact on the image quality. Once released into the cyber world an image became hard to control and impossible to track.

A LOOK BACK IN TIME

Until the 1970s the average person rarely intersected with copyright. The act of copying was almost as costly to reproduce as the original, or at the very least, was extremely time consuming. Publishing and broadcasting were primarily professional ventures and all the players knew and respected the rules. Xerox launched the photocopier in 1959[26] and in 1975 the home Video Cassette Recorder (VCR) was introduced by Sony.[27] These two products sparked the early techno-logical challenges to modern copyright, where for the first time a consumer with access to these machines could copy a professional video production or duplicate a published work and then redistribute it for a fraction of the cost of making the original. These copies were a reasonable quality and could be made at a fraction of the time. Because the very act of copying is infringement, when that copying became easy, affordable, and of a high enough quality, the conflict with copyright law began.

In 1976, computers were only institutional or for the home-brew hobbyist. It would be another twenty plus years before the convergence of the desktop computer and the World Wide Web would launch the digital revolution and copyright would never be the same. But it wasn't too long into the 1980s that the federal courts started to get busy with the many challenges pitting new technology against Copyright. In 1984 the SONY electronics company sued Universal Studios in a lawsuit, Sony Corp. Of America v. Universal City Studio, Inc.,[28] also known as the "Betamax case;" this case started the era of copy technology versus the copyright industries. The basic premise of the case was that the manufacturer of the video copy machine

would not be liable for the acts of the individuals or rather just because they provide the technology to infringe did not make the machine illegal, assuming that it could also be used to create non-infringing value. This case is often used to determine whether a technology that has copying capabilities actually is responsible for the act of infringement. This early court decision set the stage for the constant tug of war between copyright law and technology.

The Copyright Act of 1976 was the first statute revision since 1909, and it was to address some of these advances in technology. The 1976 revision introduced some important changes for independent photographers. It placed ownership of the copyright with the author (photographer), not the commissioning party (client) and the act granted six exclusive rights: the right to *reproduce* (copy), the right to *create derivative works* of the original work, the right to *sell, lease, or rent copies* of the work to the public, the right to *perform the work publicly* (if the work is a literary, musical, dramatic, choreographic, pantomime, motion picture, or other audiovisual work), the right to *display the work publicly* (if the work is a literary, musical, dramatic, choreographic, pantomime, pictorial, graphic, sculptural, motion picture, or other audiovisual work), and the right to *perform the work publicly by means of a digital audio transmission* (if the work is a sound recording).[29]

Back to the Future

Commercial photography existed for some fifty years before the 1976 copyright act extended all rights to the photographer. The commissioning party owned most assignment photography created prior to 1978 when the revised copyright law took effect, under copyright. In all likelihood the photographer would have continued to create photographs using a day rate model, even without copyright ownership. But in the mid-1940s a group of magazine photographers formed the Society of Magazine Photographers (SMP), the precursor to the modern ASMP, in an effort to improve the fees and working conditions for the photojournalists of the day. By the 1960s they had successfully convinced the magazine publishers to accept and

recognize that the "reproduction rights and ownership belong to the photographer; that each use of a photograph must be compensated for and that limitations on a photographer's freedom to reuse his own creations must be related to the purpose and protection of the publication and must be limited in time."[30]

Double-Edged Sword

This set up the effort to change the copyright act that would place copyright ownership back into the hands of the artist creators, allowing photographers and all authors to control their creative works and monetize those endeavors. With these rights, though, comes a responsibility that most photographers working at the time were not fully prepared for. Photographers want to focus on the action in front of their lens and less on the paperwork in the studio's back office. It would be over three decades before the most useful and effective tools for licensing and copyright management would be available to help photographers market and manage their intellectual property directly to buyers at a reasonable price. Many of these tools have also led to the diminishing value of all photography, sometimes even making the images freely available to the masses. The digital revolution is a double-edged sword of both opportunity and challenge for the independent professional artist.

The revised copyright law seemed to be good for independent artists, and the ASMP was very active in getting the legislation passed. There was a downside for commercial photographers who needed to learn a new business model, including sales and negotiation skills. Now photographers weren't just creating images, they were managing intellectual property. Photographers needed to have a firm understanding of what a license was, how to write them and to know their value in the marketplace. ASMP took the lead in issuing white papers and printed guides for photographers explaining the usage licensing models along with other business practices.

What ASMP could not do was tell photographers what the market value for those uses would be. As photographers struggled with the new responsibility of copyright ownership and licensing, many were fully unprepared to sell this new system to clients, who treated this turn of business as adversarial. Clients were advised to demand more rights in boiler plate purchase orders and Work Made For Hire (WMFH) language started appearing in contracts; Work Made For Hire was another controversial addition to the Copyright Act of 1976 which we will discuss more completely in chapter 5. That's not to say that photographers did not benefit from the fee-for-usage model; for a couple of decades this fee for usage would be the dominant model for professional photographers, especially those working in the advertising sector of our industry, but in hindsight the combination of the new licensing model and a lack of a baseline market value led to confusion, confrontation and ultimately a continual downward spiral in fees. For some photographers working in retail or small business markets the pay-per-use model never really worked. Instead most of these photographers worked on rates based on time or on delivery of products like print sales or albums.

TUG OF WAR

For the photographer, the issues of quality and control are not just for aesthetic concerns, but they also have financial consequences. Many photographers make a significant income stream from selling copies or prints. For a wedding photographer, having digital versions out there in the World Wide Web meant a potential loss of print sales. For the commercial photographer, controlling access to their photographic collections for specific and limited use regulated the value for those creative works. This was how they collected fees for both their commissioned assignment work that was usually for a specific concept, and client and stock images, which were often produced by the photographer to appeal to a broad range of art buyers. If these collections were easily available in high quality, not only would they have a loss of revenue, but also a perceived lower value as the images were no longer exclusive.

What Got Us Here

In those early dot–com days, the race to put content online was enormous. Every publisher and company was venturing into the World Wide Web. Digital websites required large investments in digital infrastructure including broadband, servers, and code. Without a firm monetization strategy, many of these businesses were unsure where the money would come from. For visual artists there was intense pressure by clients to provide additional electronic uses at very low fees, using the excuse that they were not yet making money. This was the beginning of the diminishing value of content. As we later discovered, the dot–com bubble burst because the free cart went before the monetization horse.

Most of us now realize that these digital challenges were not unique to photography as every analog medium was transitioning into digital bits and facing a similar struggle. We often see comparisons between photography, music, and motion pictures and there are correlations, but for the most part because we have different markets and business models for monetization, the comparisons do not readily apply. In the music business, most songwriters transfer the copyright to their compositions to a publisher in exchange for royalties. The performer on a musical recording most likely transfers copyright to the record label that bankrolls the production and then pays royalties against advances. For simple bookkeeping purposes the more the song is played on the radio, sold to the public, and listened to on television, the more often little bits of money flow through the mechanics of the music business to all the stakeholders. At least that's how it used to work before Napster and iTunes. The music business saw one of the earliest impacts of the digital.

The Day the Music Died

The recording industry's entire business model was built on selling recordings, LPs, cassettes, and CDs and the business. Radio play, music videos and even, to some extent, concerts were designed to

sell the product. They had a good thing going until MP3s. Although lower in audio quality than compact discs, they sounded good enough through headsets. File sharing websites started to pop up and music was practically free.

It wasn't until Apple, through the development of the iTunes store, streamlined the process of buying, and downloading music finally makes sense. Give the consumer an easy and legal way to access digital media and they won't steal it. The digital media genie is out of the bottle and musicians are now discovering that the middle guy, the record companies, may not be as necessary as they once were. As the platforms for creation and distribution flatten, it will be interesting to see if the cost of developing talent, funding productions, and marketing artists is still something that the record labels can provide as their salable value-added service. In most media businesses we can ask, is the middleman still necessary? Or will their role also change?

THE NEW SOCIAL CURRENCY

As more independent creative professionals self produce their projects, they will need to start thinking more like the producers and publishers they traditionally worked for. The challenges are the same and the solutions may be very similar. Affordable media storage, infinite search, and the interconnectivity of social media give today's producer the tools to develop an audience, raise capital, digitally collaborate and distribute worldwide instantly. The sharing economy is built on the currency of your connections, your links, your tweets and your likes. Monetizing this is the big challenge and is the weakness in what otherwise is a very efficient system; currently it seems that the artist monetization choices are either underwriting by a sponsor or an online advertising model like Google Ad Sense[31] that provides online publishers a platform to offer advertising on their web pages and share in the revenue generated by those ads. The big disconnect is that in the Web 2.0 model much of the advertising revenue flows to the web page publisher and not to the writers and

visual artists whose work is often "shared" on these platforms and brings the eyeballs needed for financial success, yet creators rarely if ever see any of the money generated by their content.

For the social media companies, these connections are like a cash register. What is needed is a mechanism for the content producer to collect a slice of that revenue stream. Some social media sites are starting to build revenue systems to pay creators for their intellectual property. For the independent producer, this may be the solution for long-term sustainability. YouTube, the online video platform, has created the YouTube Partners Program[32] that allows independent video producers to get paid for their videos and in 2011 YouTube purchased RightsFlow[33] to legally license and pay copyright owners of music and to manage online music rights. I see this as a sign that some of the more successful platforms moving forward will pay for professionally produced content.

It's All in Who You Know

You may want to reach beyond your own website. You may want to share your story with people who don't even know you exist. Social media connects you to everyone else, at least everyone who is connected, and these days that's a lot of connections. No longer just six degrees of separation, that is so six seconds ago. The ability to have your promotion or your self-produced project travel bit by bit to everyone who is connected to your connection's connections is revolutionary. If sharing your work were your intent, how would anyone know?

The New Face of a Thief

Not that long ago, producers paid marketers to promote their products using beautiful pictures, crafted audio, and enticing motion trailers. Today with a click of the mouse or a swipe of the finger marketing content can be shared across the planet in milliseconds. If that sharing is intended, then hooray! Mission accomplished. However if the swipe was more than just a finger and was more the

sinister use of the word, like a bad actor sharing without the consent of the content producer, that's plain old copyright infringement. "I didn't make any money" tweets the "swiper." "Information wants to be free," emails the student. "There was no monetary harm," the lawyer tells the circuit court of appeals. In the digital space, there needs to be clear intention communicated regarding the use of copyrighted works, so that everyone along the way knows what's allowed and what is not.

In our digital world, communicating the creators' attribution notice and the licensing intent of a work is one solution to calming the Wild West practices. By default, under the 1976 copyright act, the artist or copyright holder holds the exclusive rights to a work. Prior to 1989 when the United States signed the Berne Convention, proper copyright notice was required to prevent the published work from entering the Public Domain.[34] Even the words "All Rights Reserved" explains to a user that the work is under copyright and that no rights are assumed without a license. Using this scenario, both the artist attribution and the licensing intention is clear.

Although these improvements initially removed the fear that a work would lose copyright protection if not handled properly, in a digital world it has led to digital works without appropriate attribution notice, which means that an artist is stripped of valuable authorship credit and a potential user of an image who wants to get permission to use a particular work may not know who they need to contact. Without a clear license attached to the image, the consumer may not know what they are allowed to do with any given visual work. It must be assumed of course that lack of a notice does not give the user the right to a work and of course a user must also assume that all works are under copyright.

For much of the social media Internet, what would have been a copyright infringement a decade or even two years ago is now most likely user approved and permissible sharing. Many social media websites have overly broad user agreement between the social media company (them) and all of the users (you and your closet "friends"), which allows the platform a royalty free license to distribute your

creative works. This End User License Agreement (EULA) eliminates the need for subsequent licensing by the creator to the user, but, in many cases, is overreaching beyond what the websites need to operate. This has led to both fear and speculation by users of these platforms. There is a lot of copyright mythology, which overshadows the fact that there is very little case law to establish the full legal scope of these EULA licenses.

Not the Safety Net We Needed

The Digital Millennium Copyright Act[35] (DMCA), another part of a copyright law revision in 1998 that carved out a "Safe Harbor" for technology companies, removed the liability of secondary copyright infringement. Traditionally, during a copyright infringement case, a plaintiff will sue everyone connected to the infringement. The primary infringer might be a rogue publisher, but the person who prepared the scan, the printer who printed the publication, and anyone else with deep pockets had potential secondary liability. This tactic efficiently brings quick settlements if the defendent is seen as a Goliath to the artist David. The "safe harbor" mentioned above protects websites from being sued for secondary copyright infringement, as long as they play by a specific set of guidelines outlined in the statute, including responding to proper DMCA Takedown notices and removing infringed works from their site. Although the DMCA and in many cases the EULA do limit liability to the websites, they do not address the issue of the copyright owners' intent for a particular photograph or creative work.

The very same technology that initially seems to be the end—as we know it—for copyright may offer the solutions for the individual artists to take back control of their creative work and to benefit financially. The challenge of course, during this transitional period, is survival for the artists. There are many big questions to still answer and a number of changes to make.

- Cultural change in how we consume intellectual property

- Societal change, how we treat the artists who create the copyrighted work

- Legislative change, which allows all of this change to happen with an emphasis on monetization solutions benefiting the independent artist

There is a lot at stake, big money for both the copyright and technology industries. And a sustainable livelihood for the artists typically stuck in the middle of this modern copyright war. For artists there is also the emotional stake that they have in the control of their work. Which is sometimes, especially for the amateur, more important than the money.

Copyright and copy technology are in a constant tug of war. As artists, we must accept that copyright laws will always be out of step with what copy technology offers. It seems that every few months the next worst thing happens to copyright and is the enemy du jour. That is until the copyright holders come to some terms with the technology and see the value that emerges on their bottom line.

For supplemental information and resources on this chapter go to www.asmp.org/kelly4 or scan this QR code with your smartphone.

WHERE ARE THE SOLUTIONS THAT CREATE COMPENSATION?

BY RICHARD DALE KELLY

For the visual artist, a key strategy looking forward is to realize that there is no one solution that we will apply to every assignment or every client. The entrepreneur/artist will need to evaluate their personal creative and business goals while observing realistic trends in the media market that they are working in. As photographer Jay Kinghorn explains in his "Agile Photographer Manifesto," "The agile photographer will need to become agents of their own control, broaden their expertise and apply their skills to strategically help their clients navigate this fragmented and ever-changing landscape."[36] For the imaging professional, managing intellectual property ownership is just one of the decisions they will make regularly, as they create solutions for a sustainable business.

For the creative professional we have long operated under two broad types of work, commissioned and self-produced, and many artists have been able to rely on just one dominant model. Moving forward we will use many business models and provide multiple income streams, sometimes on the same day.

COMPENSATION SOLUTIONS

The commissioned assignment model will continue to address the on-demand, concept-specific needs of advertising, corporate marketing, established publishing organizations, and retail photography for weddings and personal portraiture. The economic model is firmly established as a fee for services rendered. In the case of retail photographers this is often based on time or product pricing. The other commissioned work sectors rely on creative fees plus licensing fees and are based on specific market sectors and other licensing criteria.

The visual artist who brings a unique and marketable viewpoint, or has particular technical expertise, will have little trouble carving out a niche and commanding higher creative fees. For those imaging professionals competing for the middle of the road assignments, it's not quality or vision that the clients are looking for, they want the cheapest rate on their deadline. These assignments where price is the principle factor will continue to contribute to the downward pressure on fees in your market. The only way out from the middle is to find clients whose major decision-making factor is not price.

As these markets from top to bottom demand broader and more flexible licenses there will be less secondary licensing opportunities, traditionally an area of additional income for visual artists from clients re-using images under new licenses and paying additional fees or images created for one client and later being licensed as stock. There will continue to be more requests for copyright transfers and Work Made for Hire contracts as clients hedge their planned uses for images in new ways. Corporations are risk adverse and one way to reduce liability for unlicensed uses, which might trigger copyright infringement lawsuits, is to own the copyright outright. Another reason for an uptick in WMFH clauses in contracts is that companies

are more aware than ever of the value of their image for their brand; copyright ownership will ensure that those strategic images are exclusive to them.

No matter how you sort it, there is a more concentrated effort to control spending for photography and motion. It's an interesting correlation that as the use of low cost media placements has increased, the expected values for photography budgets have decreased. The value of a YouTube channel is free, thus the perception by many marketers is that the video production for that channel should also be free or at the very least cheap. There is little consideration made for the actual cost of production value.

The alternative approach is for visual artists to think more entrepreneurial, more like a feature film producer than a photographer for hire. The visual content producer will wear more hats and have more financial and legal responsibility. But, they will also have the most to gain financially from any monetization system put into use, including up selling to clients the value of a finished product rather than just a component to be handed off to another creative.

The role of the artist/producer will include concept development, project management, fund-raising, production, marketing, and distribution. Depending on the project, imaging professionals will need to be more collaborative than ever before, hiring a team of experts to fulfill specific roles and skill sets. One of the key differences between the assignment photographer and the content producer is that the former creates copyrighted works, the latter also consumes them. This is important as the producer must not only manage their own Intellectual Property but also negotiate and clear rights with an eye on their budget and on the distribution plan for their project.

The important take away for imaging professionals is that intellectual property has both value and responsibility. Technology today offers us tools to market, distribute, license, and manage copyright; some are in the early stages of providing a true frictionless income stream, creating a lights-on-24/7 business model. There are both practical issues for visual artists to deal with, like embedding metadata, registering their copyright, and making themselves and their images easy to find.

JOJO LIGHT, ARTIST AND ENTREPRENEUR, SHARES HER PLAN

Let's use fictional visual artist JoJo Light as an example of how an imaging professional is approaching her business as an entrepreneur. JoJo has a specific plan, and she knows the value she offers her targeted clients. She has a vision for projects she would like to self-produce and she is moving forward with a holistic marketing approach. She has decided that she will commit 30 percent of her resources in money and time toward self-produced projects, 30 percent toward assignments for her targeted clients and 30 percent toward editorial work.

Progressive View on Copyright

JoJo knows from experience that, for her personal projects, she will both need to manage the copyright for the work she creates and negotiate and clear rights to the soundtrack and "b-Roll," which she will use to cut from her motion images to existing stock images. This requires her to license from various stock collections; these are typically scenes that she either doesn't have access to or are generic enough to use for editing purposes.

She is willing to cede control to some of the commissioned work because it either has no secondary licensing value and therefore will not require additional copyright management or because the use is too specific to the end user client, other than her portfolio. She will evaluate each assignment on its own merits and factor her pricing to fit the scale of the project and the market value, what she brings to the project creatively or technically, and what it means for her bottom line.

Just Say Yes

At one point in her career, she just said no to work that either required a copyright transfer or demanded overly broad rights.

JoJo now looks at these from a purely business perspective and tries to get as much money for her creative services as she can. In chapter 10, Blake Discher discusses how to get the most possible for any assignment. JoJo's decisions are not moral—they are pure business. For those commissioned assignments that offer secondary licensing options through third party sales or possible stock licensing, she will evaluate and price accordingly.

Evaluation

One lesson that JoJo learned early in her career is that her focus must be on the commissioning client and their project and not what she might do later on with the pictures. JoJo learned the hard way that exclusivity is paramount in today's marketing world and clients don't want to see their investment in strategic images on their competitors' marketing materials. JoJo addresses these concerns right away in her contracts and persuades her clients of her value in exclusivity and that comes at a respectable fee; if they want a bargain price, they give up some of that exclusivity.

Guilty by Association

JoJo also knows the value in keeping her images and name in front of the decision makers that she wants to work for. She has agreements with a few editorial clients, a few online publications, and some printed glossies. She realizes the value of being curated by these style makers that will lead to other corporate and advertising projects. Some of her editorial clients are now demanding broad unlimited use and one has had her sign a Work Made For Hire (WMFH) agreement. She has evaluated both choices and determined that they each have different values to her business. The promotional value the magazines offer, she could never buy. JoJo was able to negotiate portfolio and promotional rights for both, and with one magazine she carved out an agreement to sell fine limited edition prints from her website. She receives appropriate photo credit, including linkages to her online domains. This has Search Engine Optimization (SEO) value to her as these relevant links raise her status in search results

for her website. These public links also connect her photography brand to these established publishing brands.

What JoJo knows from experience is that the life span of an image today is very short and the fees for secondary use are minimal. Simply due to the explosion of inexpensive stock photographs available, these images have become a commodity and will rarely garner larger fees. Her goals are simply to lead a creatively satisfying business, earning fair compensation in creative fees for the quality of work and service she delivers to her clients.

THE NEW DIGITAL PARADIGM

As we quickly advance into digital platforms, our clients are requesting broader and less restrictive licenses. With the pressures of multiple platforms and the uncertainty around how they will use the image, many clients are less inclined to pay upfront for what they may never use or else they want to pay later for images that "go viral" over the web. These changes raise many questions for the creative professional: How do we track and monetize these uses? How do we, as professionals, calculate our value? Or evaluate the value of our unique images? And then, how do we build licenses for these limitless platforms? Are the days of specific licenses over? Is every license a worldwide use? Our passion for our work is what endears us to our clients; we need to separate the emotion from business.

A Universal License

The PLUS Coalition[37] was established to initially create a common glossary of contractual and licensing terms. A common problem in the commercial market was overly vague and ambiguous terms. The second step was to create a process for writing licenses that was both machine readable and able to be embedded. As commercial clients begin to integrate protocols into their internal rights management systems and as online solutions use more universal and useful metadata for monetization, visual artists will begin to embrace metadata-based information systems. This embedded information will clearly state

copyright ownership, license intent, and contact information that is both trackable and able to be updated as status of use changes.

The Print to Pixel Paradigm Shift

During the transition from print to pixels the industry has settled for broad use licenses with flat upfront payments. There are some promising technology models for monetizing online uses for images and motion. Interestingly, they may be most useful to the personal projects rather than the traditional commissioned assignments. Imaging professionals who are able to negotiate more substantial upfront fees may be better off than opting for transactional royalties for campaigns that are unsuccessful.

Calculate Professional Value

My opinion is that we should focus on those professional and creative attributes that we bring to our projects and separate the compensation from the license. This is counter to the way this industry has functioned for so long. But in a multimedia universe that is more niche casting than broadcasting, the value is in smaller more focused audiences. Applying a formula for page views or unique viewers may be counterproductive to our bottom line. I suggest that the value is what the imaging professional brings to the image. I am not suggesting a standardized rate system; in fact my system is customized to the project, the client, and their goals. A mom and pop store will pay less than a FORTUNE 100 multinational, but both licenses are the same, as in an "Exclusive World Wide Unlimited Use."

Building a Limitless License

This approach does change things a bit. Separating the license from compensation means that we can build licenses for broader uses without fear of leaving money on the table. It could mean an end to specific use licenses altogether. Stock distributors may be the last

holdouts offering some high-end, one-of-a-kind image for limited use, but royalty free and subscription plans offering access to limitless images for monthly fees have all but eliminated specific and limited licenses. In the assignment world, multiple platforms and unlimited duration has become standard. The real negotiation is for the amount of money.

Value of Intellectual Property

The rights granted to the visual artist when he or she fixes an image in a tangible medium still has value. How we piece it up for consumption changes how we license copyright. If the artist transfers large bits of their exclusive license it should be for the right business reasons. Knowing one's value in their market and successfully negotiating that value is the highest priority. The days that photographers would fall on their swords in disgrace because they chose to "sell" a copyright to a client are over. As photographer Blake Discher likes to say in his program "No More Grumbling," "...everything in the studio is for sale even his office chair!" He's not advocating giving it away, he knows the value of the copyright and charges accordingly.

The critical lesson for us moving forward is to recognize that not all work is equal; the work that is in your heart of hearts has the most value, either as a completed project, a self-published book, or a limited edition print. These are the works that are worth fighting for. This is where you have the most invested, financially, and emotionally.

Work Made for Hire

The Copyright Act of 1976 specifies a type of work, when the creator is not the copyright holder. The Work Made for Hire[38] clause defines in layman's terms that if you are working as an employee and your job description includes creating works that are copyrightable, then those copyrights belong to the employer. Part two of the WMFH clause goes one additional step allowing for nine specific types of work,

depending on the relationship of the parties and the specific circumstances of the work. The three that apply to imaging professionals are:

- as a contribution to a collective work

- as a part of a motion picture or other audiovisual work

- as a supplemental work

There are instances when, for a number of reasons, it is reasonable that an independent contractor, prior to commencing work on a project, may enter into a work made for hire contract with a commissioning party. To illustrate this here are two examples.

A wedding photographer hires a second shooter to cover some aspects of the event that she alone cannot cover. Although the second shooter is an independent contractor hired for the assignment, it would be confusing for the bride to have to interact and contract with each photographer separately. The primary photographer would have the second shooter sign an agreement outlining the agreement between the two parties. This situation comes up a lot, as a conflict between photographers, over who can claim authorship—the studio or the second shooter? And then, how images shot by the second shooter can be displayed in her portfolio? These financial considerations and business details should be included in the working agreement.

It is also customary when working on an audiovisual project like a video or motion picture that the various technicians and creative contributors enter into work made for hire agreements with the producer. As a production is being distributed it would be impossible to clear each use with every individual rights holder. If, for instance, one contributor declined, the entire project would be held hostage. This is one area of business in which traditional still photographers, as they move into more audiovisual work, will have to evaluate their role in the production. For many imaging professionals, working as a director of photography or as a camera technician may be a perfect extension for their creative work. However, they should expect to work as a work for hire contractor on those projects and expect to have no financial interests beyond a payment for services. As

visual artists look for creative opportunities and sources for multiple income streams, a photographer may one day be creating works where he owns the copyright and then on another project he could be working as a crewmember under a work made for hire contract.

Corporate Ownership

Of all the changes that occurred in the 1976 copyright act revision, the Work Made for Hire doctrine is the one I have the hardest time coming to terms with. As I mentioned above, there are instances when it is necessary to address copyright status of a work with multiple authors. What makes it challenging for independent artists is that over the past couple of decades the WMFH clause has been twisted and manipulated by entities in ways that the clause was not intended for. In some WMFH contracts, they even go as far as saying that in case the courts determine that WMFH does not apply, all rights transfer anyway. Which leads me to believe that the lawyer drafting the contract is not even sure that the WMFH clause applies. As Lawrence Lessig writes in *Remix*, "This is an awful trend, fundamentally distorting the copyright system by vesting copyrights in entities that effectively live forever."[39] I much prefer the option of granting broad usage rights or even a specific image copyright transfer to signing a WMFH agreement. However, each professional artist will have to evaluate every project on its own merits and determine if the financial compensation is worth the effort. It is my belief that not every project is a battle to the death and picking your battles is the biggest challenge of the entrepreneur.

Two things to consider with regard to Work Made for Hire: One, the agreements must be in writing and agreed upon prior to the copyrighted works being created. Two, you must remember that if you do agree to a work made for hire agreement, you are no longer the author of the work, which translates to someone or some company taking credit for your creation and thus you are prevented from showing the work as your own, even in your portfolio. You may even be sued for infringement of your own creative work if you create a work that is substantially similar.

PRINTING MONEY

With management of intellectual property comes both a right to exploit copyright and the responsibility to manage those copyrights. Knowing your value and the value of your images is key to creating a sustainable career. As we learned from JoJo Light, a photographer is no longer a one-trick wonder; copyright is not your only business model. The professional image-maker has multiple skill sets that add value to a production, an image, or a motion clip. On any given day their creativity, their leadership ability, their cost-saving solutions may have higher value than the rights and licensing associated with an image. The successful businesses are ones that evolve and adapt offering solutions and value. A good business is like printing money.

For supplemental information and resources on this chapter go to www.asmp.org/kelly5 or scan this QR code with your smartphone.

PART II

THE PROCESS OF BUILDING A MANAGEABLE SOLUTION

CHAPTER 6

YOUR FIRST STEP

BY JUDY HERRMANN

Most of us become professional photographers because we want to earn a living doing what we love. Ideally, we'd all make tons of money doing creative work we're passionate about with enough flexibility to have a satisfying personal life as well. But, most of us have to find a compromise between these three, often conflicting, pressures. Oftentimes, that means choosing self-employment. Staff positions are few and far between plus they rarely provide the creative opportunities, flexibility, and autonomy that we crave.

But as you've read in part I of this book, our industry has been undergoing disruptive change for several years now. Under the best of circumstances building a successful small business isn't easy. According to the U.S. Small Business Administration,[40] 30 percent of all new employer firms fail within the first two years. Turnover rates for firms without employees are three times higher.

To give yourself the best chance of building a successful photography career, you have to understand—clearly and precisely—what success means to you. This chapter will help you do just that.

Why You Need This Chapter

Before you invest the hard work, long hours, and financial sacrifice needed to establish a successful photography career in today's business climate, it's worth taking some time up front to maximize

Photograph © Jason Griego

the chances that you will love the career you build. By converting the abstract concept of "earning a living doing what you love" into a tangible set of concrete goals and implementable actions you will dramatically increase your chances of making decisions that will help you fulfill your personal, creative, and financial needs.

WHAT WILL IT TAKE TO SATISFY YOU?

As the person designing (or redesigning) your career, you'll want to clearly define the parameters of what you're trying to build. The first of these involves defining your needs as the owner and raison d'être for your business. The exercises outlined in this section will help you envision what you're building and why. You'll use your answers to map out your strategy, set goals, prioritize activities, and identify areas that need further research and exploration.

Scheduling a retreat where you focus on exploring your vision for your career over a few consecutive days will speed up the process. If you go that route, I recommend spending the early part of each day feeding your creative subconscious. Use that time to reflect upon what's important to you and imagine—in as much detail as possible—how your future business will function. Spend your afternoons in a quiet, comfortable space where you can work through the exercises on paper. If you hit a roadblock in your thinking, set that activity aside. Take a break and allow your subconscious to work on it for a few hours or even overnight.

Feeding Your Subconscious

Your subconscious mind is an incredibly powerful problem-solving tool but it doesn't like to work under pressure. If you feel stuck while working on any of these exercises, don't try to force a solution. Instead, get away from it—mentally and physically.

Do something that requires just enough attention to occupy your conscious mind and allows your subconscious to wander freely. Experts tell us people do their best thinking when they're walking, driving, or taking a shower. Biking, meditation, mowing the lawn, chopping wood, washing dishes, weeding or cleaning can also do the trick. If nothing else works, try focusing on the problem as you fall asleep, you might just wake up with the answer.

Keep something handy at all times—a notebook, smartphone, tablet, etc.—to jot down the inspirations that seemingly appear out of nowhere when your mind is otherwise occupied.

If a concentrated retreat isn't an option, commit to setting aside some solid chunks of time—at least three to four hours at a stretch—over the course of a few weeks. Make this time a priority. Don't cancel or reschedule it unless you absolutely have to. Don't allow any interruptions or distractions to derail you—no emails, no phone calls, no texts. Get yourself out of your usual space and into somewhere visually stimulating—it can be urban, it can be natural, it can be down the street or across town—but make it a different space from where you spend your normal workday. Again, spend the first half of each session feeding your subconscious and the second half working on exercises.

Working With a Planning Partner

For most of us, figuring what we want—what we *really* want—and allowing ourselves to look for possibilities and opportunities (instead of getting blinded by obstacles) is best done out loud. Working with a planning partner can help you progress more quickly. For best results, follow these ground rules for your planning partner relationship:

- **Choose your partner carefully.** Find someone who is creative and open-minded, who believes in exceptions as much as the rules. Your planning partner does not necessarily have to be familiar with your industry but it helps to work with someone who has experienced self-employment.

- **Objectivity rules.** The ideal planning partner is someone who is not personally affected by the decisions you make. Your business and/or life partner should be involved in this process but you need a sounding board whose self-interest does not come into play.

- **Keep a "Get Out of Jail Free Card" handy.** To be effective, your planning partner must be allowed to tell you hard truths, push you when you're being obstinate, nag you if necessary and help you stay on track.

Networking with other small business owners through local business organizations such as the Chamber of Commerce, business clubs, and lead groups or trade associations like the ASMP can be a great way to find a good planning partner. Reciprocal relationships, where each person takes turns acting as a sounding board for the other, generally work best. If you live in the United States, you can also contact SCORE.org, a nonprofit business development organization funded in part by the U.S. Small Business Administration, which connects new small business owners with mentors who may be willing to serve this function.

SATISFACTION EXERCISES

The following three exercises: the Values Analysis, Dream Career, and Satisfaction Analysis, focus on helping you identify what really matters to you. Use them to get your vision for your career out of your head and into a format where you can look at it, evaluate it objectively, and start taking action. These exercises can be completed over time, but should be performed in the order provided.

Take the time to digest what you learn through each of these exercises. The moment you start feeling overwhelmed or lost— the moment your options start shutting down instead of expanding— take a break and feed your subconscious again before returning to the exercises. The person who gains the most insights, not the one who finishes first, wins.

Revisit these exercises throughout your career. As I discuss in chapter 11, when circumstances change—and they will—these exercises will still provide a solid framework for assessing your priorities and redefining what a creatively, personally, and financially satisfying career means to you at different stages of your life.

Case Study: Satisfaction Exercises

One of my first consulting clients was an emerging photographer struggling with where to take her career. After a few years of taking any work she could get—portraits, weddings, products, events, assisting—she'd had enough. Burned out, stressed out, overworked, and underpaid, she was ready to make some significant changes.

Prior to completing the following exercises, her definition of success bought into the same globetrotting, photographer-as-celebrity image that so many others dream about. After finishing her Values Analysis (see page 84), though, she realized that fantasy was completely out of alignment with what was most important to her: her family, her friends, and her pets.

Recognizing that she was happiest when capturing the connections and relationships between people, she used the Dream Career exercise (see page 93) to redefine success by mapping out a business based solidly in her core values. Following that map, she has since built a thriving business photographing what she loves most: kids, families and pets, in a style that's true to her vision, her values, and her undeniably commercial aesthetic.

While her primary client base lies on the retail side, her singularity of vision and mastery of her chosen subject has attracted editorial and commercial clients as well, providing her with diversified income streams and greater economic stability.

The Values Analysis

The Values Analysis helps you figure out what's truly important to you. It makes an excellent framework for making better decisions and steering your business in a more satisfying direction. To complete this exercise, you'll start with the Values List provided on page 87.

Step 1: Sort the values on your list into one of three categories: Always Valued, Sometimes Valued, and Never Valued.
You can use the checkboxes provided or copy the values into three separate lists, one for each category. Choose the approach that gives you the best chance of absorbing and retaining the information you're learning about yourself.

Step 2: Identify the 10–15 values from your Always and Sometimes Valued lists that are most important to you.
It's true, your ten to fifteen top values may not all be on your Always Valued list. For many people, things that only matter sometimes still trump other values when they have to choose between them. For example, I don't require that every single thing I do be meaningful but I would not be willing to eliminate Meaningful Work from my Top Values list.

Step 3: Organize your Top Values in order of priority.
Understanding where each value falls helps you make better business decisions. Faced with a choice between building a business that gives you Financial Security, Creative Satisfaction or Respectful Treatment, you need to know which you would sacrifice in order to achieve the others. Consider using a Decision Matrix (pages 85–86) to help prioritize this list.

Step 4: Use what you've learned.
Go back through the complete Values List and identify the ten to fifteen values that actually hold top priority based on your current lifestyle. Use this new list to identify what's working and what isn't:

- Compare this new list to the one you made in Step 2. Which new values need to become greater priorities in your life and career? Which of the values you're currently living need to be eliminated or diminished?

- For each value that's holding the wrong priority in your life right now, write down what needs to change to bring your life and career into better alignment with those values.

- As you work on designing your business and career, evaluate how your vision aligns with what's truly important to you. Make a list of any potential conflicts between your career goals and your values. What would bring your aspirations and values closer together?

- Finally, make a master list of tangible actions you could take to bring your life, business, and career into alignment with your core values.

When you complete this exercise, keep these lists safe. You'll reference them in subsequent exercises.

Step 5: Revisit as needed.
As you face major decisions—or even some minor ones—revisit your Top Values list and explore how these decisions fit in with your true priorities. Recognize that your priorities and expectations will change over time. Pivotal events like getting married or having a child can create radical shifts in perspective and priorities, while simply gaining experience over time leads to more gradual changes. Revisit the complete Values List and update your Always Valued, Sometimes Valued and Top Values lists as needed.

Using a Decision Matrix

This simplified decision matrix helps you compare different criteria, in this case Values, against each other.

- Make a grid with as many columns across and rows down as the Values you're evaluating plus one. Leaving the top left cell empty, list the values you're comparing across the top row and down the first column. The order doesn't matter as long as you use the same order across and down.

- Complete the grid by comparing each value in the top row against each value in the first column and entering the winner in the intersecting cell. In other words, ask yourself, "If I had to choose

between Value 1 and Value 2, which would I pick?" then enter the winner as shown in the example below and move to the next value.

- By counting how many times a particular value appears in the table, you get a pretty good sense of the relative importance of each value. If there's a tie, whichever value won when you compared them to each other gets higher priority.

You'll only use half the table—there's no need to compare something against itself and comparing column 2 to row 3 is the same as comparing column 3 to row 2. My example shows just five values so the grid is 6 x 6. The size of your grid will depend on how many values you're comparing (don't forget the plus one).

	Creative Satisfaction	Meaningful Work	Reputation	Respectful Treatment	Financial Security
Creative Satisfaction		Creative Satisfaction	Creative Satisfaction	Respectful Treatment	Financial Security
Meaningful Work			Meaningful Work	Respectful Treatment	Financial Security
Reputation				Respectful Treatment	Financial Security
Respectful Treatment					Respectful Treatment
Financial Security					

As my example shows, Respectful Treatment trumps all other considerations for me. In fact, it's the only thing that Financial Security—making sure I can cover my family's basic needs—can't beat. The fact that I have turned down lucrative work many times throughout my career because that need was not met proves this point. Understanding that those two values reign supreme has helped me build a more satisfying career. Giving myself the emotional and financial foundation I need to function at my best allows me to pursue creatively satisfying and mean- ingful work while building a solid reputation as someone who provides top-notch service in every aspect of my career.

Sample Values List

I compiled this Values List over many years, referencing countless sources. You can use it as is or edit it as needed.

Achievement
Feeling a sense of accomplishment in your work.
❏ Always Valued ❏ Sometimes Valued ❏ Never Valued

Advancement
Opportunities for growth stemming from your work performance.
❏ Always Valued ❏ Sometimes Valued ❏ Never Valued

Adventure
Opportunities to take risks.
❏ Always Valued ❏ Sometimes Valued ❏ Never Valued

Affection
Working in a caring environment.
❏ Always Valued ❏ Sometimes Valued ❏ Never Valued

Affiliation
Gaining prestige from association with a particular organization.
❏ Always Valued ❏ Sometimes Valued ❏ Never Valued

Appreciation
Working with clients or peers who demonstrate appreciation
for your contributions.
❏ Always Valued ❏ Sometimes Valued ❏ Never Valued

Challenging Problems

Engaging with complex questions, troubleshooting, and problem solving as a core part of your work.

❑ Always Valued ❑ Sometimes Valued ❑ Never Valued

Change & Variety

Having work responsibilities frequently change in content and/or setting.

❑ Always Valued ❑ Sometimes Valued ❑ Never Valued

Close Relationships

Spending time with or searching for a significant other.

❑ Always Valued ❑ Sometimes Valued ❑ Never Valued

Collaboration

Consulting with and being consulted by others while completing joint projects.

❑ Always Valued ❑ Sometimes Valued ❑ Never Valued

Community

Knowing your neighbors, actively participating in local activities.

❑ Always Valued ❑ Sometimes Valued ❑ Never Valued

Competence

Exhibiting areas of skill and expertise as part of your daily work.

❑ Always Valued ❑ Sometimes Valued ❑ Never Valued

Competition

Pitting your skills against others.

❑ Always Valued ❑ Sometimes Valued ❑ Never Valued

Cooperation

Working in a team environment.

❑ Always Valued ❑ Sometimes Valued ❑ Never Valued

Creative Control

Having decision-making power over the outcome of creative projects.

❑ Always Valued ❑ Sometimes Valued ❑ Never Valued

Creative Satisfaction

Producing work that fulfills your creative vision.

❑ Always Valued ❑ Sometimes Valued ❑ Never Valued

Creativity

Finding new solutions or approaches, not having to follow a format developed by others.

❑ Always Valued ❑ Sometimes Valued ❑ Never Valued

Decisiveness

Making and acting on decisions quickly without oversight.

❑ Always Valued ❑ Sometimes Valued ❑ Never Valued

Economic Stability

Not having significant fluctuations in earning level or potential.

❑ Always Valued ❑ Sometimes Valued ❑ Never Valued

Effectiveness

The ability to get things done independently or when working with others.

❑ Always Valued ❑ Sometimes Valued ❑ Never Valued

Efficiency

Not wasting time or other resources.

❑ Always Valued ❑ Sometimes Valued ❑ Never Valued

Ethical Practice

Not having to engage in unethical behavior, being around people who are open and honest.

❑ Always Valued ❑ Sometimes Valued ❑ Never Valued

Excellence

Setting and meeting high standards.

❑ Always Valued ❑ Sometimes Valued ❑ Never Valued

Excitement

Experiencing a high level of stimulation, novelty and/or drama on the job.

❑ Always Valued ❑ Sometimes Valued ❑ Never Valued

Fame

Recognition from a broad community of strangers.

❑ Always Valued ❑ Sometimes Valued ❑ Never Valued

Fast Pace

Working in circumstances where speed is of the essence.

❑ Always Valued ❑ Sometimes Valued ❑ Never Valued

Financial Security
Confidence that you will be able to always earn enough to take care
of basic needs.
❏ Always Valued ❏ Sometimes Valued ❏ Never Valued

Free Time
Having the ability to limit the number of hours spent working each week.
❏ Always Valued ❏ Sometimes Valued ❏ Never Valued

Friendships
Spending time with the people most important to you.
❏ Always Valued ❏ Sometimes Valued ❏ Never Valued

Having Children
Ability to both afford children financially and spend enough time with them.
❏ Always Valued ❏ Sometimes Valued ❏ Never Valued

Growth
Opportunities to advance financially and/or through increased
job responsibilities.
❏ Always Valued ❏ Sometimes Valued ❏ Never Valued

Helping Others
Involvement in helping people directly or indirectly.
❏ Always Valued ❏ Sometimes Valued ❏ Never Valued

Helping Society
Contributing to the betterment of the world.
❏ Always Valued ❏ Sometimes Valued ❏ Never Valued

Independence
Ability to determine work practice without significant direction from others.
❏ Always Valued ❏ Sometimes Valued ❏ Never Valued

Influence
Being in a position to affect the attitudes and opinions of other people.
❏ Always Valued ❏ Sometimes Valued ❏ Never Valued

Intellectual Status
Being regarded as well-informed, achieving expert status.
❏ Always Valued ❏ Sometimes Valued ❏ Never Valued

Job Tranquility

Avoiding the "rat race" in job role and work environment.

❑ Always Valued ❑ Sometimes Valued ❑ Never Valued

Knowledge

Engaging in the pursuit of knowledge, truth, and understanding.

❑ Always Valued ❑ Sometimes Valued ❑ Never Valued

Leadership

Ability to unite other people to accomplish a common goal.

❑ Always Valued ❑ Sometimes Valued ❑ Never Valued

Market Position

Prestige gained through association with a particular client base.

❑ Always Valued ❑ Sometimes Valued ❑ Never Valued

Meaningful Work

Opportunities to engage in work that has value beyond earnings.

❑ Always Valued ❑ Sometimes Valued ❑ Never Valued

Moral Fulfillment

Feeling that your work is contributing to ideals that you value highly.

❑ Always Valued ❑ Sometimes Valued ❑ Never Valued

Order

Having tranquility, stability, and conformity in one's work life.

❑ Always Valued ❑ Sometimes Valued ❑ Never Valued

Ownership

Being in charge of your own business, having complete authority over your work.

❑ Always Valued ❑ Sometimes Valued ❑ Never Valued

Power and Authority

Having the ability to control the work and advancement of others.

❑ Always Valued ❑ Sometimes Valued ❑ Never Valued

Precision

Engaging in tasks requiring exact specifications and high attention to detail.

❑ Always Valued ❑ Sometimes Valued ❑ Never Valued

Pressure

Work environments where there is little margin for error.

❑ Always Valued ❑ Sometimes Valued ❑ Never Valued

Prestige
Recognition from your peers and/or clients.
❑ Always Valued ❑ Sometimes Valued ❑ Never Valued

Public Contact
Having a lot of day-to-day contact with people.
❑ Always Valued ❑ Sometimes Valued ❑ Never Valued

Recognition
Respect from others, status.
❑ Always Valued ❑ Sometimes Valued ❑ Never Valued

Reputation
Being known for providing a high level of work, service, etc.
❑ Always Valued ❑ Sometimes Valued ❑ Never Valued

Respectful Treatment
Working with clients who treat you with respect and appreciate
the unique value you offer.
❑ Always Valued ❑ Sometimes Valued ❑ Never Valued

Stability
Having a work routine that's largely predictable and not subject
to frequent change.
❑ Always Valued ❑ Sometimes Valued ❑ Never Valued

Strong Work Relationships
Working with people who you like or whose company you enjoy.
❑ Always Valued ❑ Sometimes Valued ❑ Never Valued

Time Flexibility
Ability to set one's own hours or schedule.
❑ Always Valued ❑ Sometimes Valued ❑ Never Valued

Wealth
Having a high level of disposable income.
❑ Always Valued ❑ Sometimes Valued ❑ Never Valued

Working Alone
Ability to complete work without contact with others.
❑ Always Valued ❑ Sometimes Valued ❑ Never Valued

Working With Others

Ability to interact with others on a daily basis.

❑ Always Valued ❑ Sometimes Valued ❑ Never Valued

Case Study: Dream Career Exercise

In 2010, I worked with a photojournalist who was struggling to make ends meet. After being laid off from a staff position, he discovered that the low pay scale offered to freelancers could not possibly support his family. He decided to pursue editorial assignments instead and wanted me to help him make this transition.

When we reviewed his financial goals, I had to tell him that he was jumping from the frying pan into the fire. Some editorial assignments pay better than others but to replace his salary solely off editorial work would be challenging.

He resisted my points until we got to Step 2 of the Dream Career Exercise (page 95). I asked him why he was so bent on pursuing editorial work and I had to push him pretty hard. What role did photojournalism play for him? What made editorial work acceptable? Why was commercial work off the table? Lots of questions, all of which boiled down to "Why do you want what you want?"

It turned out that he had become a photojournalist because he wanted to change the world. The deeper we dove into the "why," the broader his options became. He realized his prejudice against commercial work was founded in a very narrow definition of that term. The real issue was not "editorial" vs. "commercial," but the impact his work would have on its audience and who would benefit from his labors.

For the first time, he saw how some magazines would be a terrible fit for his goals while some commercial ventures—particularly those that wanted to impact the world in the same ways that he did—would be perfect. By answering "Why do you want what you want?" and pushing all the way to the very heart of it, he was able to broaden his target market to include green industries, alternative energy, water replenishment and desalination companies, government and

nongovernment agencies and other world changing enterprises to his prospect list and, over time, build a diversified client base while staying true to his core values.

The Dream Career Exercise

Taking the time to fully describe your vision for your business helps you evaluate your dreams and separate the fantasy from the potential reality. The more complete your vision, the more likely you are to build a business that's truly satisfying.

Most of us won't achieve everything we describe in this exercise— in fact, most of us will change our minds about what our dreams really are before we come close to fulfilling them. But if you complete this exercise honestly and with as much self-awareness as you can muster, what you learn about yourself and your dreams will help you build a solid foundation for your business. One that will serve you well even when your long-term goals or dreams change.

Step 1: Write a detailed description of the business you want to build. One easy way to do this is to imagine yourself ten or twenty years in the future, having built the career of your dreams, then describe how that business functions and what you've accomplished. Flesh this vision out as fully as you can. The questions on page 96 will provide a good starting point.

As you describe this career and lifestyle, reference your Always, Sometimes and Top Values lists and incorporate your feelings about important issues like creative control, prestige, free time, economic stability, etc., into your vision.

Consider everything you've learned from the first part of this book as well. You want to describe your dream career within the context of the real world—a career that's actually achievable, not one that's pure fantasy.

That being said, don't let your perception of internal or external limitations stop you from aiming for what you really want. You can overcome a lack of financial resources, training, or experience. You can also hire, partner or collaborate with people who have skills you lack.

Including details about your personal life may help you see your vision more clearly—imagining what your living space will look like, what kind of car you'll drive, how often you'll eat out, or the restaurants you'll go to, can give you a better understanding of what it will take for you to feel truly satisfied with your business and career.

Step 2: Assess your ambitions.

For each aspect of your dream career that you've visualized and described, evaluate how important it is to you. Which aspects will leave you feeling like a failure if you don't achieve them? Which can you live without? Which are you willing to sacrifice in order to gain others? Which will you fight with every fiber of your being to achieve? Your answers will help you understand what you should focus on the most as you're designing your career.

Next, explore why these things are important to you. What needs are these accomplishments and achievements fulfilling? How do they fit with your values? What else could fulfill those same needs? As the case study on page 97 shows, figuring out why you want what you want is one of the most powerful and eye-opening activities you can perform. Use that understanding to do some creative brainstorming about other income-generating activities that would fulfill those same needs and assess the full range of products, services, and markets your business might pursue. This is a critical step you must take to build a career you'll love.

Step 3: Plot your trajectory.

Now that you've identified the most important aspects of your dream career and have a better understanding of what's motivating you to achieve them, assess what you need to accomplish within the next one to three years to be on the right trajectory. Recognizing that you have limited amounts of money and time, how much are you willing or able to invest into moving your business forward in the next three years? What goals can you set for the next one to three years that are realistic, achievable, and will move you in the direction you wish to go?

Questions to Consider for the Dream Career Exercise

These questions come from years of doing this exercise for myself and with clients. Answer them in terms of the career you imagine building—not your current business or job.

- How do you and your business earn money?

- Who does most of your income come from?
 - How much money do they earn?
 - What's their educational background?
 - What kinds of jobs do they have?
 - What do they care about?
 - What do they want from you?

 Be as specific as you can about the characteristics of the people you want to work with.

- Are you doing business locally, regionally, nationally, or internationally?

- How do you work with your clients—what's the experience of working with them like?

- What do your clients think of your business?
 - Why do they buy from you?
 - What is your business known for?
 - What key characteristics would you want them to mention to others?
 - What is their experience of working with you like?

- What policies do you have in place for how you run your business?

- What kind of name recognition do you have? Local? Regional? National? International?

 Answer this for peers, competitors, your industry, your customer base, and the general public.

- How much are you willing to sacrifice to achieve that kind of name recognition?

- What meaningful accomplishments have you achieved?

- Do you have employees or partners?
 - What do they do?

- How many hours are you working per week?

- How often do you work evenings, nights, and/or weekends?

- How are you spending your working hours?

- Are you working from home or an off-site space?
 - Is your working space yours alone or shared?
 - Do you own or rent?

- How much time are you spending away from home?

- What else does your dream career include?

Case Study: Satisfaction Analysis

The first time my partner and I ever completed a Satisfaction Analysis, we discovered that we had both reached a point where we could not take working with people who didn't treat us with respect anymore. There simply was not enough money in the world to make it worthwhile. We made a decision, right there and then, to establish a "No Assholes" policy.

Knowing that we wouldn't always be able to screen the bad from the good over the phone, we agreed that everyone would get a first chance but after that, we'd follow the "fool me once shame on you" rule without the "fool me twice" option.

Enforcing this policy wasn't easy, especially when business was slow and there was real money on the table. But we stuck to our guns, partly from sheer stubbornness and partly due to an unexpected side effect.

Shortly after imposing this policy, our creative work took a gigantic leap forward. We discovered that we could not feel "less than" one day and turn around to produce our best work the next. This policy freed us to produce better images, build a stronger portfolio, and attract clients who both respected and wanted the creative vision we brought to the table. As you saw from my Decision Matrix

example on page 86, Respectful Treatment continues to play a major role in all my career decisions.

The Satisfaction Analysis

I created the Satisfaction Analysis exercise after studying a variety of brainstorming techniques that focus on using free-association to dig deeper into a specific concept or topic. Deceptively simple, The Satisfaction Analysis is a powerful tool that can lead to immediate improvements in the quality of your life and career.

Step 1: At the top of a blank sheet of paper, write "I want more..."
Then start listing everything you can think of that you want more of in your life and career. Don't worry about editing. Don't worry about the order you write things in. Personal or professional, crucial or trivial—just get it out of your head and onto a sheet of paper. Don't worry about being too serious—"I want more clients" followed by "I want more chocolate" is perfectly acceptable. Just start writing and let your mind go where it will.

Step 2: Do the same for "I want less..." followed by
"I want to start..." and "I want to stop..."
Again, don't edit yourself. Free associate and write down everything you can think of. If the same concept or issue comes up under more than one category, write it down again.

Step 3: Categorize your entries.
Go through each of the four lists you've created and identify what needs to change immediately, what you can live with for a little while longer, and what you can live with indefinitely.

Step 4: Make a master list.
Pull the high priority items from all four lists into a single document. Now, decide which of these items you are going to change and assign real time frames to each one (e.g., right now, next week, within the next three months). Mark these dates on your calendar and commit to making these changes.

Step 5: Revisit this exercise.
Set a date on your calendar for revisiting this exercise as you near the completion of your high priority items.

UNDERSTANDING GOAL SETTING

The preceding exercises are designed to help you gain a better understanding of what's truly important to you, how your career can serve those needs, and what has to change for you to build that career. You'll use this understanding to set your overarching career goals. Fulfilling each of these goals may involve multiple steps, activities, actions, and work products. It's important to know the difference.

Let's look at a concrete example. People talk about building a website as a key goal for their business. But your website is really a tool that has to serve your goals, not a goal in and of itself. The website for someone who wants to attract international luxury brands would be completely different from someone who's trading up their client base from small local companies to mid-sized regional clients, or someone who's looking to sell fine art prints and workshops to advanced amateurs, or someone who's looking to connect with hip, urbanite brides and young mothers for portrait and wedding work.

The difference doesn't just lie in the images shown. What your website looks like, how it functions, the images and copy it contains, how it's coded and designed will all depend upon what it needs to accomplish for your business. In other words, your goals.

I find it helpful to think of goals as the building blocks that define what I want to accomplish. The activities that I take to achieve those goals may involve big, deadline driven projects but those projects have to serve my goals, not the other way around.

Using SMART Goals

Countless studies have shown that effective goal setting lies in the implementation of SMART goals. SMART goals are:

- **Specific** Your goals should be clearly articulated and outline exactly what you want to accomplish. Use the five W's from journalism to define your goals clearly. Who is involved?

What is to be accomplished? Where and when and how will you accomplish it? Why is it important?

- **Measurable** Identify benchmarks for achievements within the goal so you'll know you're making progress. A clearly defined endpoint lets you know when you've achieved the goal.

- **Attainable** Your goals must be realistic and take into account any limited resources (time, money, etc.) that may affect your ability to complete them. If you set goals that are too far out of reach, take too long to achieve or require resources you don't have, you'll probably quit out of frustration. Instead, pick interim goals that will allow you to achieve your larger goals over time (e.g., if you don't have enough money to launch the business of your dreams, your immediate goal might be to amass the resources necessary to start that business).

- **Relevant** Your goals must truly matter to you. Achieving goals takes effort. If the effort doesn't feel worthwhile, your commitment will peter out. If you can't clearly state why the goal is important for you and your business right now, it probably isn't relevant.

- **Time-bound** Set realistic time frames for completing each benchmark and goal. These time frames must take into account your other com-mitments. Entering these deadlines into your calendar will help you stay on target, monitor your progress, and achieve your goals.

As you set your goals, be kind to yourself. Complete a goal early and you win a huge sense of accomplishment along with the opportunity to set a new, greater goal. Consistently missing deadlines or failing to attain overly ambitious goals, however, can be disastrous for your morale. Be realistic about what you can accomplish and how long it will take.

Setting Your Goals

Given everything you've learned about the career and lifestyle you want to create, identify the most important goals for your business right now.

Start by reviewing the exercises you've completed. What values-related goals do you need to address? Given the aspirations you outlined in The Dream Career Exercise, what financial and creative goals do you need to set? What other accomplishments or achievements do you need or want to start working toward? How do the items you identified in your Satisfaction Analysis affect your goals? What about goals relating to customer service, new products, skills or expertise, marketing and administrative functions? Examine every aspect of your business and think about how it relates to your goals.

Look at immediate, mid-range and long-term goals. You may have goals that need to be accomplished in the next few weeks and goals that you're going to work toward for the next three years. Both time frames are valid and important to examine.

Complete a master list of goals using SMART definitions where you can. You may discover that your goals form a hierarchy where some goals cannot be accomplished until other goals have been achieved. Keep your master list but pull the highest priority goals out for immediate focus.

Achieving Your Goals

Once you've defined your goals, break them down into actionable items that you can start working on immediately—items you can list on a calendar, enter into a task management system, or add to your to-do list. One effective approach is to break each goal into three tiers of activity:

- **Steps** Broad categories of things needed to achieve the Goal

- **Activities** Narrow categories of things needed to achieve the Step

- **Actions** Tasks small enough to go on a to-do list that together complete an Activity

Each Goal may involve multiple Steps, each Step will likely have a number of Activities and each Activity will, you guessed it, include

several Actions. Each Action should then be broken down until it fits into one of four categories:

- Decisions that need to be made

- Research that needs to be performed

- Purchases or errands that need to be run

- Items that need to get done

Ideally, each Action is also broken down to a point where it can be accomplished in one to two hours. If any Actions require more time, try to see if they can't be broken down into multiple one- or two-hour sessions.

Let's revisit our website example. If I say I need to build my new website, that's too big to go on a calendar or to-do list. Instead, I need to break that activity down to its component parts:

- Figure out what images I want to show

- Figure out what copy I'm going to need

- Research hosts and technologies

- Identify and work with a designer

And so on, and so forth.

Now each of these is still too big, so I need to break it down further. I can't just write "Figure out what images to show" on my calendar or to-do list. Breaking that down into tasks I can complete in one- to two-hour chunks, though, lets me get it scheduled and done:

- Go through archives to identify images that I might put on my website

- Edit that collection into keepers

- Make prints of the keepers to use for sequencing

- Hang keeper prints up on wall

- Look at keeper prints on wall every day for a week and edit/ resequence as needed

Many of these items will take multiple one- to two-hour rounds but breaking them down changes them from daunting big tasks into manageable items you can work into your schedule and complete.

MAKE THE WISE CHOICE

By deciding to become a professional photographer, you are choosing to enter one of the most rewarding and exciting careers imaginable. But as you've already read, it's also a challenging way to earn a living. For every million-dollar studio, there are hundreds, if not thousands, of small photography businesses that are just getting by.

If you're choosing this profession for the money, look elsewhere. If you're choosing it because you long to earn a living creating imagery that's meaningful to you in some way, then you owe it to yourself to do the hard work up front that will give you the greatest chance of success.

The exercises and strategies outlined in this chapter have helped me invent and reinvent my business for over twenty years. I've seen them help others in ways I never imagined possible. So, do yourself a favor. Grab a stack of paper and your favorite pen. Go back to the beginning and this time, don't just read the exercises, do them.

For supplemental information and resources on this chapter go to www.asmp.org/herrmann6 or scan this QR code with your smartphone.

CHAPTER 7

YOUR ROAD MAP

BY JUDY HERRMANN

As I stress throughout chapter 6, you can't build a successful photography career without first understanding what success means to you. Taking the time to understand why you want what you want, to identify the personal, creative, and financial needs your career must serve, and to understand how committed you are to each aspect of your dream career dramatically increases your chances that your career will support what's most important to you. Defining what you want is the critical first step to building it. But before you can move forward, you must firmly plant those dreams in reality.

A Working Business Plan will help you do just that. A written document that outlines what your company is and does, how it fits within the competitive landscape, who its customers are, how it will reach them, and how it will achieve profitability, the Working Business Plan is your road map to success.

Developing a Working Business Plan involves five distinct steps:

- **Assessment** An evaluation of the external and internal factors affecting your business.

- **Research** Identification of what you don't already know and finding the answers you need.

- **Creation** Drafting the plan itself.

- **Implementation** Applying your plan and building your business.

- **Adjustment** Periodic reevaluation and revision of your plan based on a reassessment of your values, goals, beliefs and experiences.

Before you dig in, keep in mind that if you read through these exercises without actually doing any of them, creating a plan will seem like a daunting task. It's really not as hard as it looks. Each exercise builds on the information you collected in the previous one. So start simply. Do the first one. See how it goes. Take what you learn and apply it to the next one. By the time you get around to building your marketing plan or calculating financial projections, you will have gathered enough information to make an educated guess about what will be best for your business.

Resisting Resistance

If the idea of drafting a working business plan stops you dead in your tracks, you're not alone. Many of us feel tremendous resistance to planning for a variety of reasons. But as the old saying goes "A failure to plan is a plan to fail" and in today's highly competitive business environment, you really can't afford to dive in without making sure you won't hit your head on a rock.

Take a moment to analyze where your resistance is coming from and whether it's legitimate. As you think about planning, keep in mind these important points:

- **Planning does not preclude doing.** You can start taking steps to build (or maintain) your business while you develop your plan.

- **Planning does not determine the rest of your life.** As I make clear throughout chapter 11, things will change. Circumstances will change, you will change, change will happen. When things change, you will change your plan.

- **Planning saves you time.** Planning does require a significant investment of time and thought, but once you've mapped out your goals and strategized how to achieve them, you'll be able to move forward with laser-sharp focus. Pursuing the wrong clients, offering services that will never be profitable, or building a business that leaves you creatively and financially dissatisfied are the real time killers.

- **Your plan will never be perfect.** Hindsight may be 20/20 but foresight is a whole nother story. An imperfect plan built from limited information will still move you forward faster and more accurately than no plan at all.

- **It's the process, not the plan.** The real value of planning lies in the understanding you gain about your industry, your prospects and your options. If you build a plan for a business idea and change your mind the very next day, you will still be better off than if you'd never made the plan.

THE ASSESSMENT PHASE

Like any good architect, you must evaluate the lay of the land before you begin to draft your plan. Two tools that will help you accomplish this are the PEST, which evaluates Political, Environmental, Social and Technological factors, and the SWOT, which examines Strengths, Weaknesses, Opportunities and Threats. Together, these two exercises will provide you with insights that will dramatically increase your chances of building a business that meets your definition of success.

The PEST Analysis

To conduct a PEST analysis, you'll examine the environment you're working within and assess how Political, Economic, Social and Technological trends might impact your business. While you can just think of each of these factors in broad terms, using the checklist on page 109 can help you delve below the surface of each area.

Step 1: Identify relevant areas of interest or concern.
Review each of the factors, one by one, and determine whether any developments in that area could affect your business. Think broadly and creatively. For example, at first glance, it may seem as though ecological issues don't have much impact on digital

photographers but the global influx of government monies into green businesses and alternative energy could create new industries and businesses that need creative services—a potential opportunity for industrial and corporate photographers.

Step 2: Describe how each factor relates to your business.

For each *relevant* factor, write a brief description of how it impacts your business, including how any changes you anticipate in that sector could create opportunities or threaten your plans. In particular, look for existing and emerging trends in each area that you might be able to exploit to your advantage.

Step 3: Summarize key conclusions.

Take note of any ideas, realizations or conclusions about your business or the external environment triggered by this exercise. Identify any questions you need to answer or research you need to perform to verify your thinking.

Step 4: Integrate what you have learned.

Refer back to your Values Analysis, Dream Career Exercise, and Satisfaction Analysis and assess how the PEST factors might affect your priorities and decision-making. Revisit your list of SMART Goals and revise or re-prioritize them based on what you've learned.

The PEST Factor Checklist

This list of factors, which I've compiled over time, can help trigger ideas about trends that may affect your business. Not all of these factors will be relevant at any given time and there may be other factors you'll want to add to the list based on your own observations.

Before you begin, you may want to revisit the first part of this book, which shows how these factors have come together in the past and illustrates how you can use your understanding of these trends to navigate more effectively.

Political Factors

These include governmental, regulatory, tax or legislative actions that might impact your business such as:

Current/Upcoming Domestic Legislative Issues
❑ Relevant ❑ Not Relevant ❑ Needs Research

Current/Upcoming International Legislative Issues
❑ Relevant ❑ Not Relevant ❑ Needs Research

Ecological/Environmental Issues
❑ Relevant ❑ Not Relevant ❑ Needs Research

Employment Laws & Policies
❑ Relevant ❑ Not Relevant ❑ Needs Research

Healthcare Policies
❑ Relevant ❑ Not Relevant ❑ Needs Research

Policies Affecting Communications Industries (e.g., copyright, freedom of press, Internet accessibility, media vehicles)
❑ Relevant ❑ Not Relevant ❑ Needs Research

Political Stability/Changes in Political Leadership
❑ Relevant ❑ Not Relevant ❑ Needs Research

Regulation/Deregulation Trends
❑ Relevant ❑ Not Relevant ❑ Needs Research

Safety Regulations
❑ Relevant ❑ Not Relevant ❑ Needs Research

Social Laws & Policies
❑ Relevant ❑ Not Relevant ❑ Needs Research

Tax Policies
❑ Relevant ❑ Not Relevant ❑ Needs Research

Economic Factors

Look at economic factors from a local, national and global viewpoint. Think especially about the impact these factors will have on the geographic region(s) and specific industries that your business will service. These factors include:

Availability of Investment Capital/Credit
❑ Relevant ❑ Not Relevant ❑ Needs Research

Business/Trade Cycles (Expansion/Contraction)
❑ Relevant ❑ Not Relevant ❑ Needs Research

Consumer Confidence
❑ Relevant ❑ Not Relevant ❑ Needs Research

Distribution of Wealth
❑ Relevant ❑ Not Relevant ❑ Needs Research

Economic Trends:

For your industry
❑ Relevant ❑ Not Relevant ❑ Needs Research

For your clients' industries
❑ Relevant ❑ Not Relevant ❑ Needs Research

For your geographic region
❑ Relevant ❑ Not Relevant ❑ Needs Research

For your clients' geographic regions
❑ Relevant ❑ Not Relevant ❑ Needs Research

General Economic Outlook
❑ Relevant ❑ Not Relevant ❑ Needs Research

Current Economic Situation
❑ Relevant ❑ Not Relevant ❑ Needs Research

Projected Economic Growth
❑ Relevant ❑ Not Relevant ❑ Needs Research

National/Global Economic Trends
❑ Relevant ❑ Not Relevant ❑ Needs Research

Inflation Rates
❑ Relevant ❑ Not Relevant ❑ Needs Research

Levels of Disposable Income
❑ Relevant ❑ Not Relevant ❑ Needs Research

Market Cycles (Bear/Bull)
❑ Relevant ❑ Not Relevant ❑ Needs Research

Social Factors

Like economic factors, you'll want to look at social factors from
a macro and micro viewpoint. Pay particular attention to any cultural
or lifestyle trends among the specific demographics your business
will target, including:

Buying Patterns
❑ Relevant ❑ Not Relevant ❑ Needs Research

Buyer Attitudes, Perceptions & Expectations
❑ Relevant ❑ Not Relevant ❑ Needs Research

Consumer Attitudes and Opinions
❑ Relevant ❑ Not Relevant ❑ Needs Research

Cultural or Religious Factors
❑ Relevant ❑ Not Relevant ❑ Needs Research

Lifestyle Trends
❑ Relevant ❑ Not Relevant ❑ Needs Research

Media Attitudes
❑ Relevant ❑ Not Relevant ❑ Needs Research

Population Characteristics (e.g., age, income, education)
❑ Relevant ❑ Not Relevant ❑ Needs Research

Public Opinion
❑ Relevant ❑ Not Relevant ❑ Needs Research

Social Mobility
❑ Relevant ❑ Not Relevant ❑ Needs Research

Social Attitudes and Taboos
❑ Relevant ❑ Not Relevant ❑ Needs Research

Technological Factors

Technology affects how images are created, distributed, and consumed as well as the compensation models available for photographers. Technological factors include:

Changes in How People Use Technology
❏ Relevant ❏ Not Relevant ❏ Needs Research

Coming Technologies (What's in the Research Lab Now?)
❏ Relevant ❏ Not Relevant ❏ Needs Research

Current Technologies
❏ Relevant ❏ Not Relevant ❏ Needs Research

Industry Specific Technologies:

Capture/Workflow Technologies
❏ Relevant ❏ Not Relevant ❏ Needs Research

Compensation/Transactional Technologies
❏ Relevant ❏ Not Relevant ❏ Needs Research

Distribution/Dissemination Technologies
❏ Relevant ❏ Not Relevant ❏ Needs Research

Market Research/Measurement Technologies
❏ Relevant ❏ Not Relevant ❏ Needs Research

Search/Image Recognition Technologies
❏ Relevant ❏ Not Relevant ❏ Needs Research

Technological Life-Cycle:

Innovation/Invention
❏ Relevant ❏ Not Relevant ❏ Needs Research

Adoption
❏ Relevant ❏ Not Relevant ❏ Needs Research

Maturation
❏ Relevant ❏ Not Relevant ❏ Needs Research

Obsolescence/Replacement
❏ Relevant ❏ Not Relevant ❏ Needs Research

Technological Trends
❏ Relevant ❏ Not Relevant ❏ Needs Research

User Experience and Expectations
❏ Relevant ❏ Not Relevant ❏ Needs Research

Note: As chapter 3 shows, the lightning-fast track of technological innovation combined with the role it plays in the communications industry as outlined in chapter 1 makes this one of the most important elements of your PEST.

Applying the PEST Analysis to Your Business

As shown throughout the first part of this book, political, economic, social, and technological factors have played a highly disruptive role in our industry. For every challenge they've imposed, however, they have also brought new opportunities. The PEST Analysis will help you overcome challenges and identify opportunities that fit your goals and needs.

While few business owners have the time to conduct a full PEST Analysis on a daily, weekly, or even monthly basis, learning to filter all of the information you come across through this framework will help you make better decisions. As you're catching up on the news, scanning blogs, speaking with clients or colleagues, or conducting research, make a conscious effort to think about the impact that what you're seeing, hearing, learning or observing might have on your industry, your business, or your clients. Then use that deeper understanding to give your business competitive edge.

On My Radar

These examples from my own PEST analysis show how you can use the framework provided by this exercise to give your business competitive edge.

Social Disconnect
In studying social media trends for my studio's PEST Analysis a couple of years ago, I noticed that when it comes to online marketing, everyone talks about engagement, authenticity, and

relationship building yet the imagery these same organizations use throughout their websites and social media channels frequently fails to hit that mark.

A 2010 study shows that the generic stock imagery used to jazz up corporate websites may as well be invisible.[41] And, I don't need a study to tell me that all those generic corporate headshots on mottled backgrounds don't do anything to increase my trust of the people shown or the company they work for.

A few days after noting this trend, I was able to use this newfound knowledge to establish my studio as the front-runner for an executive portrait shoot. By engaging the buyer in a dialog about social media, relationship building and audience engagement, I shifted her away from price and toward value, thereby converting a simple headshot price query into a visual branding campaign for the whole organization.

If you treat your PEST Analysis as an academic exercise, you're wasting your time. The observations you make and conclusions you draw become powerful business tools when you bring them into the daily practice of running your business.

Creativity Rules

Several technological innovations (e.g., the Internet and flat-screen, mobile, and tablet technologies) have dramatically increased the role of visual communications within our culture. We see still and moving images nearly everywhere we look. As consumers, we are drowning in a visual sea of white noise.

At the same time, other technological innovations (e.g., digital capture, conventional and mobile hybrid cameras) have dramatically increased the average consumer's participation in the creation of still and moving imagery. As any photography teacher can attest, the more time people spend creating visual communications, the more visually sophisticated they become and the less tolerance they have for sub-par imagery.

The convergence of these two trends should lead businesses that want to attract consumer attention to look for innovative visual communicators who offer creative solutions that attract and retain audience attention. What do these trends mean for your business? How can you use observations like this one to give your business competitive edge?

Your Attention, Please!
For decades, businesses have relied on interruption marketing to spread word of their products and services. Distribution channels were limited and attention was abundant—not so long ago, we all rushed home for "Must See TV" and willingly sat through ads so we could follow our favorite "Friends."

Today, consumers can access entertainment and information through countless distribution channels and effortlessly bypass any advertisements that fail to engage them. No longer a trapped audience, their attention is now divided between thousands of outlets and their tolerance for interruption has virtually disappeared.

Businesses are now scrambling to develop new approaches to engaging prospective buyers. In his April 2, 2009, blog post, *First, ten*, marketing guru Seth Godin pointed out, "You can no longer market to the anonymous masses. They're not anonymous and they're not masses. You can only market to people who are willing participants." These words ring even more true today.

The implications of these changes affect photographers both as visual communications professionals and as business owners whose customers and prospects are just as intolerant of traditional interruption marketing techniques as every other consumer.

With this trend in mind, how can you help your customers produce visual communications that their targets will willingly consume? What about your own marketing efforts—are you treating your prospects as "anonymous masses" or finding ways to convert them into "willing participants?"

Audience = Power

The shift in how audiences consume visual content has also changed our relationship with them. For the first time in history individuals don't have to rely on big distributors with big budgets. We now have the ability to build audiences and distribute our work directly.

In 2011, comedian Louis C.K. self-produced a high-production video of his stand-up performance at the Beacon Theater in Boston and used a dedicated website to sell access to the recording for five dollars per download. Within 10 days, the video had grossed over one million dollars.[42] Now, Louis C.K. already had a substantial fan base built through more traditional distribution channels— live stand-up performances, talk-show appearances and his own television program—but there's still an important lesson here: power lies with whoever owns the audience.

In our industry, Chase Jarvis and his team have proven this point time and again. For many years, Jarvis has spent countless hours engaging photographers through established social media channels. After building a substantial online audience, he began developing and distributing products that fulfilled their unmet needs. From his "Best Camera" iPhone app to creativeLIVE.com, his online education channel, he has consistently taken advantage of cutting edge technologies to develop and disseminate products designed to fulfill the unmet needs of the audience he's already built.

Today, every one of us has the opportunity to build, engage, and sell directly to our own audience. Working with established distributors who already have their own audiences may still be advantageous but it's no longer your only option. Think carefully about how you can exploit existing channels to build direct relationships with your audience and how you can use those relationships to advance your goals.

The SWOT Analysis

While the PEST Analysis helps you evaluate external factors and trends that might affect your business, the SWOT Analysis encourages you to examine how you and your business engage with those factors.

To conduct a SWOT analysis, you'll examine your company's Strengths, Weaknesses, Opportunities and Threats within specific contexts.

Conducting a general SWOT analysis of your business within the broader market is critical, but you can gain even greater insights by examining your company's SWOT in the context of:

- Your buyers/prospects
- Your current competitors
- The businesses you aspire to compete against.
 What openings are they leaving?
 What would you need to change to be able to compete
 effectively against them?

The SWOT Analysis can also be a useful tool for looking beyond your own company. Consider conducting a SWOT Analysis of your industry at large. Or using SWOT to evaluate any new services, technologies, or business sectors you're thinking of diversifying into.

As you complete your SWOT, keep in mind that this exercise requires brutal honesty. In today's highly competitive, saturated market, photographers cannot afford to indulge weaknesses and must either invest in gaining missing skills or bringing someone else on board to handle areas we lack. Pay particular attention to evaluating any personal weaknesses you may have; self-deception will cripple your chances for success.

The SWOT Factors

Use the questions below as a starting point to help you evaluate the Strengths, Weaknesses, Opportunities and Threats affecting your business. Add additional questions as needed.

Strengths
Describe the resources and capabilities you can use to develop competitive advantage:

- What advantages does your company have?
- What capabilities do you offer?
- What do you do better than anyone else?
- What are your unique selling points?
- What unique or low-cost resources do you have access to?
- What experience, knowledge, or expertise do you offer that others don't?
- What kinds of activities do you excel at?
- What do people in your market see as your strengths?

Weaknesses

Describe any weaknesses affecting your business, with the understanding that the absence of key strengths can be as damaging as a true weakness:

- What could you improve?
- What gaps are there in your capabilities, experience, expertise, etc.?
- What do others do better than you?
- What areas of weakness do you yourself have that affect your company's success?
- What kinds of activities should your company avoid taking on?
- What kinds of activities should you avoid doing yourself?
- What will people in your market most likely see as your weaknesses?

Additional Strengths/Weaknesses Considerations

Sort these questions into the appropriate category depending on whether these areas are strengths or weaknesses for your business:

- How do your price, value, and quality compare to market expectations?
- What is your comfort/skill level with marketing your business?
- What is your comfort/skill level conducting direct sales?
- What is your comfort/skill level negotiating fees?

Opportunities

Look at the internal and external opportunities you have for growth and profit:

- What interesting trends are you aware of?
- Where do your competitors' vulnerabilities lie?
- What unmet needs do your buyers and prospects have?
- What new markets are opening up?

- Who could you partner or collaborate with to create new opportunities?
 - What would those opportunities look like?
 - How could those relationships be structured?
- What new technologies might open opportunities for your business?
- How can industry, lifestyle, or economic trends be turned into opportunities?

Threats

Explore how changes in your internal and external environment might pose threats to your success:

- What obstacles do you face?
- How is your market changing?
- What is your competition doing?
- How are the requirements of your job changing?
- Do any changing technologies threaten your position?
- Could changes in credit availability threaten your business?
- Do debt or cash flow problems pose threats?
- Could any of your personal or organizational weaknesses threaten your business?

THE RESEARCH PHASE

Before investing significant time and money into any new business direction, you must first do everything you can to ensure that your ideas are viable. Review your PEST, SWOT and list of goals to identify any areas where you need additional information before you can move forward with certainty. We all have to accept a certain amount of risk but conducting thorough research before committing hard resources reduces your exposure and increases your chances of success.

In addition to standard research tools like books, magazines, websites and blogs, you'll want to take advantage of peer relationships. Networking with experienced professionals through trade associations like the ASMP, online communities, listservs, forums and social media groups can uncover a wealth of insight and information. Informational interviews and surveys, whether by phone or email, can be an invaluable tool during your research phase.

Be sure to network with potential buyers as well. Let them know about the services you're planning to offer and solicit their honest feedback. Ask them whether these services have value to them, how often they use them, who their current providers are, and what they expect to pay. Discuss their needs (met and unmet), any relevant challenges they face, and what they look for in a vendor. Find out what kinds of marketing contacts they find effective, what your competitors do that drives them crazy and what they wish your competitors did better.

Listen Carefully

The most challenging aspect of the Research Phase isn't getting answers. It's hearing them. Don't let preconceived notions about what you want the market to support blind you to reality. Listen closely and carefully, especially if what you're hearing contradicts your wishes.

If you learn that your initial ideas aren't viable, go back to your core values, focus on why you want what you want and use your creative problem solving skills to come up with business ideas and solutions that will meet both your needs and those of your buyers.

You may not get everything you want, but careful research will help you identify the mix of products and services with the best chance of optimizing your personal and creative satisfaction while realizing your financial goals.

THE CREATION PHASE

Now that you've used the exercises I provided in chapter 6 to clearly define what building a creatively, financially, and personally satisfying business means to you and have evaluated the external and internal factors that will affect your chances for success, you should be ready to bring all of what you've learned together into a working business plan.

Unlike formal business plans, which focus on attracting financial investors, a working business plan exists solely to help you make better decisions. As a result, it covers the full range of activities your business engages in—from services to competitors, marketing to financials—it provides a snapshot of where your business is right now, where you want it to go and how you intend to get it there. You'll use it as a reference to monitor your progress and make sure your business is staying on track.

Because you're the only audience that matters, your working business plan does not need to be written in a formal style. You can use lists and bullet points, refer to stories, conversations or anecdotes without writing them out in complete detail, and include slang, swear words and run-on sentences. Your only job here is to get your thoughts onto paper however they make the most sense to you.

The Working Business Plan

Your working business plan should examine each of these seven areas in terms of where your business is right now, where you see it in the mid-term (one to three years) and where you'd like it to be in the long-term (three to five years):

Your Company

A comprehensive description of your company including the services you offer, values you stand for, and policies you maintain. This may include a mission statement if you have one. You may also choose to include a brief history of the company and key players.

Your Geographical Boundaries

A description of the geographic region you work within and where your clients are located. You may also choose to include a description of your physical location/working space.

Your Competitors

An overview of the competitive landscape that includes at least five direct competitors by name and examines how their businesses compare with yours.

Your Prospects

A description of your ideal prospects that includes at least five specific prospects by name and examines how their needs compare with your offerings. If you're not sure who your prospects are and where they hang out (in person or online) you'll need to revisit the research phase.

Your Prospecting Plan

A description of the characteristics your best prospects share along with your strategy and budget for identifying and vetting potential prospects. You'll learn more about prospecting in chapter 10.

Your Marketing Plan

A detailed overview of how you intend to market your business including any associated costs and your target annual marketing budget. Chapters 8 and 9 will help you design your marketing strategy and develop the mix of tools that's right for your business.

Your Financial Plan

An overview of your pricing strategy, profit margins, annual budget and financial projections. The ASMP's online Cost of Doing Business (CODB) calculator, which you can access by following the QR code or URL at the end of this chapter, will help you figure out both costs and profit margins.

Don't let putting a financial plan together intimidate you. Obviously no one has a crystal ball so these numbers will just be your best guess. As you grow your business and gain experience, your ability to make accurate financial projections will improve.

Make the Smart Call

Before you invest substantial time and money into building your business, you must be confident that a viable market with adequate profit margins exists for your services. Conduct careful research and don't shy away from seeking the help of a skilled accountant who has experience working with entrepreneurs. The mistakes they'll save you from making will more than make up for whatever fees they charge.

Drafting Your Plan

If you're struggling to draft your plan, the questions below will help get you started. Use what makes sense to you, ignore anything that doesn't seem relevant and add anything that's missing.

Your Company

- Who are your key players?
- What experience, expertise, and skills do they bring to your company?
- What services do you provide?
- What makes you unique?
- What does your company stand for?
- Why do (or should) your customers come to you instead of someone else?
- What services do you not provide?

 No business can be all things to all people. For any projects that your business would turn down, identify resources you can refer customers to or bring on board when they have those needs.

Your Geographical Boundaries

- Where is your company located?
- How far are you willing to travel without travel fees?
- How far are you willing to travel with travel fees?
- How far are clients realistically going to need you to travel?
- How far would a client realistically travel to work with you?
- How much work would out of state clients realistically need you to perform locally?
- What are the advantages and disadvantages of your geographical location?
- What are the advantages and disadvantages of your physical location/working space?

Your Competitors

- Who are your primary competitors?*
- Who are their key players?
- What experience, expertise and skills do they bring to their company?
- What services do they offer?
- What are their strengths?
- What are their weaknesses?
- What do you do better than they do?
- What do they do better than you?
- How do their prices compare to yours?
- How do their marketing efforts compare to yours?
- Why would customers choose them over you?
- Why would customers choose you over them?
- Why do you consider them to be your competition?

*Note: As you complete this section for the mid- and long-term, include people or companies you aspire to compete against as well as current competitors.

Your Prospects

- Who are your ideal prospects?
- What industries do they work in?
- What job title do they hold?

- What is their socioeconomic/educational background?
- What tier of the market do they work in?
- What services do they need?
- What are their priorities—what matters most to them?
- How much money do they spend on services like yours?
- What do you want them to hire you for?
 > Any job they have? Only big budget jobs? Only creative jobs?
 > Only jobs involving certain styles or subject matters?
- What else do you want from them?

Your Prospecting Plan

- How much money can you budget for prospecting?
- How will you spend that money?
- How much time can you set aside to research and identify prospects?
- How will you identify specific prospects who need your services?
- How will you vet prospects to confirm they need your services?
- How will you prioritize the time and money you spend identifying and vetting prospects in different markets?
- How are you going to stay on top of prospecting when you get busy?
- How will you track the contacts you've made with prospects?

Your Marketing Plan

For In-Person Marketing

- Will you attend networking and lead generation events, and if so, where and how often?
- Will you initiate in-person portfolio reviews and if so, how? What other in-person marketing activities will you engage in and how often?

For Advertising

- Will you invest in any advertising, direct mail or email promotions, and if so, who will you target, what vehicles will you use and how often will you publish?
- What forms of follow-up will you perform?
- What will your call to action be?
- What other types of advertising (e.g., ad specialties) will you use?

For Public Relations

- Will you send press releases and if so, to whom and how often?
- Will you write any articles and if so, for whom and how often?
- Will you pursue having feature stories written about you and if so, by whom and how often?

For Online Media

- What function does your website serve, what content will it house, how often will you update it, how will you drive traffic to it?
- Will you have a blog and if so, what will its purpose be, how often will you post, how will you drive traffic to it, and what topics will you cover?
- What other social media tools will you use and how often?
- What purpose will your social media efforts serve?
- Who will your social media efforts target and what interests them?
- What kinds of information will you post in each social media channel you choose?
- What other types of marketing activities will you engage in and how will you structure those activities?

Your Financial Plan

- What income streams will your business pursue?
- What annual sales volume do you expect each of those income streams to achieve in one, three, and five years?
- How much gross and net income do you expect your average sale to generate?
- How many sales must you make to achieve your target volume?
- What percentage of your sales do you expect to come from:
 - Existing clients?
 - Existing prospects?
 - New prospects?
 - Existing services?
 - New services?

THE IMPLEMENTATION PHASE

As you begin to draft your working business plan, keep your to-do list, task management system and calendar handy. Convert appropriate items from your plan into SMART goals (defined on page 99), break those goals into Steps, Activities, and Actions, then enter them into the appropriate tracking system. Be sure to give yourself realistic deadlines that take into account all of your other commitments.

Don't wait until you've finished your plan to start moving your business forward. As soon as you're reasonably certain that a Step, Activity, or Action is the right thing to do, start working on it. You can always modify your priorities as you get closer to finalizing your plan.

THE ADJUSTMENT PHASE

Your working plan serves two distinct functions. As your road map, it helps you maintain your focus and avoid pointless detours that will take you away from where you truly want to go. As a living, breathing, working document, it simultaneously provides the flexibility to change with your changing needs and circumstances. The moment any aspect of your working business plan no longer rings true, modify it.

Keeping your working plan in tune with your changing circumstances will help you maintain clarity of your vision and purpose. You'll make better decisions, spend your limited resources more wisely, and dramatically improve your chances of building a strong, successful career doing work that's both creatively satisfying and financially rewarding.

THE BOTTOM LINE

It may seem as though both this chapter and chapter 6 are all about exercises. In fact, they are all about gathering information so you can make better decisions. Your career is one of the biggest investments that you will make in your life. Just as you would never buy a house without getting an inspection, you owe it to yourself to examine your business ideas from attic to basement. If you find structural damage, you can decide to reinforce, rebuild, or keep looking for something with a stronger foundation.

Examining what success means to you and exploring the viability of your business ideas will give you the confidence to move forward knowing you've done everything possible to minimize your risk and maximize your chances of success.

For supplemental information and resources on this chapter go to www.asmp.org/herrmann7 or scan this QR code with your smartphone.

BRANDING YOUR BUSINESS

BY COLLEEN WAINWRIGHT

"Branding only works on cattle."
—*Jonathan Baskin*
author/speaker/consultant on new marketing

For years now, one poor, overworked little word—"branding"—
has taken quite a beating.

We talk admiringly about someone's branding—how slick their
website is, or how well it matches their business cards, or how you
can recognize it at fifty paces. We talk about redoing our branding,
or hiring someone to help us do our branding, or perhaps how
we're putting off doing our branding until we have more of a
steady cash flow.

All of these thoughts, however well-intentioned, are wrong.
Worse than that, they are very costly thoughts to have.

BRANDING IS NOT WHAT YOU THINK IT IS. AND IT'S NOT YOUR FAULT.

Most of the time, we confuse "branding" with one *facet* of branding—
visual identity. We think of logos (or "logomarks") that stand in for
famous products and companies, for example, Betty Crocker's spoon,
Apple's apple, Nike's "swoosh." Or we think of the type equivalent,

"logotypes" or "wordmarks"—Disney's famous signature script, that off-kilter "E" turning the name "Dell" into a cube, and so on. Maybe we even include *color palette* in our definition of branding: Pepsi is as red, white, and blue as Coca-Cola is red and white. UPS owns brown; Shell is (mostly) all about the yellow.

There's good reason for the mix-up. For much of the nineteenth and twentieth centuries, much of what it meant to "brand" something was treating it like you would the cattle that were otherwise indistinguishable from your neighbor's: slap something on the outside to make it identifiable as uniquely yours. Marketers got a little fancier as time went on, promising life-changing effects and adding jingles and smash cuts to the mix, but the song remained the same—and was distinctly outside-in. It was a brilliant way to sell what were essentially commodity items, and as consumers, we bought into it, both literally and figuratively. From shampoo to cigarettes to cars, we identified with the brands we bought largely because of the way they were positioned.

CONTINUITY IS GREAT— AS LONG AS IT'S COMPREHENSIVE.

Before we throw out the baby with the bathwater, know that a strong visual identity is still a valuable business asset. There's nothing wrong (and plenty right) with having your marketing materials all visually aligned, especially if they're well-executed in a style that reflects the personality of your business. There are very real brand (i.e., product or service) attributes that can be translated into branding we can see, taste, or touch. Apple does a terrific job translating their clean, spare, user-friendly approach to product design into print and TV ads with a wry sense of humor, and that core message is reinforced by their packaging, stores, and website. I'm no design Grinch! I'm all for strong visual branding done right, whether it's soup-to-nuts or just sticking to a particular color or typeface. (Hey, I've been using Century Schoolbook, all lowercase, for twenty years and through four completely different business incarnations.)

But if the brand-with-a-capital-"B" behavior of a business doesn't align with the great promises their branding-with-a-lowercase-"b" is making, neither will the customer's takeaway. Target may stand for stylish, affordable family goods, and their red-and-white-and-bulls-eye-all-over identity does a great job of conveying the type of experience you can expect when you walk into one of their stores—until you visit a Target on Black Friday or the day after Christmas, and all that lovely branding goes to hell in a hand basket.

Unless you've got consistent behavior to back it up—terrific customer service, an attitude that makes you easy to work with, or even a website that just works, period—all the beautiful visual ID in the world won't help you much.

BRAND IS HOW PEOPLE PERCEIVE YOU, NOT HOW YOU TELL THEM YOU ARE.

If you've been paying attention, you're starting to see a pattern: what you've been calling your brand—an image of you and your business that exists in the marketplace—has everything to do with other people's takeaway of you. As one saying goes, it's how other people talk about you when you're not in the room. Or, as Internet superstar Ze Frank brilliantly sums it up, "Brand is an emotional aftertaste."[43] It's how we feel after interacting with any facet of you or, by proxy, your marketing. (Although these two things—you and your marketing—are rapidly converging, as we'll discuss in chapter 9.)

In some ways, this is terrifying news. It seems as though there's no place to hide, no margin for error. Any little slip-up can become a branding disaster, with the potential to wreak havoc on our image, and eventually the bottom line. Also, it strips away the opportunity to brand "up"—to position ourselves and our businesses as bigger/fancier/your-adjective-here than we really are. But it's part and parcel of the times. On the Internet, after all, people are only a few keystrokes away from the truth. Customers share their experiences with all kinds of businesses in social media, on their blogs, and on websites dedicated to the topic. Witness the alacrity with which

certain heretofore highly regarded corporations will respond after being pummeled on Twitter. Or take a spin over to TripAdvisor.com and note how many hotel managers respond personally to the praise and especially the complaints their guests share in reviews. Posturing doesn't work very well when anyone with a smartphone can pull aside the curtain to reveal the true identity of The Great and Powerful Wizard of Oz.

This shift in how we define branding also holds really good news for photographers and other creative, high-touch businesses. As we'll see, experience is now weighted more heavily than window-dressing. You have more than a little control over influencing customer perceptions, and you can do it without the kinds of big financial expenditures required in the days before ubiquitous digital media.

Of course, this will require an investment of time. Nothing comes from nothing!

WHAT YOU CAN DO TO BRAND: BEING SPECIFIC, CONSISTENT, COMPELLING

As I write this, there's a whole category of photos on photo-sharing service Flickr (and a burgeoning number on the popular mobile app Instagram) devoted to documenting fan or "unboxing" experiences of services and products. First-time and repeat travelers on Virgin America snap photos of their beloved new-favorite airline: of the terminals, sleek and clean; of the planes' interiors, with their crazy red-purple lighting. And yes, Sir Richard and company have done an incredible job of visually branding the newish air carrier.

If you look more deeply into what's happening, though, you'll see it's not just about slick surfaces or a sexy, retro-futuristic color palette, but about a deeper, more design-based thinking-through of the entire experience. Successful brands pay meticulous attention to detail and to acting consistently. Virgin America is sexy, stylish and futuristic from beginning to end, with a wink of playfulness. The website functions smoothly and easily. The "brand" goes beyond a red/purple color

scheme and disco-fabulous lighting: the safety video, a delightful mid-century-esque animation, is sexy! Ordering food from the seat-back touchscreen is like something out of the Jetsons. These are not random, dissociated "touches" or window-dressing; they are the visible, outward signs of the thoughtfully conceived, meticulously executed Virgin America brand, which at its core is about a particular flavor of service.

Compare Virgin to another airline with an equally strong (but utterly different) emotional aftertaste and you start to see how branding-through-actions works. Southwest Airlines is also built around a great customer experience, albeit with a distinctly different flavor. If Virgin America is retro-fabulous, Southwest is Egalitarian Air. The company's policies on change fees (none) and checked baggage (free!) make it unusual in the industry and adored by its frequent fliers. From website to boarding order to the announcements from the easygoing, often funny, flight attendants, everything is straightforward and easy to parse. They take great pains to ensure a good customer experience, but through an entirely different set of actions rooted in a very different brand identity.

Any positioning can be executed through the lens of the particular business to differentiate it. For example, the concept of a "luxury hotel" connotes many things: attention to detail, high level of service, assurance of comfort in all interactions. The Four Seasons executes luxury perfectly with a formal, old-school grace, while Kimpton lives at the edges of hip. Two different brands, each executing "luxury" in its own distinct, meticulous way. Apply that thinking to any type of photography practice—portrait, architectural, lifestyle, corporate, fashion, etc.—and you can create the same meaningful, truly differentiated experience. And in a world of limited time, attention, and money, your best bet in shaping that emotional aftertaste that turns window-shoppers into customers, and customers into long-term clients, is creating an amazing and consistent experience from beginning to end.

Now that we're clear it's possible, let's look at how to go about building a great brand experience from beginning to end.

THE FIRST STEP:
PLANTING YOUR FLAG ON A HILL

By now, I hope it's obvious that good branding starts with a clearly defined niche. What kind of photography do you do—exactly? The generalist photographer—even the regional, semi-niche photographer—won't cut it in an age when the average civilian carries a camera in his or her pocket that will take excellent, high-resolution shots. As Susan Carr discusses at length in chapter 1, the digital age continues to drive prices down and expectations up. The only way out is to specialize, and to do it in a spectacular way.

You may want to reread chapters 6 and 7, which delve deeply into a process for determining your photographic niche. But from a branding perspective, a couple steps of business planning are worth repeating here.

For example, getting crystal-clear on your particular skills. What are they—*exactly*? What do you do differently (and preferably better) than anyone else? Think beyond your actual area of photographic expertise, and factor in your "soft" skills: Are you an intrepid traveler or a homebody with a granular grasp of the local terrain? Are you rock-and-roll? Cool and sedate? Stylish? Goofy? Rough around the edges, but with a tender heart? Getting a good handle on your true personality, quirks and all, is critical to the kind of branding that's rooted in you, and that will allow you to differentiate yourself without having to agonize over it. Like your mom always told you, "Tell the truth; it's easier to remember that way."

And do not discount the value of what you may consider odd or even irrelevant interests. You are uncovering the secret sauce that makes you unique. Think of your brand as a Venn diagram: the circles where your unique set of interests, background, and experience overlap with cost-of-entry skill and the market are where you'll find your sweet spot.

Are You This Person with This Problem?

Examples

- A print art buyer at a B2B agency on microchip account?
- A renewable-energy start-up who harnesses the wind from unphotogenic blowhard politicians?
- A dance company who performs exclusively on snowy mountaintops?
- An HR department worker tasked with getting shots of camera-shy board members?
- A no-kill shelter devoted to the rescue and placement of skittish black Labs with a fear of cameras?

I Can Help!

Examples (I'm a...)

- Silicon Valley-bred nerd specializing in macro photography.
- green-energy photographer who spent 10 years on the Beltway.
- highly-mobile photographer who salsas on the weekend with no fear of heights.
- portrait photographer who hosts a Top-10 podcast interviewing introverted C-suite execs.
- hero to three rescues and shot all of Rothko's paintings for MoMA.

Here's How...

Examples

- I have a portable clean room that packs easily for travel.
- My post process makes the invisible visible and my makeup artist made her bones on the Sunday talk shows.
- I have an aerial rig that functions to −30° Fahrenheit and I'm not afraid to use it.
- I shoot fast and leave 'em laughing.
- I've developed a no-flash rig camouflaged to look like a squirrel.

While you're digging around for the truth of who you are, don't forget to figure out what you really love to do, or you won't keep doing it. It's far easier to do some of the drearier aspects of any business if you know they'll propel you forward in the space you want to occupy. But be sure to temper your love with a dose of reality. Research the current business landscape: Where are the holes? Where are the opportunities? Are there opportunities, or is the field shrinking? Where is the money, and where does it look like the money will be going? Are you okay with making less money to pursue a photographic practice that feeds your soul?

If you've already read chapter 7, this will sound very familiar, and there's a good reason why: successful branding can't happen in a vacuum. Furthermore, it's a moving target, not something that's fixed in stone. As you change and as the market changes, your brand must change—although a better way to look at it might be "your brand must evolve." Your branding (like your marketing, as you'll see in the following chapter) must always be rooted in the truth of you.

THE SECOND STEP: GET "THEM-FOCUSED"

There's an online social network I belonged to for several years called Biznik. It began as a small-business alternative to LinkedIn, which was then even more big-boy corporate in tone and functionality. Where LinkedIn was about résumés and loose connections, Biznik was designed from the ground up with features to foster community and real connection, including a real-life component: its members were (and are) actively encouraged to host and attend "meatspace" events in the real world to connect with their fellow Bizniks.

To ensure that its brand ethos is maintained even when the community manager isn't around to police things, Biznik has two hard-and-fast rules. First, a complete ban on multilevel marketing; it did not want people coming out to network or opening their Biznik email only to be spammed with a sales pitch. The second rule is "the 95/5 Principle," which boils down to this: anything you do under the aegis of Biznik must be at least 95 percent about the other person—the remaining 5 percent can be shameless

self-promotion. The lopsidedness of this percentage split shocks most people at first: how will they get their point across, pitch people, make sales, and dominate their slice of the universe if they're not allowed to list all their services, recite their impressive statistics, share the glowing testimonials from satisfied customers and otherwise tell everyone how great they are?

The reality is no one cares how great you say you are; they care about how great you are for them. The only way for them to really believe that is to have an experience—better yet, a collection of experiences—that prove it. They don't want to listen to a sales spiel about how knowledgeable you are in your field, or worse, a bunch of assurances about how great you are to work with. Anyone can talk about themselves, and these days, with the free tools provided by social media, everyone is talking at once. (Raise your hand if you've ever hidden someone on Facebook who pitched their services or basked in their own glory just a wee bit too often.) What people *will* remember and respond to are experiences with you that are *great* or even *awesome*. The way to ensure the highest number of those experiences is to make sure you are always focusing on the customer's needs, not your need to tell people about yourself to get the customer's business.

YOU, IN A COMPELLING NUTSHELL (THE FORMULA FOR TALKING ABOUT YOURSELF)

A great way to ground yourself and your brand in "them-centricity" is to come up with a core statement about what you do in a way that's clear, simple, and completely focused on your ideal prospective client. Not only will it serve as a touchstone for deciding what does and doesn't align with your brand identity, it can pull double-duty as a starting point for all kinds of marketing copy: your "about" page and bio, for starters, but also your tagline, your elevator speech, your advertising—pretty much anything you use to describe what it is that you, uniquely, do. (As you'll see in chapter 10, this will serve you from a sales perspective as well as a branding one.)

It's also one of the toughest things to come up with. (There's a reason we all groan when someone asks us for a bio.) During a consulting session with a particularly talented client, who contained such multitudes that she was difficult to pin down (to say the least), I stumbled on a three-step process that aids greatly in coming up with this core piece of branding copy. It worked its magic so instantly and perfectly, I immediately dubbed it "The Formula," and it goes like this:

Are you this person with this problem?
I can help!
Here's how...

The Formula works because it keeps things focused on *them* (and what *you* can do for them), rather than letting you wander off into dig-me territory. It infuses your credentials with life and meaning rather than letting them become some dry list of factoids. It helps start a conversation, rather than just lying there, static and inert. Let's look at what we're defining when we use The Formula to describe ourselves.

Are you this person with this problem? Identify exactly who your ideal client is. (For more info, see chapter 6.) Is it the manufacturer with a hot new product who's extremely allergic to assembly-line downtime? The overworked law office manager whose principals are notorious for snarling in their headshots? A hotelier whose property is a nightmarish maze of reflective surfaces?

I can help! Here, you give your relevant credentials, background, outside interests—the "reason why" you're the best (or only) person for the job. Your verifiable track record as a lightning-fast interior shooter shows you have the shortest downtime of any industrial shooter. Your twenty-five-year history of coaxing smiles from fearsome heads of state. Your training under the avowed master of shooting gigantic sheets of glass. This part is the only one that's all about the "I" (and it's still got to be filtered in terms of them).

Here's how... Here's where you explain your process and outline the services, packages, etc., you can deliver: on-site portraiture for the terminally grim, or of heavy equipment, or outdoor night

shoots of architecturally significant properties. If there's an opportunity to give people a taste of your process, that can work, too. Do you have a special set of tools that you've created? Rigs? Hilarious, back-pocket jokes for the seriously trenchant grouch?

While you can write out your answers in exactly the style of The Formula, please don't stop there. Do a page dump or, as writer Anne Lamott dubbed it, a "sh*tty first draft."[44] Then return and tweak, return and tweak. The goal is to come up with a core piece of crystalline copy that could serve as an easy-to-parse website landing or "about" page, but it won't come out perfectly right away. Also, think of your version of The Formula as a living document that will change and grow with your business, which will have to change and grow with the times—much like your business plan, as outlined in chapter 7.

Once you've applied The Formula to your central piece of marketing copy, try applying it to other elements of copy, or even other non-copy aspects of your branding:

- **Your landing page** A great landing page quickly lets a prospective customer know they've arrived in the right place—or not, so they can move on, and not waste either of your time. Check the elements of your website's landing page against the three steps of The Formula. Do the images reassure your ideal client that you can solve their particular problem, or did you choose them because they were personal favorites? If there's descriptive copy, is it addressing their concerns or your vanity?

- **Your bio** Yes, your biography tells the story of you—but only in terms of what's relevant to your prospective clients. Does what you're sharing here help a buyer make the decision to go with you over another photographer? Will the credits, history, and interests you list help close the sale or are they just there to fill space or make you feel good? If awards are important, can you list one or two and link to more? Can the word "awards" itself link to a deeper page in the site with a full list? What's right for your market?

- **Your social media bios, tagline, elevator speech, and so on** You can pull out pieces of your Formula-generated copy and use them as the basis for other bios you'll use across the web, as well as your printed material—even the language you use to introduce yourself in networking situations.

- **Your website content (portfolio, blog posts, news, etc.)** If you share a list of helpful links, are they truly helpful to your end user? And organized so she can make easy use of them? Do your blog posts talk about what you can do for them? There's nothing wrong with including news of your accomplishments, but keep your overall content ratio in line with the 95/5 Principle: more stuff that will be useful to them (more on what "useful" means in chapter 9), less "dig-me" stuff about you.

- **Your user interface (UI)** Does your top-level navigation speak to your target audience? If you offer a couple of different services for distinct clientele, are there obviously labeled buttons or menu links that take each directly where she wants to go? If your ideal clients are older, is the font large enough to be easily legible?

Don't worry about making sure each element addresses all three parts of The Formula. For example, your navigation bar most likely will speak to the first part of the formula (*Are you this person with this problem?*), or maybe even one or the other component of that question (*Are you this person?* or *Do you have this problem?*). Outside of your "about" page and possibly, your bio, having your branding elements address two or all three steps of The Formula is great (and can be fun to work toward), but it's not a requirement. Mainly, The Formula is there to free you up by giving you parameters. It helps you step outside of yourself and look at the problem from your prospects' perspective.

If you need some examples to prime the pump, you can certainly look to fellow photographers. But consider looking to adjacent creative markets as well: often, it's easier to see differences in other lines of work, as you don't have the blindness that comes from being too close to something. Conduct a search for graphic designers as if you're looking for someone to help you with updating your website. How do the different designers present themselves? Lots of

THE MARKET
Who needs and can pay for your services?

YOUR BRAND

WHO YOU ARE

SKILLS YOU HAVE

Background
rural/urban,
country of origin,
cultural history,
medical history,
parental status,
relationship status, etc.

Interests
hobbies, charities,
sports/fitness, causes,
cultural/artistic,
scientific, current events,
politics, etc.

Experience
previous careers/jobs,
service organizations,
volunteering, travel,
schooling, etc.

Business-Related
finance/accounting,
project management,
marketing/PR/sales,
leadership, etc.

Communication-Related
public speaking,
acting/improv/performance,
singing, dance,
journalism/writing,
music/composition, etc.

Image-Related
retouching,
video,
motion graphics,
graphic design,
illustration,
fine art, etc.

copy or mostly imagery? Ample white space or crazy-quilt explosion of stuff? As photographer Susan Carr (the author of chapter 1) states, "My business partner and I did this nearly 20 years ago and are still using the basic brand—modified as we changed, but font, colors, etc., the same. The process of interviewing designers was fascinating. I learned more about marketing and sales than ever before."

A WORD ABOUT WRITING (AND HOW TO OVERCOME YOUR FEAR OF DOING IT)

By now, you've probably gotten the basic idea that good, user-centric writing is important. Yes, visuals are important, too; great work is the cost of entry, and curating the work to adhere to your brand strategy as outlined by your version of The Formula is equally critical. If your budget allows, you can certainly hire a copywriter to write your bio, your about page, and any other copy you choose. Writers are more than happy to take your money!

Beware of handing over the job too quickly, though—there's a real benefit to becoming a better writer even if you're an image-maker. After all, you're going to encounter all kinds of garden-variety experiences where writing is necessary, and where good writing will help set you apart: in social media and your emails, to name a couple. Tone is another aspect of branding. You may be able to hire a copywriter for the website, but if the level of language sophistication is wildly divergent from your own, you may have problems when it comes to social media use, email, face-to-face networking and interactions. People should recognize your tone from place to place the same way they recognize your style across your photographic work. Are you chic and sophisticated? Homey and accessible? Humorous? Serious? Most of us are a combination of these things, but whatever your mix is, keeping it close to your authentic voice is helpful. (That thing about lies and remembering, remember?)

But let's say you're just petrified to write. And you can't afford a writer to impersonate you on Facebook. Like anything foreign, the best way to acquire a new skill (or improve on an existing

one) is to practice—preferably in low-stress situations. If you only ever use the phone to communicate with friends and family, try emailing them for a change. Keep a journal—online or analog—and commit to writing a certain number of words or pages per day. There is a great free online resource called 750words.com that can keep you motivated to write daily. Or if you have an accountability partner or mastermind group, you can commit to a certain word count "publicly" with them, and receive gentle support. Some very famous authors, when they were just starting out, had a practice of literally typing out passages from their favorite works, to get a feel for tone, rhythm, structure, and flow.

One of the best ways to improve your writing skills is to take a class, either in-person or online. In addition to the built-in accountability created by weekly assignments and the guidance of the teacher, you learn a great deal from your fellow classmates. (It's also comforting to note that each of us struggles with some aspect of writing.)

Trust me—if I can overcome my fear of the camera to practice taking better pictures, you can pick up a pen or open a word processor and ratchet up your writing skills!

VISUAL IDENTITY: THE CHERRY ON TOP

Once you've done your due diligence and mapped out your brand identity on paper, take a look at the elements that make up your visual identity. You can certainly work with a graphic designer, but there are plenty of visual ID decisions you can make on your own, before you spend a dime hiring someone else. Think about ...

- **Typefaces** Do you prefer serif faces (Caslon, Georgia, Times, etc.) or sans serif (Helvetica, Futura, and so on)? Do you lean toward the classic, elegant, and refined? Or do hand-hewn, "fun," or casual feel more like you? You can use more than one typeface on your website, your business card, your blog, your emails, but sticking to one or two can help reinforce your brand over time— even across categories.

- **Color palette** Are there colors that feel more "you" than others? Or that help convey the image you're projecting? Choose a couple and stick with them. Your website should echo your printed materials. And don't forget handwritten touches. Maybe you always send out your "thank-you" notes written in green ink.

- **White space vs. lively clutter** Some people are all about the empty spaces, whereas others like a profusion of images and text.

By making simple choices like these and sticking to them, you can differentiate your photography business even on a template website. Even if you can afford the best graphic designers to do custom work for you, constantly revising your visual identity can cost you from a branding perspective. If prospects, customers, and fans don't recognize you from one place to another, it's harder for them to get a handle on whether you're a good fit.

IF *THEY'RE* DOING THE WORK, *YOU'RE* DOING IT WRONG.

There's a terrific book by web consultant Steve Krug called *Don't Make Me Think*. It lays out the basics of user-centered web design, which (bear with me) have much in common with good branding.

Consistency, for starters: graphic or visual elements that stay consistent from page to page, so you don't suddenly wonder whether you're in the right place. Then there's clarity: a good user interface (UI) is simple and logical to navigate, so the user doesn't get lost— menus and links are clearly marked, page layout is easy to follow, and so on. Finally, there's specificity: user-centric copy is not just well-written, but clear and focused. The selection of every element adds up to the total User eXperience (UX) of a website, and the best UX sweats the details (sounding familiar yet?) to make an individual web user's experience on that site seamless, fruitful, and enjoyable. The person on the receiving end of a website with strong UI/UX doesn't have to stop and think; they know what that site is about—exactly.

Each element of the well done, user-centric website works in harmony to communicate the core messaging, so the user doesn't have to.

This outstanding advice for building websites also provides a great lens through which to view every aspect of your branding—and your marketing, which we'll cover in the next chapter. If someone has to stop and think about what kind of services you provide, where and when they can reach you, what kind of experience they can expect when working with you, there's a problem with your branding. And that someone doesn't have to be a prospective client, but anyone. You never know where your next referral will come from. Doesn't it make sense to ensure every outward-facing representation of your business is on point?

At its core, branding is about being specific—in everything from services to serif choice—and being specific means making all kinds of editorial choices to make your audience's job easier.

In fact, it shouldn't feel like a job to them at all; it should be fun! What can you do to make it *fun* for people to engage with you? To make every interaction delightful? We are living through an age where there is far more information available than there is time to consume it—an attention economy, where attention is a scarce and sought-after currency. (See chapter 1 for a more extended discussion of the factors that contribute to this new economy, and its impact on image-makers.) *Delight* helps keep you top of mind, so take every opportunity to create it. Maybe your visual ID is terrific, and your website is seamless. But how about your outgoing voicemail message? Is it delightful? Does it even align with your brand, or are you still using the default Robot Man voice that comes baked into the service?

Are your postcards and note cards delightful? How about the messages you inscribe in them—are they ho-hum, or refrigerator-worthy? It takes a lot for a note card to make it to my fridge, but once it's there, it takes even more to dislodge it. That's prime real estate. Honestly review your "bedside manner"—are you comfortable talking to prospects and clients, or do you stumble over yourself trying to deliver that killer elevator speech? Toastmasters, a service organization devoted to helping people overcome their fear of

public speaking, is terrific for getting better in this very important area. Again, as Blake Discher points out in chapter 10, creating great tools and keeping them shipshape will really help you in the sales department, as well.

The bottom line in this new attention economy is to be consistent, and consistently delightful. Or, as I like to sum it up: "Always be awesome." Because awesome is the "new normal." Because if you aren't, you can bet that someone else will step up and be awesome. Yes, it's a tall order and certainly, no one is perfect. We all have our weak areas; mine are legion. Rather than becoming discouraged about how much there is to do, try to see the glass as half-full: everywhere you look, there are opportunities to strengthen your brand, and most of them cost nothing but some thought, time, and effort.

Besides, when you commit to being awesome across the board, a magical thing tends to happen: rather than having to chase people down, people start coming to you. And that, my friend, is truly awesome.

For supplemental information and resources on this chapter go to www.asmp.org/wainwright8 or scan this QR code with your smartphone.

MARKETING TODAY

BY COLLEEN WAINWRIGHT

"You have to market your work with the same creativity you used to create it. It should be fun, actually. If you feel like what you're doing is humiliating you're probably right. And it's probably not very effective, either. Nobody trusts a salesman who doesn't believe what she's selling."

—*Stephen Elliott*

author/director, founder of online cultural site The Rumpus

Mention "marketing" to most people and it conjures up some vague mix of advertising and public relations, with a little (or a lot) of selling and yelling thrown in. They may associate marketing with a mix of traditional go-to vehicles like postcards, business cards, and portfolios; at this advanced stage of the new media game, they would likely also include digital tools such as websites, blogs, and e-newsletters. They may even include slightly less obvious things like speaking, networking, and (deep breath) cold calling as part of a possible marketing mix.

All of these fall under the broad descriptor of "marketing," although I hope to make a strong argument for leaving out much of the selling (except for the good kind, described in chapter 10) and all of the yelling. But along with these more obvious vehicles, marketing also includes a number of ancillary "old-school" activities: pricing, packaging, branding and positioning, distribution or delivery, and customer service. Then there's the growing list of marketing tools born of digital media—podcasts and MP3s, videos and slideshows—and all of the tweets, re-tweets, status updates, curation, commenting and so on that we do in social media.

For my money, a more useful definition of marketing is "everything you do that connects you to your customers and the people who might put you in touch with them." Or, as I once put it in a poem— yes, I feel strongly enough about marketing to immortalize it in verse—"Marketing is the truth of you, translated into the language of them."[45] This view is in keeping with the ideas about branding in chapter 8. Because while in previous times marketing was more about pushing messages out into the world—information about how great we are at this, that, and the other—this new definition stresses the importance of authenticity, caring connection, and a strong "them-focused" attitude. The old marketing is about foisting; the new marketing is about invitation and delight.

NAVIGATING THE NEW WORLD OF MARKETING

The good news is that, in many ways, there's never been a better time to be a small business, marketing-wise. Unlike the predigital age, many of the best vehicles for marketing yourself are cheap or free. A generation ago, there were no blogs, no social media sites or apps, no inexpensive tools for capturing sound, video, and images, and no web to upload them to. The bad news is that the sheer preponderance of opportunities can be overwhelming, not to mention learning the best practices of each.

You need a map and a plan for navigating this new world of opportunities, along with a few guidebooks on adapting successfully to the local customs. And don't forget those goals! It's pretty hard to know whether you've gotten somewhere if you haven't picked a place you want to get to. The business planning system outlined in chapter 7 offers an exceptionally clear and detailed means of getting there from here, as well as figuring out what "there" and "here" look like.

And as tempting as it may be, *no skipping steps*! As a former acting teacher liked to say, "If you call me for directions to Grand Central Station, the first thing I'm going to ask is 'Where are you right now?'" You have to know where you're starting from as well as where you want to arrive. The directions to Grand Central are going to be a lot different if you're starting out in Far Rockaway (or for that matter, Kansas City) than they are if you're at Penn Station. A sound business plan grounds you in where you are, and helps you establish reasonable destinations given your time, energy, experience, and budget.

Back to the good news: once you have a handle on where you're at and where you want to go, there are dozens, arguably hundreds, of tools you can use to get there (i.e., to market yourself today). If our description of marketing is "translating the truth of you into the language of them," anything that connects you to your audience and expresses that "truth of you" in a way that they can understand can be considered marketing. While it's likely that some portion of your actual operating budget should be directed toward marketing vehicles with a hard cost, you'd be foolish not to take advantage of the many virtually free tools available to you today.

SETTING UP YOUR ONLINE MARKETING "UNIVERSE"

As a professional open for business, you attend various events, one-on-ones, and conferences to meet up with fellow photographers, prospects and clients, but your studio or home office remains your base of operations. On the Internet, social media sites are the gathering places and your business website becomes home base— the mothership, if you will. You meet, mix, mingle and share elsewhere, but you provide a well-appointed place to hang out for those who want to know more about you and what you have to offer them.

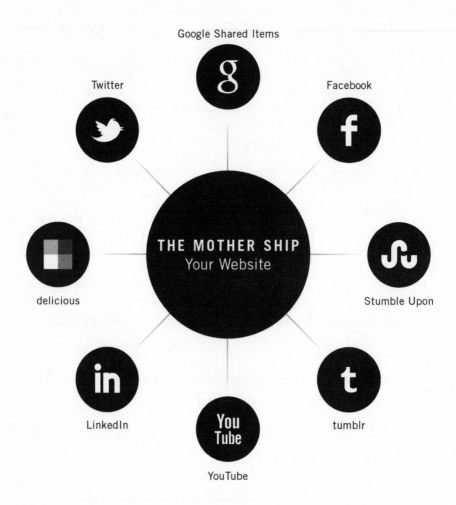

Google Shared Items

Twitter

Facebook

THE MOTHER SHIP
Your Website

delicious

Stumble Upon

LinkedIn

YouTube

tumblr

Based on diagrams by Darren Rouse and Chris Brogan

Looking at the above image, if Ansel Adams were getting started shooting today, he'd want to establish his own central hub (hopefully with a high-level domain version of his business name, like anseladams.com). Then he'd hit Twitter and Facebook to mix and mingle, join a few LinkedIn groups on landscape photography and large-format cameras, maybe throw a video or two of himself shooting away on a butte up on YouTube.

When people became intrigued by this Ansel fellow's helpful links on Twitter or his cheery updates on Facebook, they'd follow the link back to his mothership, where they might:

- view his well-organized portfolio of past work,

- learn more about the way he works in his bio or "about" page,

- read his blog, featuring insider info on his most interesting assignments and possibly a few how-to tips,

- discover links out to the rest of his social media universe to explore further, and

- find his contact information (preferably on every page) to hire him for a gig.

As time passed and he established more and more of a presence online, assuming he had talent and professionalism (let's go ahead and say he did), Ansel would build a name for himself as the guy to go to for all things landscape-photography. More and more, other people in his social-media orbit would do the heavy lifting for him, re-tweeting and sharing his content with their friends, associates, and followers, because they liked him and found his stuff interesting and useful.

A MARKETING FRAMEWORK FOR THE NEW ECONOMY: BE USEFUL. BE SPECIFIC. BE NICE.

In the olden days, marketing was a series of discrete activities: print mailings and trade ads; networking events and one-on-one meetings; creating and distributing business cards, letterheads, thank-you notes; and so on. Things changed, but more slowly; work life and personal life rarely overlapped.

The new economy (described in the glossary of terms on page XIV) has radically changed the marketplace. Today, things are far more fluid—the lines between personal and business are fuzzy or even nonexistent, making it easier (and even expected) to be yourself rather than to put up a front. Further, the place where you present yourself as open for business can be digital or virtual as well as "meatspace" (what some kids somewhere decided to call "real life"). Finally, thanks to the web, marketing is easy to do, even when you're not there. You can create marketing vehicles with the flip of a switch, the press of a "return" key, the ease of a "like."

The dark side of all this lickety-split marketing is that you can do damage to yourself just as fast, far more widely, and it can be very hard to erase. What goes on the web is very, very difficult to remove from the web. What's more, the online digital universe continues to change rapidly, with new outposts popping up every day. As I write this, Facebook and Twitter are the most popular social media platforms on the web, with Google+ a distant third. But that could shift with anything from a change in policies that finally drives users over the edge to a new social media site that in magical sparkle-pony fashion combines every attribute people are seeking with none of the downsides they hate. RIP, Friendster and MySpace; hello, Instagram and Pinterest. (For now, anyway.)

A rigid, lengthy, detailed list of rules and guidelines no longer works because (a) the tools and landscape are changing too fast and (b) they are so diverse, complex, and experimental, there's no general consensus on behavior or customs that works across the

board. (There's not even one right, agreed-upon way to use Twitter alone!) Whereas this extremely simple framework—Be Useful, Be Specific, Be Nice—provides a set of behaviors that's sturdy enough to lean on, while remaining flexible enough to accommodate virtually any marketing tool you may find yourself using. Referring back to them frequently helps ensure you are ALWAYS BEING AWESOME and, ergo, creating the kinds of delightful experiences that engender passionate followings. Let's look at these three behaviors, in reverse order...

Be Nice!

Niceness is one of those "no duh!" things—the world is a better place when people are nice, and clients hate you less so it's good for repeat business. (Kidding. I'm sure all of your clients love you.) But especially in the attention economy, being nice is about following certain rules of etiquette—observing "house rules" of the place you're hanging out in. The rules are different for Facebook and Twitter, for a Chamber of Commerce breakfast and an ASMP or other association gathering. Take time to learn the baseline rules of any new place, either so you can adhere to them or break them consciously.

Niceness also means being respectful of people's time and attention. Don't clog up comments threads with meaningless junk. "Add to the conversation" should really read "add something *useful* to the conversation." (More on that in the section below, on utility.) And whatever you do, don't hog the conversation. Remember that the world's most fascinating conversationalists are those who spend more time listening than talking. That goes for Facebook as much as it does the real-life gathering. Balance your tweets with re-tweets, your updates with "likes," your blog posts with responsive comments.

Finally, niceness often means taking the time to add that something extra, from a compliment to a thank-you to any other note of grace. In the attention economy, often the nicest, most appreciated actions are those you take to respect other people's time, like making sure your email subject lines are clear, trimming your posts on email

forums, or just taking the time to write a shorter letter—even a shorter email signature! Inexpensive text-expansion programs like TextExpander for the Mac or Texter for the PC let you store and execute a variety of email signatures appropriate to the situation. (Full disclosure: after years of being a rabid fangirl, I managed to charm/badger TextExpander into becoming a client.)

Be Specific!

Specificity is about narrow focus rather than diffuse. It's primarily the province of strategy and branding, which we covered in the previous chapter (chapter 8).

Be Useful!

This is where the rubber meets the road, marketing-wise. Utility is about tactics—actual steps you can take and actions you can execute to demonstrate to prospective customers how awesome you are. (Although just generally having a mindset of being useful wherever you can is not a bad way to make sure people love you.) Because everything seems to happen in threes, there are three distinct activities that comprise utility, which can be used individually or in combination. You can:

- **Inform** Examples aplenty to follow, but briefly, we define information as anything that adds to the other party's useful body of knowledge.

- **Support** Included here are all the actions, attitudes and behaviors that lighten someone else's burden or otherwise support them, their hopes, their dreams, their endeavors.

- **Entertain** No tap dancing or joke telling necessary! "Entertainment" means anything that's not strictly business. The lighter side, the human side. (Although if you are good at tap dancing and/or joke telling, go for it!)

Now that we've got our loose framework of behaviors clearly outlined, let's take a look at how they look in action in the world of digital media. Once you have a solid understanding of this, it should be fairly easy to extrapolate and find tangible, 3D examples on your own.

SHARING INFORMATION THAT MAKES PEOPLE SIT UP AND TAKE NOTICE

Information doesn't mean "dry, boring data." Neither does it have to be complicated to generate. It simply means creating, curating, or sharing content that's useful. Electronically speaking, websites, blogs, and newsletters are the most commonly used—or often misused—ways of delivering information. They're so easy to get right, it's amazing how wrong most people got them. On the other hand, it's an incredible opportunity for you as a marketer.

First and foremost, websites should make it clear where the reader has landed and what to do next, as we discussed in chapter 8. The information on your site should be easy to find and easy to read. Think about the size of your typefaces and how your site looks viewed from a mobile device. There's a longstanding joke about how useless many restaurants' all-Flash websites have turned out to be when people are out and about—which is exactly when many of them are looking for a restaurant.

If you're game for adding information on a regular basis, blogs are a great way to establish your brand and continue marketing your business. They can be made up of fresh or aggregated content, which can run the gamut from tutorials to relevant personal stories to opinion to inspiration. As a general rule, you're better off avoiding straight news; that's covered pretty thoroughly on the major outlets and Twitter. But if you have an interesting slant on the news, or can synthesize a few different ideas into a new piece, you can create something new and of value. Newsletters have the added benefit of letting you create a list of interested clients, prospects, and even fans. Remember that the information in them has to be useful *to*

the reader to serve your needs as a business. Think "helpful tips" and other user benefits: deals and special offers. Showing your latest work, however amazing it may be, is not enough.

Don't worry about giving away information for free! If you're truly an expert, people who need your services will hire you, once they're convinced they know and trust you to do your stuff.

And people who take the information you've shared to do it themselves will talk you up, doing your marketing for you. Unless you're replaceable, sharing isn't a problem. (And if you are replaceable, you need to apply some serious time and effort carving out a niche for yourself that only you can occupy. Go immediately to chapters 6 and 7: do not pass "go"; do not collect $200.) The people who hire you do so to get your expertise applied to their unique problem. Demonstrating your ability to grasp problems and come up with outstanding solutions can only help your cause.

For example, Michael Katz, a consultant who makes his living helping businesses produce e-newsletters, writes a biweekly newsletter full of tips on how to write an e-newsletter—with every issue, he's telling you how to avoid hiring him, or taking his training courses, or skip buying his book on the subject. But people do hire him, because over time, they see clearly how good he is at what he does. Similarly, "clutter buster" Brooks Palmer shares his incredibly simple strategy for decluttering on his blog, over and over. Here it is, for free: (a) hold one thing at a time and ask yourself "do I love this, or can I let it go?"; and (b) be gentle with yourself as you go. Not too complicated. But someone who struggles with clutter already knows that the "secret" to getting rid of useless crap is to get rid of it. They need help—the kind that, over time, they come to trust Brooks can deliver. So they buy his book, decide to attend one of his workshops, or hire him for one-on-one help.

If you don't have time to generate new content, curating information that's already out there can also help build your reputation as a knowledgeable photographer with great taste. Tina Roth Eisenberg, the Swiss-born, New York-based graphic designer who goes by the handle "Swiss Miss," has built an empire by aggregating terrific design content. Delia Lloyd, an American ex-pat journalist living in the UK, turned her voracious reading appetite into an asset by aggregating the best of the week's links in a Friday blog post "round-up." Closer to home, Los Angeles-based photographer Gregory Mancuso publishes a delightful newsletter that collates the best content he's come across that month. Often it's tangentially related—a video of an exceptionally gifted Jack Russell terrier (Greg has a locally famous service dog named "Enzo") or a story about his beat, the beach cities of Venice and Marina del Rey—but one special holiday issue contained an elaborate how-to for getting exceptional shopping values through his time-honed techniques. The newsletter shows up every month, reminding me of Greg in a pleasant, helpful, specific way.

Sharing your toys—the hard-won knowledge you, as an expert, have gained—is not just an act of generosity. Craig Mod, a U.S.-born designer living in Japan, has built a big following and reputation by creating exquisite, in-depth, "evergreen" how-to pieces on topics like self-publishing and running crowdsourced funding campaigns. Being generous (i.e., nice) with your wisdom and experience can create lasting value for you as well as the world at large. Two New York city partners, Kevin Burg and Jamie Beck—he, a motion graphics expert, she, a photographer—created an elegant twist on the animated GIF (Graphics Interchange Format) they dubbed "cinemagraphs." They began sharing their work on their Tumblr blogs, and sure enough, client work followed, in droves. Then there's the example of Austin Kleon, a writer, artist, and avid newspaper reader in Austin, Texas. A few years ago, Kleon began sharing an artwork series he created of "newspaper blackouts"—themed poems created by blacking out strategic blocks of text in various news stories—on his blog. That work morphed into a book, which led to speaking engagements, which led to a second book.

BEYOND BLOGGING: SOCIAL MEDIA, VISUAL MEDIA, AUDIO MEDIA, AND RICH MEDIA

As you've probably already guessed, Twitter, Facebook, Google+ and other social media platforms are ideal places to share information. Many people use Twitter especially as a kind of home-rolled news feed, following their favorite tweeters in different industries to get a good overview of what's happening. Just make sure that what you're sharing is truly useful to the people you're connected with there. You can alert followers to great reading material, of course—profiles of players in the worlds of imaging and design, well-written reviews of helpful books and films, useful tutorials, thought-provoking editorials, and so forth. Try to avoid sharing the same-old, same-old. You'll need to keep a finger on the pulse of what's blowing up across the blogosphere, and don't just pull items off the feed of popular news sources.

Don't limit yourself to web pages when thinking about ways to share information. PDF "manifestos," ebooks, slideshows, and magazines are great ways to showcase ideas, information—with the added bonus that done right, you can use your own work without it coming across as "dig-me." You could illustrate a series of quotes on a theme, create a how-to piece using photos and text, or collaborate with other artists to create an original book. Ishita Gupta cofounded the online magazine *FEAR.LESS* as a downloadable PDF that showcased interviews with a variety of authors, artists, and thinkers on the subject of fear. Beyond providing her with a rich new set of contacts and the excuse to connect with people she admired, the beautifully produced publication helped build a name for her as someone who understood production and content. That, along with the work she'd been doing with marketing visionary Seth Godin around alternative publishing, led to a second career as a consultant.

Uploading your work to social sites like SlideShare leverages the social component—your work is more easily spreadable, and the spreading, trackable. Videos uploaded to YouTube, Vimeo,

Facebook, or your own site offer multiple opportunities to share information. You can create screen-sharing tutorials explaining software, processes, or the byzantine changes to Facebook's privacy policy. With a Skype connection and split-screen technology, you can do a series of video interviews. Or you can shoot straight video of yourself in the field or the studio, demonstrating techniques. And much of what you can do with video works for audio; podcasts can give straight information, aggregate stories, provide interviews, and more.

Above all, remember that the idea is not to spout information about YOU and YOUR BUSINESS and YOUR THING, but related and tangential subjects that reinforce you in people's minds as someone who knows your stuff. Being informative most definitely does not equal being a blowhard.

SUPPORT: LENDING A HAND (OR SHOULDER, OR EAR) WHEN NEEDED

Support is about you spreading the word of someone else's thing. We spread the word for each other and talk each other up because we want to share what's good, and because the thumbs-up is far more valuable coming from a third party. Write book reviews on your blog, on services like GoodReads or Shelfari, or just share on Facebook or Twitter. Promoting your favorite causes and those of friends, colleagues, and clients is a great way to support them. Just be sure you're doing it judiciously. As I learned from social-good consultant Jill K. Murphy, every request for a donation, petition signature, or crowd-funding contribution is actually two requests: one for the thing you're asking, and another for the attention of the person on the receiving end.

A great proactive way to support people is to write recommendations for people you're connected to on LinkedIn or Yelp, or testimonials for people who have done excellent work. Do it without being prompted, and without asking for reciprocity. You'll probably get it anyway—

there's a way these things work. And one of the finest ways of all to support people is with a sincere "thank you," whether via snail mail, email, wall posting, or voicemail.

Support can also mean tending to the needs of your readers, or the end-user of your messages. Daphne Gray-Grant sends out each of her highly informative newsletters with a word count and an estimated reading time, something author Jonathan Fields also provides on his blog posts. And never forget that every comment or reply box is a place to support someone else's Facebook post, update or tweet. Great content doesn't have to originate with you.

ENTERTAINMENT: SHOWING THE LIGHTER, LESS-BUSINESS-Y SIDE OF YOU

You wouldn't show up at a cocktail party or even a business networking event and immediately start talking business. (At least, I hope not.) Showing a bit of your off-duty self helps give people a feel for who you really are. And if the real you is clever, funny, or talented in multiple ways, terrific—go ahead and show it! At the very least, though, try to be human.

If you are witty, Twitter and Facebook are great places to share it. Some of my favorite Twitter feeds belong to people I follow mainly because they make me laugh. If you're not so personally hilarious but you have a good eye, you can aggregate the best funny or interesting or touching photos, human-interest pieces, and videos you find.

Sharing Hipstamatic shots on Facebook or mobile-app photo-sharing service Instagram definitely counts as entertainment. It's fine to be random with your shots, but it's even better if you can have some kind of angle (no pun intended). Shawn G. Henry, a San Diego-based portrait photographer, has developed a minor following of folks on Facebook who look forward to his regular shots taken from various Southwest flights. Some show the wing from his seat, while a separate (fascinating) ongoing series of shots revolves around where or not Shawn scores his favorite seat on the carrier's planes. (The one

in the exit row with no seat in front of it, providing maximum legroom.) Whether he posts a POV shot of himself having nailed the prized seat or a sneaky-Pete sidelong shot of the frequent flyer who nabbed it ahead of him, it's sure to generate a flurry of "likes" and rollicking comments. And while it's doubtful that this was his original intention, it doesn't hurt that all of his friends on Facebook now think of him as the hardest working photographer we know, jetting around the way he does.

You'll have to use your judgment about how much is too much, and where the line is. Some people's "brand" allows them to get away with much edgier or much more personal stuff than others. Never share more about your personal life, tastes, and interests than you're comfortable with. And definitely don't share anything that will run you afoul of the law or get you in trouble with friends, family, or clients. When in doubt, leave it out—what goes on the Web stays on the Web, whether you want it to or not.

THE GAMIFICATION OF MARKETING!

Mixing and matching these elements of informing, supporting, and entertaining is where you can get really creative and make marketing that sets you apart from the crowd. It's also a great way to turn what can be a chore into a game: how many elements can you deliver in one marketing message? Some examples:

Inform/Entertain

During one period of underemployment, social media expert Claudia Yuskoff created a series of YouTube videos with tips and recipes from her family's Mexican kitchen called *Mmm Me Gusta*. This "infotainment" piece turned out to be a great showcase for her skills, helping her secure a new gig running a local company's social media department (and netting her an audition for a cable-TV reality show, but hey, that's Hollywood). San Luis Obispo photographer Sky Bergman created the "Cooking with Nonna"

series to document her amazing 99-years-young grandmother's action-packed regimen of cooking, exercise, and traveling. Nonna's advice for a long and happy life is incredibly inspiring and fun to watch, and Bergman gets to hone her own videography skills.

Support/Entertain

Minneapolis photographer Karl Herber created a simple but effective newsletter to market his photo tech business centered around a monthly haiku. At the end of the first year, he offered a prize of photo tech support to the first reader who sent him copies of all twelve previous newsletters. He awarded the lucky winner with some services, and also got some useful metrics on reader engagement for himself. ASMP's blog has a great, simple example of combining support and entertainment: each week, contributors are encouraged to change up their bios to subtly reflect the weekly theme: money, equipment, marketing, and so on. The keyed bios reinforce the theme, supporting the blog, and the reader gets a small hit of entertainment seeing how the authors tie their bios into that theme. It doesn't have to be funny or big; "entertaining" means "not strictly business." (Ironic for a blog entitled *Strictly Business*.)

Inform/Support

Los Angeles-based designer Heather Parlato does an occasional roundup on her blog sharing events run by colleagues and clients that might be of interest to her readers. Before visual sharing sites Ffffound and Pinterest turned up, designer-photographer Shelby White built his own website tool for visual social sharing—and later posted a tutorial for fellow designers on his process for developing the site. You can use Facebook and Twitter to share especially good promotions and deals your clients happen to be offering. Just do it judiciously, making sure they're both good and useful to your friends and followers. In one particularly creative display of combining information and support, one Facebook friend of mine used a "thank you" to friends and family for his birthday wishes, to

slide in both information on texting photos to a digital picture frame and a tasteful pitch to channel any gift-giving impulses to a favorite cause via a different text campaign.

The brass ring in mix-and-matching is creating marketing that informs, supports, and entertains all at once. Writer/speaker/ "broadcaster" Merlin Mann, an exceptional multitalent, manages this better than anyone I know, creating useful, highly entertaining content, from videos to articles to podcasts, in support of the products, people, and services he thinks are awesome. Demonstrating his facility with this for free through his many Internet outposts is undoubtedly a key reason why companies now pay big bucks to sponsor *Back to Work*, the informative and entertaining podcast he cohosts with Dan Benjamin. But sometimes, coming up with a message that nails two or all three points means just taking an extra moment to craft a tweet or Facebook status. If you're posting a message of support, is there a way to improve the clarity of the information, or add a touch of humor or personality? Market less often, but better.

SOME CLOSING THOUGHTS ABOUT MARKETING IN THE NEW ECONOMY

With the proliferation of marketing tools comes an accompanying question: *Do I have to do everything—or even any of these things?*

Absolutely not! In fact, it would be difficult to imagine how you could use every marketing tool that exists and still get any work done. Take it slowly. Think about where your strengths and interests lie as much as who your market is and where they hang out. The more your marketing engages your full creative self, the more you're likely to keep moving forward with it. (And as I hope this book has shown, all of life is going to be about moving forward, at ever-increasing speeds, for the foreseeable future.)

As for copying the examples in this chapter, please try to think of them as springboards for your imagination rather than precise recipes to follow. Think back to the quote that opened this chapter: you

must bring your full creativity and your 100 percent authentic self to your marketing, just as you do to your photography. Your work is indelibly yours; so must your marketing be.

Besides, all of the examples we've discussed in this chapter have already been done! The attention economy craves fresh, new content, not me-too stuff. What can you—and only you—do that will set the world on fire? How can you combine your unique set of skills, interests, experiences, and infuse them with your unique passion to make something no one has seen before? And make no mistake: when you truly follow your heart, and support it with all of your energy and creativity, your marketing and your work will take you to radically new and exciting places.

Start with a sound plan: one that honestly and realistically lays out your goals and your market. Then go to town, throwing everything you've got at it to bring it to life. The more you do, the more likely you are to create marketing that pulses with life: that truth of you, translated into the language of them, that transcends the mundane realm of "content" and "messaging," to become pure poetry.

For supplemental information and resources on this chapter go to www.asmp.org/wainwright9 or scan this QR code with your smartphone.

SELLING IN THE NEW ECONOMY

BY BLAKE DISCHER

WE'RE SALESPEOPLE FIRST, PHOTOGRAPHERS SECOND

There, I said it. In print.

Again and again, when I speak around the world to photographers of all levels, I suggest they take as many sales training classes as they can. I explain that if they can't, a) sell their product; and b) sell themselves, they'll not be as successful as they could be in this business. Sales is not a dirty word!

My eight-year-old son is an expert at sales. I think we all were at one time. He quite freely lets me know what he wants and works to "sell" me on why he should get it. He says a Nintendo Game Boy will help him with his math studies. He talks all about its features and how it will benefit me... yes, me! My son "gets it" without consciously realizing he is practicing good sales techniques. He intuitively understands that if he sells me on his goal in a way that makes my life easier, he will get what he wants.

We're in a relationship-based business. That is to say, your "people skills" will have a great deal of impact on your bottom line. Your inflections while speaking on the telephone, your use of good grammar and punctuation in your email correspondence, your self-confidence when meeting people, and your overall friendliness are important in the eyes of clients. And not just your skills, but those of your assistants and crew as well. You get only one opportunity to make a first impression.

Your selling and negotiating style will undoubtedly be different than mine and different from almost everyone else you know, and that's perfectly fine. As Colleen points out in the previous two chapters, be authentic, find your "voice," your delivery style, and your level of comfort in interacting with others.

Two Ways to Improve Your Bottom Line

We've all heard many times: work smarter, not harder. Most of us do this subconsciously. To oversimplify, do tasks that make you money first, tasks that don't, last. Multitask whenever possible. Leverage your drive time by listening to educational audio content instead of the radio. Return calls to your clients on your mobile phone while doing errands.

But here's what I think is the best way to improve your bottom line: seek out better clients, and be willing to let those low-paying clients go. When I started in the business, I can remember working for small, local companies whose budgets were tiny. It was a way to start building my portfolio and a great way to hone my negotiating skills.

There eventually came a day when the new, larger client with deeper pockets that I'd been wooing called with a job for the very same day I had a shoot scheduled with a local auto repair shop. I was fortunate, I called the shop's owner and asked if I could reschedule his job and he agreed. But if he hadn't, the right thing to do, of course, would be to do the small client's job and let the other go. Ouch!

More sophisticated clients are much easier to work with in many ways. For example, they understand and respect copyright. I remember

when I mentioned copyright and licensing to the auto repair shop's owner. He didn't really understand it. After all, when he installs an exhaust system on someone's car, they own it. Forever.

The larger, more sophisticated clients' knowledge about licensing and copyright is twofold: first, they encounter it again and again; and second, their large use of the work makes licensing a factor in the image's price. The lower-end client, on the other hand, does not use the work enough for the license to have much impact on its price. While licensing take place, you will likely bundle them an unlimited use package that fits their modest needs.

In my seminars I'm often asked how one goes about raising their fees with their existing clients. My answer is always, "You don't." Clients you're already working with are very resistant to price increases; it's just too easy to find a replacement for you at this level. Move on to larger clients.

Getting Yourself in Order

What would happen if you decided to get out of bed during the week—I mean just Monday through Friday—one hour earlier? One hour before the rest of your family rises and the tumult of your day begins. One hour of silence. One hour for personal growth. One hour dedicated to your education. I've done the math and if you are willing to do so for one year, you'll gain six full weeks of time!

This time is truly your time to do that which will help you to be more successful. All of us learn in different ways. An assistant who used to work for me preferred to watch online video courses; I do best with a printed book that I can make notations in. A good friend of mine swears by listening to audiobooks or podcasts. Embrace whichever works best for you and you'll get more than a month of learning without even noticing.

But whatever you do, don't read your email or browse the web aimlessly. Each of these are huge time sucks, and you already know it. We've all done it... we browse the web, jumping from one site to another, and before you know it, we've wasted more than an hour with nothing to show for it.

What's Your Competitive Advantage?

Perhaps the most important step in running a successful photography business, or any business for that matter, is determining the ways in which you are different from your competitors. (Refer to chapters 6 and 7 for exercises that will help you to identify these.) These factors represent the "value" you bring to a client and these value added items are what you are selling. You need to differentiate yourself from your competitors. What is it you do differently? Why are you a better choice for the client?

Your differentiation (value) could be your "style"—the "look" of your finished photography. Does all of your work look similar? Perhaps a certain method of post-processing lends a certain feel to all of your images, your lighting technique or your use of strong formal composition. Perhaps the speed at which you work (less disruptive) or your level of experience in a certain setting is what differentiates you from your competitors.

Whatever it is, you need to talk about it when speaking with a potential client. Let him or her know why you're the best person for the job. In most cases, if you focus the conversation on price, the price drops. But if you focus the conversation on your value, the price will rise.

How to Develop a Targeted Prospect List

There are two ways to develop a list of prospects. One is the shotgun approach and the other is the rifle approach. They're so named because a shotgun shell contains many small round projectiles that exit the barrel of the gun and spray in a wide pattern. Your aim needn't be exacting because a wide swath of the small pellets is created and anything in their path will be hit. The rifle approach requires far more precision in aiming and you aren't necessarily going to hit a target you might not have been aiming for.

An example of the shotgun approach would be the purchase or rental of a mailing list of prospective buyers. The list contains the mailing addresses or email addresses (or both) of buyers who could perhaps use the photography you produce. You can narrow the lists by geographic region, by size of agency or company, or by account type. An example provider of such lists is Agency Access.

The rifle approach involves your creation of a more targeted prospect list which allows you the luxury of being able to spend more effort per target. You would create a list of prospective clients yourself, perhaps looking at magazines that use your type of photography for the name of the photo editors or art directors. Also check out the annual photography issues of magazines to see which art directors have clients that use the type of photography you produce. Magazines having annual issues containing award-winning photography are *Communication Arts*, *HOW*, and *Lürzer's Archive*.

Both methods are effective and most photographers, including myself, use a blending of each to reach prospective clients and stay in communication with existing clients.

Your self-developed list could target a single industry. Jenna Close, a photographer in San Diego, and her partner have sought out a very specific client type: energy companies. They've compiled a list of utility companies worldwide that could use their services.

If you are a portrait photographer, your list could consist of potential customers in your local market. Independent research can build these lists—it's work you can hire out or do yourself.

Networking 101

During the economic downturn, networking is what saved my business. I learned to always be networking, no matter where I was or what I was doing. There's an old axiom in networking and sales that goes something like this: It's not who you know, it's who knows you. You need to raise your visibility in the marketplace and an easy way to do so is through networking.

In order to be successful, whether at a networking event where other business owners gather to meet one another and network, you'll need what some call an "elevator speech." Your elevator speech should contain three elements: your name, what you do, and why the other person should care. Think of it as a twenty- to thirty-second commercial about you. Photographer Judy Herrmann uses what I think is a great example:

"Hi, I'm Judy Herrmann of Herrmann + Starke and I help people grow businesses. As a professional photographer working with still and motion imagery, I work with advertising, editorial, and corporate clients to create strategic visual communications that enhance brands and communicate key messages. My work helps organizations attract customers, build audiences, raise money, sell products, and sometimes even change the world."

That's fantastic! It's a great conversation starter; after all, who could resist following that with the question, "How exactly do you do that?" Now the conversation is rolling and you're explaining why you're the best at what you do. Many artists are somewhat uncomfortable talking about themselves, thinking it's bragging. It's not bragging, it's selling! You need to sell yourself and talk about your differentiation at networking events.

Have an Amazing Business Card

That's right, amazing. Forget the cards from the office supply stores. I'm talking about amazing... letterpress cards, plastic cards, die cut cards... anything but boring "me too" business cards. You need a card that stands out from the pile. When you hand someone your card, you want to hear, "That's a great looking card."

Why? Because if your card is not memorable, the person will forget who it came from. Because what we all do is empty our pockets each night, dumping the pile of cards into the little junk holder on our dresser. Then, a month later, we dump the little junk holder into the top drawer of our dresser. Then a year later, we dump the top drawer into... that's right, the garbage. But if you made a great first impression and had a great business card, you'll be memorable.

Work the Room

When you're at any sort of networking event, resist the temptation to hang out with people you know. You're there to meet new people. If someone you know is there, ask them if they can introduce you to someone they know but you haven't yet met. They'll in essence be "endorsing" you to the new person. Don't be a wallflower! I set—and reach—a personal goal to hand out 500 cards every six months.

If You Must, It's OK to Be a Backup Quarterback

Anyone can give many reasons why they can't do something they know they should, and one reason some photographers shy away from networking is that "everyone there will already have a photographer." Nonsense! You're right, they might, but that's no reason to not network. If after you've met someone and they say they already have a photographer they're happy with, I suggest saying something like this, "You know Bill, I know [other photographer's name] and he is a good photographer. But here, take my card anyway, you never know when you might need a photographer and [other photographer's name] is already booked and maybe I can help you out of a jam."

That was easy. Now you've let the prospective new client know a couple of things: you're a good person because you don't bad-mouth your competitor, and you're making an offer to help the client should he need help. If you do get the chance to work for him or her, do the best you possibly can, provide excellent work, excellent service, and excellent follow-up. Who knows? You might gain a new client for keeps!

Your Goal: Get Appointments

The goal of any networking you do is to get your work in front of the people you meet. Sure, you can simply email samples of your work, but that's the easy way out. Instead, try to get a face-to-face meeting. In this day and age of easy electronic communication, we tend to forget the value of an in-person meeting. Give your prospect a call, and ideally get an appointment to see them or, even better, take them to lunch and bring your iPad portfolio with you. If you don't have a portfolio on your smartphone or tablet, you need to get one. Your competitors already do!

WHEN THE CALL COMES IN

As your parents told you, you only get one chance to make a good first impression. In many cases, the client's first impression is your outgoing voicemail message. Be sure it's professional, gives your name, and lets the caller know when you'll call back. Endeavor to return calls as soon as possible; it's just too easy for the caller to find another photographer. Even a delay of just fifteen minutes can cost you a new client or another job. There's no need to play music in the outgoing message, get to the point quickly because your caller is probably in a hurry. Don't encourage them to give up and not leave any sort of message at all.

Once during a visit to another photographer in the building I previously had space in, I heard her answer the phone with a quick, terse, "Studio." This practice was popularized in the ego-driven '80s in large metropolitan areas. Today it simply sounds arrogant. It also shows your age! A more professional way to answer the phone might be to say, "XYZ Studio, this is Michael." Answering in this way sounds a bit more sincere and personally engaging.

It's All About Selling

Many photographers fail to realize that if a prospective client is calling you on the telephone to discuss a job they have, they've likely already seen your work, perhaps on your website. Remembering this can help your self-confidence a great deal because they obviously like your work; if they didn't, they would not have picked up the phone to call. I'll take you through the sequence of a typical call for me.

Be a Good Listener, Ask Smart Questions

I remember my dad telling me, "You have two ears and one mouth... use them in proportion." Good advice. When on a telephone in a sales call (which you are when called for a quote), consider listening as job number one. Your task now is to glean as much information as you can about the client, the job, and ideally, what sort of budget they've set for the project.

I always try to get the call off to a good start by keeping the conversation more personal than business, provided the person on the other end of the phone doesn't sound rushed. I'll ask questions early on to help me discover how they found me. Was it my website? An email? Snail mail promo? The goal is to discover which of my marketing efforts is working.

If I'm asked for a day rate or "a ballpark figure," I don't give them. I explain that my fees are based on the scope of the work and, "please tell me a bit more about the project." If I must talk, I ask open-ended questions; questions that require more than a simple yes or no answer. Open-ended questions start with what, how, and "tell me about." Closed questions begin with do, are, and will. I'm in discovery mode now and need answers so I can correctly estimate the job.

Is This the Decision Maker?

In sales, it's very important to discover whether or not you're talking to the decision maker. A great, nonoffensive way to ascertain this information is to ask, "Is there anyone else in the company I might email a few samples of my work?" If he or she gives you a name, it's likely that person is, at minimum, involved in the process and may possibly be the actual decision maker. Then I'll ask, "Is there any way to get that person on the phone?" If the caller says yes, that's fantastic.

If not, you'll need to give the person on the phone "talking points" about you and what services you offer so that he or she can in turn explain to the decision maker why you are the best person for the job. You are effectively making that person your salesperson!

Why Are You Best for the Job?

At some point during the conversation I need to shift the conversation from discovery to sales. That is the point at which I talk about my value, my differentiation, and why I'm the best choice to be awarded the job. My job is to instill confidence in the buyer about my ability, as well as my crew's. I've listened closely to what his or her requirements are and now I'm working hard to find a way to satisfy them. As I said already, if I focus the conversation on price, the price will fall. So instead, I'll focus the conversation on my value (what it is I do better or differently than others), and the price will likely rise.

What's the Budget?

At some point, I'll ask if they've set a budget for the project. Most of the time the client will say no, but sometimes they'll tell you. If not, we'll talk more about the project and at some point later in the conversation I'll ask, "You know this project fits me perfectly, I just did a similar shoot for XYX company and I'd love to work with you on it. Tell me, about where do I need to come in at on the project?"

You'd be surprised how many callers will now give you some idea of what their budget is. That's of course, provided they like what they've heard from you so far.

Another technique for discovering the client budget that might work for you is to ask about it using an extreme range: "Are we talking about a $500 or $5,000 project?" They might come back with something along the lines of, "Oh no, somewhere around $2,000."

If you can gain any information at all about how much they want to spend on the project, you'll know early on whether or not you want to take the time to prepare a detailed estimate.

Never Quote on the First Call

One of my strict policies is that I never quote a price during the initial phone conversation with a client. I've learned the hard way that it's just too easy to leave an expense item out of your mental, quick calculations in an effort to give a price. I'll tell the client that I'm going to work up an estimate, send it over, and then follow up with a phone call to see if he or she has any questions.

Regardless of how much they insist, I do not give ballpark figures. I really need to know all the details of a project before giving an estimate, but even more important, I want to take time to go through how I will do the job. On more than one occasion I've given a ballpark estimate and after thinking about the project realized I needed to rent a piece of equipment (such as a hydraulic lift) that I hadn't initially considered.

Regardless though, be respectful of their needs—if they need your estimate in a couple of hours, say you will get it to them.

It's a Numbers Game

An experienced salesperson will tell you that sales is a numbers game; history shows that you'll be successful about 10 to 15 percent

of the time. What does that mean? It means that in order to be more successful, you need to fail more. Don't be discouraged, no one closes every prospect.

It's also a given that about 30 to 40 percent of your potential clients will buy based on price alone. In other words, regardless of your differentiation, regardless of how good you are at sales and presenting your value, and regardless of how good a photographer you are, there are certain buyers who are solely motivated to buy based on price alone.

Market Factors

My dad once told me, "You'll never be a star in your own backyard." And he was correct. Generally speaking, each of us are typecast into a certain type of photography in our own market. Usually it's the sort of photography when you first broke into the market. That means as you move up in ability or specialty, your local clients will still think you're only capable in your first area of specialization and skill-set. For this reason, I am able to generally charge higher fees outside my own market.

Another market factor that comes into play is the local economy and the amount of local competition. If your market is depressed, it is likely many of the photographers have lowered their rates and in order to be competitive you may have to.

You might choose to not rely entirely on local work. Very, very few can choose to ignore it completely, so the goal is to find a balance and keep steady work coming. Besides the obvious, a few benefits of in-market work are referrals and local visibility.

Be Prepared to Justify Your Prices

With every estimate you prepare, you must be prepared to justify your price. You need to be comfortable with the price you are asking for. Clients do call back for additional information or to ask you about a

specific line item they perhaps don't understand. Be a good listener, figure out exactly what they are asking, and then answer the question with confidence.

In the event you need to lower your price due to competitive pressure or budgetary constraints, be sure to take something away, such as a change in the licensing terms or eliminating a production item like the makeup artist or stylist. In any case, you need to pull something back, otherwise the client will think you didn't give them your best price initially or were just trying to charge as much as possible.

If I'm asked to lower my price after sending an estimate, I lower expense items rather than the creative fee because the creative fee is the number clients tend to remember.

Follow the QR code or URL at the end of this chapter for additional pricing guidance.

Maintain Your Momentum

We've discussed differentiation a couple of times already; what is it that sets you apart from your competitors? Here's something simple you can do that will certainly help you to stand out from the crowd: send a snail mail thank you card after every job you shoot. Every job. Whether you've worked for the client for fifteen years or this is your first job. People receive fewer and fewer handwritten cards in this age of lightning-fast electronic communication. Your card will definitely be remembered!

Ask for Referrals

One of the best sources of new business are referrals from your existing clients. Here's how you might ask your client for a referral:

"Hi Cheryl, this is Tom. I saw the calendar we worked on together and I wanted to follow up to make sure you were happy with how it came out." Assuming she liked it, you'll then ask, "Is there anyone you can think of that might be able to use my services in the future?" Then, "Would it be OK if I followed up with them and mentioned your name?"

When she gives you a name, you should immediately call them and say something like, "Hi Sarah, this is Tom at XYZ Photography. I recently completed a project for Cheryl and ABC Company, and she gave me your name as someone that I should contact to see if you could use photography for your next project. I'd like to stop by to show you samples of my work." If the referral is not local, then offer to email or snail mail samples and follow up with a phone call.

This type of referral is extremely valuable because, in essence, your existing client is vouching for you and your product and you can share that with the prospective new client. Be sure to send a thank you note to the person who gave you the referral and keep them apprised of your new relationship.

Testimonials Are Gold

Testimonials on websites are fast becoming popular. In today's rushed world, however, merely sending an email asking for a testimonial will likely not yield positive results. Your request will likely drop to the bottom of your client's to-do list. Because of staff cutbacks, most of our clients are doing the work of several people and might not have the time to get to your request.

Make it easy for them. Instead, write the testimonial yourself and then email it to your client with a paragraph letting them know you've enjoyed working with them in the past and you've attached a testimonial about the photography you provided for their approval. Don't go overboard in your review of yourself, keep it humble and let them embellish if they care to.

Keep in mind that some corporations forbid vendors from trading on their name. Check any contracts or other written agreements you may have signed before posting any testimonials on your site. Don't assume your company contact knows the corporate policy.

Is This Client Worth Keeping?

From time to time we ask ourselves if a particular client is worth continuing to work for. Perhaps it's a client you've been working for years and as such are charging much lower fees than you are your newer clients. I have just such a client. We've worked together for eighteen years now, and admittedly the fees I charge are far below where they should be.

This client, however, is of great value to me not because of the revenue she generates, but because she is an unending source of new business referrals. She knows that she is paying less than all my other clients, but she keeps quiet about it to the prospective clients she refers me to. We've agreed it's our little secret! She tells me about the prospect and I follow up immediately. It's a win-win situation for both of us.

It's important to keep in mind that there are clients whose value to you is not in immediate financial gain. It could provide nice portfolio images, marketing exposure, or additional referrals.

Giving Back to Your Clients

To help you with client retention, here are three ideas to get you thinking about ways in which you can give back to clients. They're all tasteful and don't fly in the face of most corporate gift-giving policies.

First, is the third party referral. You know what a referral is already— a lead offered by another person to help you gain a new client. But the third party referral is a bit different. Here you act as a "connector" between two individuals you've done business with.

Perhaps you photographed a series of posters for client A. You've seen the finished product and thought the printer did a fantastic job with your photography. Now you're shooting a job for client B that will eventually go to press. Here's an opportunity for you to make an introduction between the printer and client B. Monetarily speaking, you don't have anything to gain from "connecting" the two, but in

another way you have much to gain. If the two persons you've intro-
duced to one another have a good experience, they'll both remember
that it was you who made the introduction. Eventually, your good
deed will be rewarded.

Second is a brilliant idea I wish I could take credit for. If you're
utilizing email marketing in any fashion, send a computer desktop
background as the sample of your work. We're the envy of many
of our clients because we have opportunities to photograph, and have
access to, wonderful locations and beautiful scenery. Simply format
your image to fit today's screens and perhaps put a subtle watermark
in the lower corner, and you've given a gift that cost you little but
might be very much appreciated by your clients. You can do this
for both existing and prospective clients.

Third and last are decor prints. Print, matte, and frame a print of
your work and hand deliver it to your client for their office or cubicle.
It doesn't cost a lot but the perceived value of a signed, fine art print
by you is high. The print shows your level of creativity and conveys
a great deal of sincerity.

Practice Makes Perfect

Just as you were told when you were young, practice does indeed
improve your confidence and ability to negotiate and sell yourself.
In closing this chapter, I suggest you do a bit of role-playing with an
assistant, coworker, or another photographer. One person should play
the role of the prospective client and the other the photographer.
Then switch it up. An assistant I used to work with made the shift
to being a full-time photographer. She is every bit as talented as
I am; what she lacks is my many years of experience in selling and
negotiating. To help her, in fact to help both of us, we'd role-play
buyer/photographer a few times a week. She's now a successful
photographer in my market and I can hear her self-confidence
when I talk to her on the phone.

IN CLOSING...

Selling is not like riding a bike. You cannot stop for a time and then start up again as good as you were. Unfortunately, it takes years and years to get good at it and the learning process never ends. Mostly because your skills are used differently every time you interact with a potential buyer. You're adjusting your conversation to what they're asking for, what they're saying. Your listening skills, questioning skills, and photography skills (!) are constantly improving. With experience comes confidence and calm.

My son knows that if I don't say yes today to his request for a Nintendo Game Boy, he can just ask again tomorrow! We have the same luxury if you think about it. We get another opportunity to do better with tomorrow's inquiry. After every call you take, do an analysis of what you might have done better. If you need to, write yourself sticky-notes containing pointers and put them up in front of your desk.

Experience makes better salespeople. Don't ever stop selling!

For supplemental information and resources on this chapter go to www.asmp.org/discher10 or scan this QR code with your smartphone.

CHAPTER 11

CHANGING YOUR COURSE

BY JUDY HERRMANN

In the twenty-three years I've been in business, my partner and I have radically changed our business model six times and gone through countless smaller course adjustments. We've learned that no matter how much you plan—no matter how hard you try—you cannot avoid change. Fortunately, managing and adapting to change is a skill that can be learned. And it's one that photographers are uniquely suited for. The trick is applying the same creativity, problem-solving skills, and adaptability we use in our creative work to our careers.

TYPES OF CHANGE

There are countless reasons why you might find yourself needing to change the course of your business and career. Surprisingly, almost all of them fit within just three categories:

Diversification comes into play when you're happy with what you've been doing and just want to add to it. You might be excited about an opportunity to do something different. You may feel more financially secure having multiple income streams. Or, maybe offering new products or services is the best way to grow your business.

If a new tool, technique, or technology comes along that lets you do what you're already doing better, faster, cheaper or more easily, you're dealing with an *adaptation*. Adaptations can be relatively

Photograph © Jake Belvin

inconsequential (e.g., upgrading software) or monumental (e.g., switching from film to digital). Adaptations don't just involve technology. Every time you master a new skill or adopt a new approach to doing something, you're adapting on some level.

And then there's *reinvention*. For whatever reason—maybe the work you've been doing doesn't excite you or it's no longer financially viable or you just can't stand your clients—you need to stop doing what you've been doing and start doing something different.

Not every situation will fit perfectly into a single category. You may find yourself grappling with two or even all three categories at the same time or in rapid succession. Understanding which type or types of change you're experiencing will help you figure out the best strategy for dealing with it.

How you respond, emotionally, and pragmatically, will depend on the type of change you're dealing with, your risk tolerance, your personality, and the specifics of your situation. This chapter provides a range of approaches, techniques and ways to think about change that will help you adapt to all kinds of changes—big or small, exciting or scary, immediate or gradual, anticipated or sudden.

THE NATURE OF CHANGE

Let's start by looking at what you need to consider no matter which type of change you're dealing with.

When we first start a new business or career, one of the biggest risks we face is that our enthusiasm, excitement, and naiveté will lead us to underestimate the costs, risks, or downsides hidden in our ideas. When we change our direction, we face the opposite problem. More often than not, feelings of disappointment, loss, confusion, self-doubt, failure, anger, or frustration stop us from seeing the opportunities hidden within perceived threats. And, the more invested we are—financially or emotionally—the harder it is to accept the need to change. That perspective shift can make us dangerously resistant to change.

Since change is inevitable, it's smart to prepare for it. Get into the habit of doing a gut check on your business. What's working? What isn't? Are there any aspects of your business that could work better? How can you make your business the best it can be? Make an effort to think about these questions informally on a regular basis and as a more formal part of your goal-setting process at least once per year.

Get into the habit of using the PEST, SWOT and business plan exercises I provided in chapter 7 as a framework for filtering every piece of information you come across. Are you seeing trends that might affect your business? Will they strengthen or weaken your position? Will they create opportunities or threats? Are there hidden synergies that you can leverage? Is there anything you need to change about how you conduct your business? Again, this does not have to be formal. Your goal here is to simply remind yourself to always think about how you might need to adjust your business based on what you learn about external forces.

Practice Makes Perfect

Practice your change management skills by making small, low-risk course adjustments based on these kinds of questions. Having that built-in momentum will help you when larger, harder changes come along. Dealing with change is far easier when you don't have to push yourself out of a rut you've gotten too comfortable in.

The Power of Paying Attention

As Peter Krogh notes in chapter 3, diffusion of innovation theory[46] teaches that innovators initiate trends, which are picked up by early adopters and the mainstream eventually follows. Being an innovator can be painful—they don't call it the bleeding edge for nothing— but paying attention to innovators can provide important clues that will help you figure out when it's the right time to leap.

If Tom Kennedy had not visited the MIT Media Lab or participated in the Time-Warner "Open" experiment or noticed the advent of the first graphical web browser as he describes in chapter 2, repositioning his career to take advantage of those innovations would have taken longer and been much harder. Instead of being blindsided by change, he was able to anticipate it, prepare himself for it, and respond decisively to it.

The sooner you notice a trend, the more time you have to internalize new information, draw appropriate conclusions, connect seemingly unrelated dots and reframe your thinking. Plus, changing the course of your business or career won't happen overnight. It will take time, money and effort to figure out what to change and how to change it, get buy-in from clients and make the change self-sustaining.

No matter which type of change you're dealing with, making a concerted effort to pay attention to external changes that could affect your business will help you be proactive instead of reactive; to embrace change on your own terms and at your own pace.

Questioning Assumptions

Managing all three types of change successfully requires a willingness to question your assumptions. Our brains are hardwired to repeat patterns—we become so wedded to how we've always done things that we start to treat our assumptions as inalienable truths. Breaking through those barriers lets us think more creatively, imagine better alternatives, invent or reinvent products and services, and solve problems more effectively.

In chapter 6, I showed how understanding why you want what you want can help you see your options more clearly. This examination can be taken even deeper. Try listing everything you believe to be true about your situation. Then ask yourself why those things are true and how you could make them untrue. In particular, question:

- anything you believe that may not be true or may no longer be true,

- anything you think has to be done a certain way but doesn't really,

- anything you believe is a requirement or prerequisite that isn't, and

- anything you think you can't control but you could influence.

This simple exercise can help you uncover hidden opportunities. How you define your work, yourself, and your clients is a good place to start.

Redefining Your Work

We call ourselves photographers, but what does that really mean? Long before hybrid cameras and electronic distribution led still photographers to explore digital video, Gail Mooney and her partner, Tom Kelly, began working with motion imagery. A few years ago, during a chance conversation, I asked Gail about their foresight in embracing this medium. "Well," she replied, "I wasn't a visionary or anything. I got into photography because there were stories I wanted to tell. One day, I realized that I could tell some of them better if I incorporated sound and motion."

Gail may not see this as visionary but there's a powerful lesson to be learned here about how you define your work. Gail didn't get into video because it was the hot thing or because the market demanded it. She just wanted to tell stories. Instead of defining herself by her medium (I'm a photographer), she defined herself by her core motivation (I'm a storyteller). This redefinition started opening new doors for her nearly twenty years ago and continues to open them today.

Redefining Yourself

Many of our assumptions tie deeply into our self-image. Attributes like the kinds of projects we take on, who we want as clients, or how we structure our billing can stop us from seeing opportunities.

Photographer Ed McDonald describes the moment he realized he was holding back his business. A talented lifestyle and portrait

photographer, Ed targeted high-end annual report work. When one of his long-standing clients asked him to help with their graduation and event photography, he balked. After turning them down three times, the lightbulb came on. By reframing his definition of his business and himself, Ed was able to strengthen a long-standing client relationship and give his studio greater financial flexibility.

When you examine why you've made the choices you've made about the services you provide and who you provide them to, you open the door to a world of possibility. Along the way, it can be helpful to assess your skills and interests. Think about what you're good at, where your weak spots lie, what you love and hate doing, what you avoid doing, what you're willing to learn and what you're willing to change.

Redefining Your Clients

In the book *Blue Ocean Strategy*, W. Chan Kim and Renée Mauborgne describe how traditional businesses look at industries as a defined market space where gain is only achieved at a competitor's expense. Market saturation leads to reduced profitability and growth, which leads to commoditization of products and cutthroat competition. Sound familiar?

But there is another way. By focusing on unmet needs, businesses can create demand instead of fighting over it. Growth is achieved by making the pie bigger and by the time competitors catch up, the leader has solidified their position.

Many photographers carry way too many assumptions about our clients' needs, wants and expectations. As the first half of this book shows, photographers aren't the only ones whose world has been hit with disruptive changes. Developing candid communication lines with people on the other side of the table can be an invaluable way to identify unmet needs that you could fulfill.

MANAGING DIVERSIFICATION

Adding a new income stream to your business may seem like the easiest type of change to manage, but diversifications are not without risk. It's wise to proceed with caution. A few years ago, I stumbled across a Bain & Company study of diversification among U.S. retailers.[47] They discovered three principles that dramatically increase the chances of a successful diversification:

1) Expand into areas that are close to your core business.

2) Look for new markets that have larger profit margins than your core area.

3) Estimate the potential for growth in the new market before entering it.

Ninety-four percent of the companies Bain studied that didn't follow any of these principles failed. Those that followed one increased their chances for success to 30 percent, while those following at least two of the three principles had a 60 percent or higher chance of success. My own experiences echo their findings.

Look Before You Leap

Of all the types of change, diversification is the most similar to launching a new business. Before investing any money in a diversification, revisit the research strategies I outlined in chapter 7 to make sure your idea is viable. Informational interviews with peers, clients, and prospects can be particularly helpful.

In 2011, my partner and I started talking seriously about incorporating motion imagery into our business. Before spending a dime, we spent about six hours on the phone interviewing seventeen photographers about their experiences making the transition.

Next, we called our clients. We found out what kinds of motion imagery they were currently using, what they wished they could get, and what they wished their current vendors wouldn't do. We learned about their

needs, their frustrations, and their preferred work flow. Then, we asked, flat out, "If we started to provide motion imagery in the same style as our still work, would you use it?"

Understanding exactly what we were getting into and getting client buy-in before making the investment gave us the confidence to move forward with this diversification quickly and decisively. Instead of bootstrapping our skill development, we could justify spending real money, as we knew the investment would quickly pay for itself. Within just six months of deciding to move forward, we showed a thirty-second demo clip to one of our largest clients and landed a motion assignment that more than paid for our entire investment in training and equipment.

Build Sums That Are Greater than Their Parts

The best diversifications allow you to build synergies between your existing business and your new direction. While this can mean offering new services to the same clients or using your existing skills and equipment for a new market, you shouldn't hesitate to look for broader synergies.

In 1994, my partner and I incorporated digital photography into our offerings. It was hugely expensive—our first Mac cost over $4000 and had a whopping 32 mbs of RAM—and that was nothing compared to our first digital back. Clients were leery of this emerging technology and we needed to overcome their objections fast. After evaluating all of our options, we decided that establishing ourselves as experts in this new medium would give us the best chance of successfully managing this transition. We started by writing articles and entering every award competition imaginable. Those articles led to speaking engagements and soon we were on our way.

This strategy worked because it supported our primary income stream: art directors could tell their clients, "These are the people teaching *other* photographers this stuff" and most objections would fade away. It cut costs as manufacturers gave us free software and equipment. Our name recognition and cachet grew when these same

manufacturers promoted our work through their marketing channels. The magazines we networked with as writers turned to us when they needed quotes or interview subjects. Some even wrote feature stories about our award-winning work as well as our digital know-how. Finally, it provided new income streams through speaking and writing fees, sponsorships and consulting relationships.

Keeping Those Balls in the Air

Having multiple income streams is a great way to build financial stability and security but it adds a lot of other stresses to your life. Providing your existing clients with the same level of service they're used to while building new markets or gaining new skills can be challenging. Be careful of spreading yourself too thin.

You may need to explore outsourcing time-consuming activities that don't require your specific skills, bringing in staff, or collaborating with other people who can support your efforts. Task management systems—especially those that sync between your computer, smartphone and tablet—can really help you juggle the challenges of going in two or more different directions.

MANAGING ADAPTATION

When it comes to incorporating new tools, techniques or technologies into your business, the key to success lies in assessing when it's the right time to make the leap. In chapter 3, Peter Krogh describes the adoption of technology as a continuum running from early adopters through the majority and ending with laggards. This same continuum applies to virtually any adaptation.

It's important to note that there's no consistently perfect spot to choose on that continuum. Sometimes, early adopters reap huge rewards. Sometimes, they lose their shirts. Sometimes, laggards miss out on opportunities. Sometimes the only thing they miss is the headache of relying on a tool that's not quite ready for primetime.

Making a conscious decision to avoid adopting new tools, techniques, or approaches for sound business reasons is one thing. Avoiding them out of fear or denial is another. Before you decide you can ignore a new tool, technology, or trend, make sure you fully understand what that delay will cost you.

Paying attention and questioning your assumptions will help you determine which adaptations you should jump into quickly and when you should bide your time.

MANAGING REINVENTION

When you find yourself needing to completely change your direction, it's smart to go back to the very beginning and reassess what you really want out of your business and career. Revisit the exercises I provided in chapter 6, do your research and make sure your idea for your new direction is viable before committing to it.

As you explore your options, it's important to recognize that unlike diversifications, where you have a viable business that you're adding to, reinventions involve abandoning something you've worked hard to build. This can be emotionally and financially devastating.

Years of experience have taught me the value of "running toward" over "running from." The sooner you're able to shift your perspective and embrace your new direction with enthusiasm, the more successful your reinvention will be.

Several years ago, I had a conversation with a photographer who had been a dedicated and successful photojournalist. For reasons beyond her control, she had to quit her staff job at a prestigious newspaper and reinvent her career into one that would give her more flexible work hours. She decided to pursue wedding photography.

I will never forget her forward thinking attitude. "You know," she said, "I went into photojournalism because I wanted to do social documentary work. If you think about it, what's more 'social documentary' than documenting engagement and wedding rituals?"

Instead of bemoaning the loss of her former career, she brought the same passion and enthusiasm she had for journalism into her new business. I don't think it's a coincidence that she was named one of the best wedding photographers in the country within a few years of her reinvention.

Timing Is Everything

From a financial standpoint, it's important to learn when it's time to cut your losses. In a recent webinar, "Examining Compensation Models for Visual Content,"[48] Joe Weikert, general manager and publisher for O'Reilly Media, observed that Tom Peter's "Fail, Forward, Fast" mantra isn't just about learning from failure. It's about judging—quickly and accurately—when it's time to walk away and pursue a new direction.

Reinventions take time, energy, and money. The more resources you put into a business that isn't taking you where you want to go or isn't financially viable, the less you have to support your new direction.

In some cases, you may need to look at completing your reinvention in two or more steps. In 1991, after killing ourselves for three years to build a business that had us working crazy long hours producing creatively unsatisfying work for far too little money, my partner and I knew we had to change our direction. But we didn't have the money or the portfolio necessary to launch ourselves into the style-based market we wanted to pursue.

Instead, we launched an interim business with the sole purpose of generating enough revenues to support our long-term goals. Armed with a $1200 fax machine that could transmit a Polaroid in 128 shades of grey, we offered a menu of services that allowed clients to order and approve straightforward product photography without leaving the comfort of their offices. The flexibility this business provided gave us time to build a strong creative portfolio. By 1994, it generated enough profits that we could afford to start marketing this new body of work to high-end clients.

Easing into a Reinvention

If your existing business is still generating income but either isn't what you want to be doing or isn't earning as much money as you need, you may want to diversify into your new direction. You can gradually pull back from your old business as your reinvention ramps up or just pull the plug when you no longer need it.

GETTING UNSTUCK

When faced with change—especially big changes like reinventions or major adaptations—it's easy to get overwhelmed, confused, unfocused and even paralyzed. If you know you have to embrace change but you just can't get yourself to do it, get help. There's no shame in it. The best athletes in the world still need coaches, and the cost of not moving forward is probably greater than what a consultant, coach, or therapist will charge you.

Change is hard. We will put up with a world of misery, convince ourselves that new tools and techniques will never replace what we're used to, and throw good money after bad, all to avoid change. Why? Because the rock bottom, hard knock truth about adapting to change is that the only way to do it is to change yourself.

Changing the course of your business gives you an amazing opportunity to build off of your hard won experience and knowledge. Seizing new opportunities, mastering new skills, meeting new people, and expanding your revenue streams can be exciting and even fun. With each diversification, adaptation and reinvention, you will become better at anticipating and managing change. This will give you tremendous advantages as you work your way toward building a career that's creatively, personally, and financially rewarding.

For supplemental information and resources on this chapter go to
www.asmp.org/herrmann11 or scan this QR code with your smartphone.

Entrepreneurs in every creative class have developed strategies of change that are wide and deep. The following interviews are with people who have been in business anywhere from a few years to several decades. Their work includes advertising, weddings, editorial, pets, headshots, fine art, portraits, celebrity, events, architecture, corporate-direct, and all the specialties that fall in between—which is increasingly the place where many photographers live. The work is mostly produced digitally—though not always. Motion has entered the mix, even CGI (Computer-Generated Imagery). It's a broad mix, and an expanding one.

These people exhibit a few common traits: they produce work at a high level, have exceptional people skills, and take care of business as a businessperson. They all understand the importance of marketing. And another thing—they each recognize the only constant in their careers is change; that never changes. These interviews are in their own words.

PART III

CASE STUDIES FOR THE NEW ECONOMY

BY BARRY SCHWARTZ

NEW PRODUCTS AND SERVICES

BY BARRY SCHWARTZ

It is the rare photographer who is able to deliver only the same products from one end of their career to the other. Adding or subtracting a product usually means a change in services: image files can be delivered by FTP, but not prints. Video requires a crew instead of a single creator. Photographing a wedding may mean relearning how to use film and wet-labs.

Photographers have to know what their clients need right now— as well as the foresight to see where the market may be heading— in order to lead the way for those clients who will be grateful they got there first.

SARA ESSEX BRADLEY

saraessexbradley.com
Started career in 1998

Career Summary After fulfilling her post-BFA ambition of bartending, moved to New York City and assisted food photographers for four years. She then moved back to New Orleans and added architectural interiors as a specialty, along with travel and lifestyle. Clients are editorial and commercial.

Licensing and Copyright

The clients are now driving the bus when it comes to licensing terms, at least in my market. I have had to allow much more liberal usage for the same—and often less—money, but I am very protective of retaining copyright. Buyouts are still very pricey for me.

The year 2009 was a very down one for me—the weakened economy finally hit home. I had the opportunity to shoot for a local food magazine, but the rate was substandard. I realized that it's better to be shooting than not, and I have control of the copyrights. I have been shooting for them ever since, and I'm building a beautiful stock library to draw from in the future. The exposure has also led to other better-paying gigs.

The fact that the stock is all digital does wake me up in the middle of the night in cold sweats. Back up, back up, back up, my nervous subconscious-self is screaming.

I realize the industry is moving photographers into motion, but I haven't been compelled to do it. I still feel strongly that the best marketing plan for me is to be very very good at what I do specifically, and not try to diversify and dilute my output.

MELISSA GOLDEN

melissagolden.com
Started Career in 2006

Career Summary Majored in International Affairs and Journalism. Worked as a staff newspaper photographer for six months, then went freelance. Mostly editorial. Portraits, documentary projects, and photojournalism.

Personal Work

I try to make all of my work personal, even the assignments. I always try to shoot what the client wants, but if time allows I also shoot for myself on every assignment I have. And often that's what I end up

featuring from my assignment work, so when I say that all my work is personal work, most of it really, really is. For the most part I try to feature pictures I care about.

I pursue a lot of personal projects, things I shoot on spec or for my own artistic fulfillment, because if you're just shooting for the paycheck, I think that your work gets stale, you stop loving it, and this is such a wonderful field that to treat it as a job you have to do is just depressing.

I shoot two or three weddings in a year; it's not a huge percentage of my income, but I treat the weddings in particular as grants—the money from the weddings I use to go shoot personal projects. Other things I want to pursue in other areas of photography, I allocate wedding money to do that.

The high-end portrait has become my bread-and-butter; I'm still a photojournalist at heart, but the portrait photography certainly pays the bills. They always say, with your work, with your marketing, show what you want to shoot, and that's what I try to do.

Copyright

I want to drive home the point that, as an editorial freelancer, everybody and their mother is trying to get you to do work-for-hire and take your copyright, and it's so essential to guard against that if you hope to sustain your career for any length of time. Either that, or have a staff job, but those are few and far between.

As a freelancer, you have to own your copyright or be properly compensated for your copyright. Otherwise, you'll never make it very long.

I turned down a lot of work at first, when I switched my policy. And it hurt. But in the long term, I have really benefitted myself, and I keep making money off of pictures I've already been paid to take. Syndication is a beautiful thing.

Networking

I didn't even think of it as networking at the time, I just enjoyed
my colleagues' company so much that I sought out conferences and
events; anything where there were going to be photographers and
photojournalists. I made it a point to build that network of friends
and colleagues nationally. I travelled to meet people, just photogra-
phers at first, but some photographers became editors, over time
positions changed, and my network kept expanding. When I went
freelance, I was able to call upon that network to get me started
with some news organizations, wire services, national papers,
and I built up myself from there.

Blog

It took me a number of years to start a blog, but now I would say
my blog brings in more viewers on a monthly basis than my website.
That's where I put all my fresh work, and my thoughts and musings.
I use Twitter, Facebook, Google+, Tumblr. I use all the social media
networks to spread the word when I have a new blog post, a new
feature on my website, and I get a good number of hits off of that.
People re-tweet, they re-post, and that just spreads the word
organically. I never do any direct mail marketing.

Contests and Awards

I find that the ultimate bit of advertising for getting your name
out to the ears and minds of editors is winning contests. I consider
the entry fees as part of my marketing budget, and when I do place,
invariably I get a dozen phone calls within a short time after the
contest, usually from new clients, usually from editors saying
"I just saw your work in such-and-such contest." To me, that's the
absolute best way… but the odds are not good. It's extraordinary
what winning a contest can do for you, careerwise.

It's more of a rocket-boost, it's not a sustainable strategy unless you
can win contests every damn year. A sustainable strategy at this point
is keeping up with my blogging. I try to blog two to three days a week,
and I keep track of my analytics for my blog, and incoming traffic,

number of views, and there are noticeable spikes on the days that I blog, people coming in from all venues. My blog is really my public space, even more than my portfolio website.

Eddie Adams Workshop

It really was the start of my work as a successful freelancer, and it boosted me toward the magazine world and away from newspapers and wires, and toward magazines, where I actually got to keep my copyright.

While I was there, I won an award—it was an assignment with *Parade* magazine. A year went by, and I hadn't heard anything from them, and I kept calling and I thought they forgot about me. One day they called me up, and they were familiar with my work from the 2008 campaign trail, and they asked me if I would like to spend a day in the life of Secretary Clinton, shadowing her at the State Department from dawn till dusk. That level of exclusivity, and the pictures I got... those pictures still sell. That got me in front of some agencies when I was shopping that around looking for a place to syndicate, and that's when I met with Redux and hooked up with them. And that all originated with the Eddie Adams Workshop and that award.

When I went to meetings with editors at newspapers and magazines, I carried my laptop and an iPad to show my work, though am now transitioning to show my work exclusively with a formal printed book. I was doing pretty well getting meetings on my own, but there was a certain level of clientele that I was trying to break through to reach, and it wasn't until I hooked up with Redux Pictures, my agency where I'm a contributor, that they were able to get the meetings, the assignments at the higher-end magazines, like *GQ* and *Esquire*, that I had been wanting to meet with and work with, but couldn't get in myself.

The combination of personal marketing, low-level things, social media, and Redux, and having my name up on their website, having them Tweet, and feature me as a photographer, it's kind of that one-two punch that helps get my name out there.

LYNN GOLDSMITH

lynngoldsmith.com
Started career in 1971

Career Summary Began doing editorial work, added commercial and advertising, specializing in location and studio portraits of entertainment figures with a focus on musicians. In 1980, founded LGI Photo Agency, which she sold in 1997. Has published several books, and Goldsmith's vintage work as well as current images are in galleries and institutions.

Fine Art

My main focus is on fine art, as it is not only a source of revenue, but more pleasurable than editorial licensing or assignment work. I don't think much about adding new clients. I think more about what I want to shoot and what I want to do with my images: exhibitions, books, apps, etc.

I make more of my income from the fine art world than I do from commercial or editorial work. I've done numerous books on Rock and Roll's icons, as well as books that have nothing to do with popular culture, *Flowers*, the *Great Circus Parade*, and my latest book of self-portraits, *The Looking Glass*, is a limited edition fine art book. Different bodies of work are exhibited in different kinds of galleries. Sometimes my rock and roll images and self-portraits show together because those bodies of work are concerned with the theme of identity.

Because photography is far more accepted now in the arts, due to museums like the Getty and the Metropolitan Museum of Art starting their own collections, the desire to collect—and the prices—are higher than ten years ago. So it's possible to earn a living being an artist who uses photography as a mode of expression.

The big question in the fine art world is how do you create work that gives you a brand of being particularly unique. In many ways technology has enabled numerous artists to find their voice,

and I find more and more photographers pursuing success in the
fine art world.

Most companies, whether they're publishers of magazines or books
or advertising agencies, will be able to find talent who still give away
their services because they want to break into the business. I don't
know how to deal with that, except in the talks I give, which stress
the importance of ASMP, for not only educating newcomers about
what rights one should learn to negotiate for, but to have a community
that hopefully can stand up together and keep this industry from fall-
ing apart by educating both photographers and clients of photography
about the costs of being in business, the respect for that monetarily,
as well as the talent to get the job done well.

My own frustration with how the editorial and entertainment business
changed in terms of payments and rights has led me to new ideas
about how to be able to still create the work that I want to make, and
to be able to carry the overhead necessary to do that.

Life is a process of reinvention, no matter what field you work in.
Change is not only a part of the creative process, it is a requirement.

MARK GREEN

mgp2.com
Started career in 1983

Career Summary Green began as a music photographer and assistant
but quickly moved into annual reports and work for publications,
agencies, and client-direct, as well as producing corporate and indus-
trial libraries in energy, agriculture, and transportation. Around ten
years ago, he added video production and multimedia.

Video

Around 2002, my photo business was going fantastic. I was a very
successful annual report shooter, working on eight to ten books a
year. About that time, I first held a digital video camera in my hands.
I loved the look and feel of video cameras and saw the potential

for them to be great tools for imaging. Around that same time I experienced broadband Internet for the first time and thought when broadband access becomes the norm, still photography alone won't be enough to keep people engaged. Within a year I was starting to dabble in video, and now, ten years later, video-related assignments are fully 50 percent of my workload. I was proactive, not reactive, and it has proven to be a great move creatively as well as on a business level.

As recently as five years ago around 75 percent of my billings were from annual report photography. But in just five years that's gone down to 5 percent of my business. In other words, the entire business model that my twenty+ years career had been built around is essentially gone. Video production has picked up almost all of the slack.

We've been bundling rights usage up front for some time now. We frequently shoot for direct clients (as opposed to agencies) and the corporations need and expect to be able to use their photos quickly and without hassle. We market Extended Rights Use packages from two years up to all-rights-use for a line item cost up front. So the rights use is monetized, but up front, not as residuals with all of the attendant headaches.

We also offer bundled photo and video shoots that end up being a good deal for our clients and have helped us increase our day rates because of additional services offered—or at least buffered us against the downward pressure facing rates. We also offer some video editing in house, which is profitable.

Collaboration

Video is a much more collaborative business. Although many of our projects are smaller crews that we handle in-house, I also hire camera people, audio people, teleprompter operators, lighting people. There's a lot more moving parts to most video productions.

It's really opened my mind into collaborations on the photography side. Being involved in the video side has helped me see that you use who's best for the job. I think that's all part of the new way of looking at things that hardly anybody these days just does one

thing. To survive in this economy people have to branch out. So I think you just never say never; keep your mind open and don't be afraid to collaborate and open up your ecosystem a little bit.

Defining Products

I have clients now that really know us as a video production company more so than as a still photographer. I do both and I market both. Offering video has allowed me to market to a different budget space.

Whereas my still photography is still a super-premium product with a premium price point, the video side is what I like to call "the high end of the low end." We produce industrials and corporate videos, but we do a really nice job for a reasonable cost—reasonable by comparison to big-budget productions or network commercials, but still very profitable for a studio at our scale. And best, we've been able to market these services to many of our existing clientele, leveraging our brand equity.

I've been able to add this into my business workflow, and it has certainly been a huge help to keeping me solvent during this technical upheaval we've been going through.

CHRIS HOLLO

hollophotographics.com
Started career in 1989

Career Summary Began working as an independent photographer right out of college. In 2000, Hollo's wife, a graphic designer, joined the company, and they also produce web designs and video. Specialties are commercial, corporate, editorial, fashion, and music; Hollo has been the official photographer for the Grand Ole Opry since 2000.

Full Service

New clients would come to us asking for photography for an album package, and we would ask who they were going to get to design

the packaging, and they didn't know. We would ask if they had a logo, color ideas, a website, et cetera, and they would have nothing. We began offering complete agency-style services to accommodate clients that needed more of a package of creative services.

For instance, we had a soldier, stationed in Japan, email to say that he was about at the end of his tour and was wanting to know if we would be willing to photograph him for his self-produced, debut album packaging. He was planning on moving to Nashville to pursue his music career and had seen an image I had taken in a country music magazine. We met when he was home for the holidays and agreed to help him with his CD packaging. He was the first person who had come to us with nothing and who needed everything. He had no website, logo, printed materials, media kit or anything else. We ended up shooting his album art, designing and printing his packaging, designing posters, creating a logo, designing a website, and several other printed items that he needed. We were able to handle everything ourselves.

In the past, we were more concerned with making sure that we had every little usage accounted for on an invoice, whereas now we mainly try to make sure that we get the larger, more costly usage. Clients are likely to have a budget to work with; it just takes some doing to get that figure. I find that if they don't give me a budget, sometimes when I submit an estimate for a shoot, their response is something like "that is way over our budget, thank you anyway." I immediately call them to let them know that based on the information I had, that is the optimal way to handle that job, and that is why I asked for your budget in the first place. I can usually rework the estimate to their actual needs and will oftentimes end up with the assignment. If not, I will try to refer someone else who may be able to do the job for the budget they have available.

AMANDA KOSTER

amandakoster.com
Started career in 1993

Career Summary Koster first worked as an assistant for several years, transitioned to full-time photojournalism, documentary, commercial and advertising work, and author and speaker. She has also become a multimedia and video producer, which now dominates her work for nongovernmental organizations (NGOs) and other socially engaged nonprofits and national institutions.

Multimedia and Video

I stayed a still commercial photographer until very recently, though I had been creating video and multimedia for my personal work with international NGOs all around the world since the start of my career. Multiple forms of media add layers to the storytelling that photos alone can't. Now, in addition to my commercial photography business, I have a long-term contract as a multimedia producer with a software company, doing basically what I was doing for my personal work, which is little mini-movies about healthcare.

I'm psyched more today about my career than I ever was, because it suits my personality and the things I like to do; and to get paid for it is super. I like the content because I don't feel like I'm selling sneakers—which is what I used to do. My work is more in sync with my values, and that feels good.

New Business Model

Regarding commercial work... relationships are my economy, not dollars. Dollars are the result of healthy relationships, not the other way around.

I understand tight budgets, flowing budgets, and seemingly impossible deadlines. I know some of my clients are strapped, and to think I can earn the exact same rates for all clients is absurd. I am more interested in building trust and relationship

than hard and fast day-rates. I earn business vs. expecting it.
I really listen to the customer's desires, constraints, needs,
struggles, and goals.

The whole reason I became a photographer was to tell stories
and help people. My personal work is primarily social documentary
multimedia work. There are times I share that work for free with
some grassroots national and international nonprofits who seriously
do not have the budgets for me. For instance, I know that licensing
a few of my images means the van that rescues homeless kids
doesn't go out that day. I believe in giving back for giving's
sake, so I do.

I have received funding through other sources such as grants,
foundations, private donors, Kickstarter campaigns, advance
placement with various news outlets, and advanced print sales
to cover expenses, exhibitions, and time.

SalaamGarage

While I was doing all this international work with NGOs, a lot
of people wanted to come with me on these trips, so I founded
SalaamGarage, where we lead trips with multimedia makers, either
amateur or professional, and writers, and sometimes teachers
or farmers. We get really, really intimate access to international
NGOs and nonprofits, and we truly hear the stories of what they're
doing, which are just riveting. This kind of experience is impossible
without building relationships, which is the primary focus of
SalaamGarage. This led to my book *Can I Come With You?*
and a career as a public speaker.

I thought that empathetic storytelling would be a great match for
social media, so that exploded and now I've got a public speaking
career. To me, the moral of the story in this climate… is to let go
of the identity as a strictly still photographer. I think your career
can morph and change and grow in a lot of different directions
if you bend a little and let it.

Some of the best marketing I do are these public talks where people
meet me and they see what I'm all about and they get a sense of my

personality, and they approach me or I approach them or we have a conversation and we see opportunities. Simply put: meet people.

I realized telling a good story in a way where people are moved is a valuable asset to many different kinds of organizations. I'm not saying give away your stuff for free, but maybe that the new economy is eyeballs and relationship skills versus dollars.

Learn how to communicate and learn relationship skills, because ultimately that is your most valuable asset. That will turn into money. That will turn into clients.

ETHAN PINES

ethanpines.com
Started career in 2002

Career Summary After photography school, worked for a few years as an assistant but quickly became an editorial and advertising photographer. Portraits, conceptual, lifestyle, fine art.

Production Value

I've been putting together a higher level of production value into my testing—and even into my editorial shoots—to create more portfolio images that hopefully stand above the crowd. The only way to avoid bidding wars and the ensuing race to the bottom is to offer something that's not easily replaced by another photographer. You want the client to hire you for the way you shoot, not for your pricing. From what I'm seeing right now, clients are starting to commission more new shoots than they were over the last one or two years.

I've also worked on bringing in more revenue from stock. Clients are commissioning fewer unique shots than they used to, due to decreased marketing budgets and the cheapness and availability of microstock and royalty-free stock. I make sure to only do shoots at a high-quality level that are viable for rights-managed stock, and I've had some good stock sales.

Night Trees Project

I've always shot a ton of personal work that I felt had a fine art bent to it, but if you want to have a gallery show, you really need to have a body of work that's long-term, a cohesive body of work. The Night Trees project started very spontaneously. I was in Las Vegas for a two-day shoot. I had my 4 x 5 with me, and I didn't use it at all on this shoot, but at one point I was just driving through this neighborhood and I saw this bare tree above a house. Both things just looked like they were out of the late '60s, just weathered and vintage. No chain link fences around, no new hardware or windows or doors. No billboards around, nothing like that. It looked like it could be from any era and this tree was perfectly centered in front of the house and towering over it like a lollipop. I just loved it and it looked great at night under the lights. I loved the way it came out and felt there's something about it that speaks to me. I haven't seen it before, so I just continued this Night Trees project.

How do you separate yourself from other photographers or get some recognition? Many times it's just beautiful personal work that really resonates with people. You have to do whatever it takes to stand out a little bit above the crowd because there are so many photographers now and so many good ones. And that being said, I'm shooting this because I want to. Maybe it'll bring in some clients maybe not.

Relationships

Faced with increased competition and my own inner drive to continually improve, I've made my product—my images—more compelling and more sophisticated over time. And my marketing has changed. With the increased competition that exists now, I have to market more than ever, via more avenues than ever. It's so easy for photographers and would-be photographers to promote themselves that it's far more difficult to stand out above the din and clutter. It used to be you could have a website and a spread in Workbook and be all right. Now, there's the website, source-books, online portals, email blasts, social media, blogs, getting on to other blogs, photo competitions... the list goes on. You have to do it all.

Relationships are very important. I have good relationships with my clients. Having more personal meetings is something that is part of my marketing plan for this year. It's more about fewer clients, but having real relationships with them. I do an email blast about once every two months. I get some good responses, some people actually write back from design firms and agencies and say thanks, we really like your work. I get a few opt outs but not many. Over the last four years I've either been in *Archive* or *AtEdge* consistently. I do contests. Which can be, if you get in, really good.

The Trees were in the Communication Arts Photo Annual in 2010 and then actually last year in The International Photography Awards. Which was cool. It's nice exposure and it gives you something to send out in an email.

Personal Work

My website doesn't distinguish between... it's just portrait, lifestyle, and animal. There is a section that says Personal, but there's nothing that says the stuff in my portrait, lifestyle, and animal sections can't come from a shoot that I set up myself. I feel if it's in a section on your website, it should have a consistent feel because it's just too jarring for people to be going through and suddenly something's completely different.

The biggest thing that you can offer that distinguishes you from other photographers is your imagination, your mind. That's the tool you've got that will really take it to the next level. Equipment is great. It's fun and it's exciting, but the most important things at the shoot are you and the subject. The people in front of the camera.

IAN SHIVE

ianshive.com, tandemstock.com
Started career in 2001

Career Summary Shive began assisting at age eight when he developed black and white film for his father, a professional photographer. In 2009, he cofounded a stock agency, Tandem

Stills + Motion. An environmental and conservation photographer, his clients are editorial, advertising, and nonprofits, and he has published a book and an iPad app.

I am the founder and operator of an agency that represents 300 other people in a similar genre of nature and conservation, but also travel, culture, geography.

Everything's built in the cloud on an Amazon S3 server using unique software that we built. Our competitors have twenty-six employees, we have three, because our software does all our heavy lifting, and we actually consider ourselves almost a software company first and a photography company second. We're using advanced SEO technology, Google Adwords, Facebook Adwords. We've reached 750,000 people a month in impressions.

National Parks Book

A book will transform a career. That for me was the turning point, as far as really entering a new phase of my career. I would literally send weekly updates on the press I'm doing, the press I'm getting. Now, it's got evergreen status. Because it has consistently performed, it has distribution. And, I'll continue to promote, but I don't need to do the breakneck tour of the country and two-week promotions of it that I was doing.

I promoted for six months. I had a very long, sustained campaign. I did three book signings a week, two to three talks a week. I was doing one a day at one point. I was doing morning shows, radio programs, you name it. Sometimes you go out and there's three people there. Sometimes you go out and there's 300.

Social Media and Publishing

The next big thing that's happening is licensing for the iPad... that's becoming a very big part of our daily negotiations, and that's a sure sign that things are starting to change. I do think iPad rates are going to continue to go up.

What's happening with publishing and doing books, it's very hard for publishers, because you look at your royalty on a book, it might only be, let's just say, two bucks on a book, and you might be able to get four bucks on an iPad app. The iPad tends to yield a little bit more juice out of it because not only can you buy the book online, you don't have to wait for it to be shipped. You can buy the book and it just downloads. I mean, that changes everything.

The number of sales I got from Facebook far exceeded any retail outlet, and the difference was, because somebody reads an article about you and sees a gallery of your photographs and in the heat of the moment of, "Man, I love this work and I love this story," and the PR is doing what it's supposed to do, and they read something about you, they can click a button and place an order, and you collect the funds.

Video Licensing

There are a few different ways a video gets licensed. Typically somebody will license multiple clips at a time, whereas a lot of people only license one photo at a time. They'll license five or six video clips because they're actually producing a piece and a piece is usually multiple clips. So, motion clips tend to be a little bit lower-priced. We basically do everything on a "use" basis. Every time the clip is used, it's being paid a rate, and that use is based on what use it's going to. So, we have three different prices. We have web, electronic, and at that price, we have commercial web and advertising, and then we have TV broadcast, theatrical. And, we'll base the prices on that, based on the use, and it's always unique.

MARKETING AND SALES FOCUS

BY BARRY SCHWARTZ

Marketing is sales. No matter how it's done, the goal remains the same: Here's Me and My Work, Now Hire Me. Then: Hire Me Again.

The most effective form of sales comes out of personal relationships, even though many photographers work for clients they never meet in person. There are endless new paths to reach—and retain—clients, and endless strategies mixing the new and old, electronic and paper. Everything that happens in a business relationship is marketing, intentional or not, and the process can be as creative as the work produced by any photographer.

TERI CAMPBELL

terishootsfood.com
Started career in 1987

Career Summary After the Ohio Institute of Photography, worked as a contract photographer at Procter & Gamble for four years, then opened Teri Studios. Since the late 1990s has shot primarily food.

Photograph © Julie Fowells

Great

My staff includes a producer, a digital artist, and an assistant, but I'm the only photographer. For that reason, I feel like everything that comes out of here has my name on it, and I want it to be great. That means I have to turn down a lot of jobs when the client is asking me to scale back. So I would rather turn it down—or do it but not be able to charge for it.

If a client pays less, it usually means they got a deal, not that they got less. If a client doesn't have the budget for a food stylist, but I really want to do the job, even though it means making less money, I will hire the food stylist at my expense because I want to do it right.

My prices haven't increased in years, but I have become more specific about the number of shots that are included in our estimate. As your skills increase and you work faster, you find yourself being penalized because even though you have done the required amount of images, the client sees it's only 3 o'clock and wants to shoot more. If you are charging based on the number of shots and the client wants more, then you can charge an additional fee for it.

I don't have a rep, unless you count Wonderful Machine. I advertise in *Workbook* and have a website. We actively post updates on LinkedIn and are becoming more active on Facebook.

Fruitcake Contest

Our big promotion every year is the Fruitcake Photography Contest. We send our clients a fruitcake and we ask them to photograph it. The original concept was based on the fact that many clients were buying digital cameras and doing more projects in-house. We thought, "you think this is so easy? Try photographing food, try photographing a fruitcake, make that look good." Next thing we know, our clients began creating these really cool and creative images. It's become the kind of contest that people look forward to each year. It entices people to interact with the food, interact with the photography and realize, "wow, this is kind of difficult, I have a better appreciation for food photographers now."

For our most recent competition, we included a Facebook People's Choice Award, so that everyone could vote for their favorite fruitcake image. Of course, you had to "like" our site in order to vote. This promotion helped to quadruple our "fan" base.

Because the entry deadline is January 31, and since most clients get the custom-printed box with our logo on it in mid-December, most of them have it sitting on their desk for six weeks—with our name right in front of them that entire time. Every couple of weeks, they are getting an email blast saying, "hey, two weeks left to enter... ." It just keeps on giving, because there's so many aspects of this promotion that keep our name in front of our clients—or potential clients—for weeks.

JAMES CAVANAUGH

cavphoto.com
Started career in 1975

Career Summary Graduated from New England School of Photography, specializes in architectural, aerial, and location photography. Clients are architecture and engineering firms, interior designers, corporations, contractors, and developers.

Digital

What we lost in providing prints or duplicate transparencies was more than made up by charging $60 per file postproduction, plus billing $125 an hour for more serious retouching.

I tell clients when you hire me for a day or two or three days to photograph a project, that license covers any of those images; I'm creating a library for you. If you only need the files now for your immediate needs, it doesn't mean you can't come back next week, six months, or six years from now and get the other ones. And they say what about the rights? I say I want you to use these pictures as much as you can, everywhere, so you get a lot more business so you can hire me more often.

Social Media

Every day on Facebook I post an architectural photograph, and for the last two months, one of my photos I took in China. People tell me at meetings, "I really look forward to seeing what you post every day."

So it is building my street cred. People think I'm insanely prolific because they see fifteen different pictures a week plus my e-newsletter.

One of the things about LinkedIn is when you're linked in with somebody, you can go to their profile and look at who they are linked to. I'll go to an architect who links in with me and look at their profile, and let's say they have 87 connections. I literally go through all 87, and I will invite maybe a couple dozen to link in with me.

Now when somebody links in with me, they immediately get a package from me. I call them mini portfolios, and they have five 6 x 9 prints in it and a little cover note, and the cover note says, "Thanks for joining my network on LinkedIn, and I've also added you to my email list. Once a month I'll send you my newsletter. If you don't want to receive it you can opt out right on the newsletter page. But I hope you'll continue to get it to see the great projects I'm working on with other people here on the LinkedIn community." In the last year I've sent out 800 of those mini portfolios.

I've been sending out the e-newsletters for close to eighteen months. I've only had 20 people opt-out. Typically I get 300 to 325 people that open the emails, and about 130 that click through to the web gallery. The click through rate on an industry average is between .5 percent to 1 percent. My click through rate is 21.4 percent.

I've tried to be the easiest possible guy to work with. The thing about architectural photography that is a bit unique is that a significant portion of our income comes from relicensing the images to the other parties that are involved. If the architect doesn't hire me to shoot that project, I've got nothing to sell to anybody else.

I ramped up my phone calls, my personal presentations, research. In January through April of 2011, I went on more sales presentations face-to-face than I had done in three or four years. I got a lot of

requests for work and I sent my estimates out and I lost literally every single job. I lost $40,000 worth of work in the first four months of 2011. And I'm like what the hell is going on? The meeting went well, they tell me they love my work, they love the portfolio, they want to work with me, they sent me proposals, and I lost every one.

So I picked about a half dozen of them, called them up, and said I really need to talk to you. They go, yeah, your work is really, really wonderful but we just can't work with you because you raised your prices so much. And I'm like, okay, that is interesting; I haven't raised my prices since January of 2009.

What had happened in the marketplace is everybody else competing against me dropped their prices way down. So I had become more expensive in relationship without raising my prices.

I sent out a letter and said that my clients had made clear to me that their budgets are stretched with the current economy, and I said we want to find ways to make it easier to work with you. I said what I've done is drop my fee for aerial photo work 20 percent, and I've included a new estimate for you to replace the old estimate I'd sent you previously. I sent those out Monday morning. By Wednesday, all seven had booked the jobs.

It wasn't the rights, it wasn't anything else, it was the money. That was it. As soon as I brought my prices down 20 percent—on the fees, not expenses or anything else—just the base fee, I put myself back in the market. My sales for 2011 increased by 85 percent over 2010, even with the poor first four months. Sales for 2012 for the first quarter are up 300 percent.

CLARK DEVER

clarkdever.com
Started career in 2009

Career Summary Dever opened his studio in 2009 as a photographer working in editorial and commercial markets, and quickly branched out into consulting on web strategy and doing video production. Specialties are documentary, portraits, and events.

Digital

I think that one of the real paradigm shifts with digital has been the amount of educational materials available from really great writers through blogs and video content. So you can get a tremendous education in lighting and posing and composition and all the elements of photography through the web for free.

It used to be this very elite type of experience where you either went to art school or maybe you went and assisted for a while and learned that way. I'm an avid reader of all these different photography blogs, *Strobist* and *Chase Jarvis* and *Fstoppers* and *A Photo Editor* and I've learned so many things. I mean there is just a ton of podcasts on iTunes. I think it's harder to learn the business than it is to learn photography at this point.

Social Media Marketing

My number one goal is to get you to follow me on Twitter, add my page on Facebook, or subscribe to my RSS feed. Because I know in the long run if I'm diligent and I keep producing content, I will convert you because you'll start to identify with me, identify with the brand, and then hopefully when the need arises you'll call me for your purchasing decision.

Twelve Hours in a City

In 2009 JetBlue had a promotion where for $599 you could fly for thirty days. One of my friends messaged me and said you should do this and you could blog about it. We started hatching out ideas and I quit my job the next day, bought a ticket, and we started filming from there. Within forty-eight hours of making the decision I put up a blog (twelvehoursinacity.com), and we had some initial branding set up.

We were on Twitter talking about it, and Twitter at that time had just reached critical mass where it became like the news media thing of the day. A *Time Magazine* reporter saw it and called us. We had all sorts of contact information on our page, we had a copy of our press release there, and we put it out over PRNewsire.com.

The next day CNN called... they'd also seen us on Twitter. The day that the promotion started we ran as the travel section lead on CNN.com. So those two initial hits are what generated the traditional news media; like 90 percent of it. If you hit a publication that's that large you get this kind of avalanche effect, where other publications who track them also want to do the same story and put their spin on it. Whenever we were in a big publication I would do ten interviews the next day. I would wake up and from the time I woke till about noon, I would just be doing interviews with all these different news media.

We ran our own PR. Basically there were four guys on the trip and anytime we knew we were flying into a city someone would send the press release. They'd do the research, figure out what news organizations were there. We'd send them the press release saying hey we're gonna be in your city tomorrow. Here is all our pre-existing coverage, and a lot of times they'd meet us at the airport and we'd do a spot there.

It's just really planning; being aware of the marketing aspect of it was almost as important as the content. I mean without the content the marketing would have been worthless, but without

the marketing and the PR effort and the thought that went into the branding, we wouldn't of had anywhere near successful a project.

Even if they didn't understand what Twitter was, by that point everyone who had blogs was able to point directly to twelvehoursinacity.com. We listed all of our media appearances, they would read our blog post, and they'd see the quality of the imagery. It was about the story in real time. It came back to that timeliness, right? I knew that every day at 7 AM on the East Coast people were gonna start hitting our website. I'd better have that blog post refined and edited and posted because we were gonna be the water cooler chat that day at work, and that's how we're gonna spread the message.

You don't get what you don't ask for. A lot of times the reason we were able to do these really cool things was because we were constantly going to our fan base and saying, you know, we'll deliver you this product for free, how can we make a better product? Let us know.

ANDREW ECCLES

andreweccles.com
Started career in 1987

Career Summary Became a full-time photographer after assisting for five years for, among others, Annie Leibovitz, Steven Meisel, and Robert Mapplethorpe. He is primarily a still photographer, though sometimes a commercial director, and works for editorial, advertising, entertainment, and nonprofit clients.

Labors of Love

I've been very fortunate in that I've had some long-term relationships with commercial clients, but there are things that are so close to my heart, where I need to feel like I'm photographing subject matter that I like and love, and that's the Alvin Ailey American Dance Theater. That's been a labor of love. I get paid when I shoot them, but I also

didn't get paid for a book I shot celebrating their fiftieth anniversary, and got to do whatever I wanted with unlimited access to the company, and I spent half a year doing that.

Marketing

The irony is that some of the things that I've being forced to do now are some of the things that I did at the very beginning all over again. I put together a brand new portfolio and took it to a client two days ago. I wore something decent, and I went up and met with the two people who are responsible for hiring photographers because I really want to work for them, and I'm going to be doing a lot of that this year, 2012. I mean I have a ton of jobs on the calendar right now. I'm swamped with work. That is all great. I'm knocking on wood as I'm saying this, but I need new, exciting creative editorial.

I think we all thought we could get away with email blasts. A website is a tool that no photographer can live without at this point; being able to quickly put together PDF portfolios to send to people, tablet-friendly ways to get images to folks quickly. I think what's happened in the new economy where there's clients with less money, there are more photographers in a saturated market, we're having to go back to some of the traditional ways that you get work and that's, first of all, face-time, pounding the pavement, meeting with people, creating fresh, new, and relevant work—personal work—coming up with some sort of a project. Anything you can do that helps convince your potential client that you are an artist is extremely important.

I'm going to personally have a real throwback year, this year. I'm going to try every couple of weeks to take a portfolio to somebody that I want to work with again. I think the only way to truly compete in this environment right now is to go back to all the basic stuff. Really it's providing clients with new, fresh work that they haven't seen. Let them know that you are still eager, you're still excited, that you're not jaded, you're not bored, you're not overpriced, just make yourself available.

CHASE JARVIS

chasejarvis.com
Started career in 1996

Career Summary Areas are portraits, sports, lifestyle, and fine art.
Began his career with advertising work, and clients now include
editorial and direct-to-client, including working as a commercial and
music video director. He is a speaker and has published three books.

Vision

The crazier personal projects I do, the crazier jobs I get. I mean,
I created the world's first book of mobile phone pictures. They're
shot with a two megapixel camera that didn't have a focus, didn't
have an exposure. And that little book was all over the place. It
was in the museums, it was in all the Apple stores. People saw that
and they didn't say, "Come shoot our campaign with an iPhone."
But they said, "Wow, you have an interesting vision. Can you
bring that sort of real life vision to our project?"

Business Models

Technology, depending on how you look at it, either helps or hurts
the profession. We're a hyphen; for someone who is a purist from
a pragmatic or a methodological standpoint, that causes a lot of
problems. I consider myself a purist from the artistic perspective,
in that I like to make things. But that's really where the purity
is sort of boxed up. I enjoy the opportunity to be a photographer,
to be a director, to have a voice in a landscape where we used
to have no voice.

Now I have, basically, a media outlet that's larger than a lot of the
companies that hire me, given my following. And that is another
component part of being an artist these days. It's not required, but
it's there for you if it's something you think will help you, your work,
your message as a creator.

To me it's a tremendous opportunity, it's a tremendous challenge, it's something I think is ultimately helping and driving us into a direction of continued democratization of the creative powers we have within us, and I think it's for the better.

I realize this is a controversial viewpoint. It has rarely been favorable or held in esteem from my peers. I was vilified ten years ago for saying this, and the irony is that now the same people who were vilifying me are calling me if I can help them.

For me the evolution is there's depth where there used to be flatness. And that's threatening because some people don't really want to be deeper than the transaction that is between photo buyer and photo seller or licenser. And when there is depth and transparency and you are required to do things more than transact around an image, it's more work. I don't blame people for being upset or feeling threatened or all those things, but that is really a constant. What industry in the world stands still for its scared population? None; no industry does.

To be paddling upstream when you're in a flood is sort of antithetical to the understanding of the best way to try and move yourself forward out of a particular quagmire. Sometimes doing nothing is more dangerous than doing the wrong thing, you know. It's not necessarily error avoidance that we're trying, it's error recovery.

I try and make a lot of small mistakes as opposed to big mistakes, and that has very much to do with putting it out there every day. If you only put it out there once a year, a new body of work, and you've blown it, then you get no feedback, you're really putting all your eggs in one basket. I prefer to shoot and run and shoot and run, and then you're course-correcting and finding not only how the market responds—because the market is only one component—the first and most important component is I have to like what I'm doing, I have to be motivated.

Social Media

We've got more tools at our fingertips now than ever before. Most of the tools are free or cheap. From a technological standpoint, integrating all of the things that I do is reasonably easy. It's hundreds or thousands of dollars, not tens of thousands or hundreds of thousands.

What's more interesting is the conceptual aspect of it. What's the purpose behind it, what's the higher purpose, and where is it all going? So from that standpoint, photography is and always has been about the image, and how we think about the image is really what's changed and evolved over time.

Content

There's a balanced breadth of content, and it was built on the premise of sharing and being transparent, and that's really where I built my following, and part of the platform is how can we share rather than hoard?

The fundamentals in face-to-face human interaction, and the fundamentals of what it's like in a media-savvy landscape are the same. You want to entertain, you want to provide value, that's literally how I think about it. Whether it's entertainment, whether it's education, whether it's information or largely curation.

What I've tried to do is just paint a picture of what you see is what you get; there's not a lot of bullshit here, I'm a straight shooter, I'm a hard worker, and yeah there's a lot of disruption. I'm trying to break this model over here, I'm trying to change this thing over here, and I'm either going to do this or I'm going to die trying. And I don't need to appeal to everybody. In fact, as soon as I start trying to appeal to everybody, I end up appealing to nobody. And if I get hired by twenty people a year, I've had a banner year.

SPENSER LOWELL

spenserlowell.com
Started career in 2007 (post-photography school)

Career Summary Began taking pictures professionally while in high school, and after working in photo labs, enrolled in photography school, then moved into editorial, commercial, and advertising, specializing in architecture, science, and portraits.

Reaching Out

I have always taken the approach of reaching out to people the way that I would want to be reached out to. I wouldn't want to waste someone else's time with sending them work that isn't applicable to them. I believe in doing the research and looking for people that I could actually see myself working for, and just creating something that is more personalized, something that says something about me, and something the person who's receiving it might enjoy.

It takes a lot more time. I'm not reaching as many people, but in my experience, it's been very effective. I've always sent a printed piece. When I first came out of school, I had 80 contacts so making 80 of those was no big deal. Now I have maybe 300 people, 400 people that I'll send promos out to.

Once I send out printed promos, I'll follow up with an email. I usually will send out promos when I'm planning a trip to that particular city, so if I'm going to New York, I'll send all my New York contacts promos. I'll follow up with an email that has a link to my website on it. The goal is for them to see as much work as possible; the promo has ten pictures, the website has a hundred pictures, and then I'll call them or schedule an appointment. At that point, I actually exist to them. We exist to each other.

I remember when I first got out of school, it was so intimidating. It's like the photo editor is like a celebrity and now it's like we're coworkers, we're friends, we're people who mutually respect each other.

I've created friendships with a lot of the people that I work with, and it's a result of trying to make things as personal as possible, and I don't think email promos are personal enough, at least for me.

A far as social media is concerned, as much as I'm saying about making the marketing personal, I don't like to share my personal life necessarily with people I don't know. So I don't Facebook. I don't Twitter. I don't do any of that.

Just on a statistical level, my percentages of who I market to, and then who I work for, are much higher than they would be, I believe, than if I were just throwing shit at the wall.

GAIL MOONEY

kellymooney.com
Started career in 1977

Career Summary After photography school, worked as an assistant, and after becoming a full-time photographer focused on travel, advertising, and documentary work. Clients are editorial, advertising, nonprofits, institutions, and corporate-direct. Began producing motion (stock footage shot on 35mm film) thirteen years ago, and along with stills, produces videos, multi-media, and recently released a full-length documentary.

Video

I embraced video early on, for a number of reasons. Technology made it possible and affordable for me to tell stories utilizing this medium without the need of a large crew and a Hollywood budget. Technology has created new markets hungry for motion content. Ask any publisher what type of content they are looking for in this new economy to populate their websites, their apps, their iPad, and other mobile-related editions.

Distribution and Copyright

I am able to create my own ePubs, printed books, and films and distribute them myself through numerous portals. This allows me to keep control of my copyright and enables me to license my own work—directly.

Kickstarter and Crowdfunding

Kickstarter isn't for the fainthearted. You've got to be willing to do the work to be backed financially. With Kickstarter, if you don't make the monetary goal that you set, in the number of days that you have also set, you won't get any of the pledges made. You have to be prepared to work it—maintaining a balance between promoting it too much and annoying people or not promoting enough and thus not meeting your goal. You want to make people want to become a part what you are doing.

You really need to think differently than you do when promoting yourself for commissioned work. The crowdfunding mindset is all about finding your community. Aside from getting the funds needed to make your project happen, you are also organically building a following. This becomes your target audience for when you complete your book or your film or whatever it is you are asking support for. If you work it right, this becomes your audience or market for future projects.

Opening Our Eyes Documentary

I exceeded my goal with Kickstarter. My timing was right. I heard about Kickstarter right after I had returned from a ninety-nine-day journey around the world with 150 hours of footage and 5000 photographs. I know how to edit, but I also knew that I needed help, and that bringing a professional editor onboard would raise the bar on the film.

After the movie was complete, I did another fundraising campaign on IndieGoGo. I ended up not making my goal this time around, but with IndieGoGo you don't need to meet your goal—you get whatever

is pledged. I did, however, make one huge connection by deciding to go with IndieGoGo that has proven to be financially beneficial. IndieGoGo has a partnership with the San Francisco Film Society. I applied, and was approved for fiscal sponsorship by the SFFS. This means that I can continue to accept donations that will now be tax-deductible for the donor by contributing through the SFFS and their 501c3status. It's helping a lot of filmmakers out.

Social Media

You can't talk about crowdfunding without talking about social media. Facebook, Twitter, YouTube, Vimeo, blogs, et cetera are all platforms to promote yourself, your work, your projects—whatever. Keep in mind, though, one rule of thumb: your posts should be 20 percent about you and what you are promoting, and 80 percent sharing other information that is valuable to your peers. Some say it should be no more than 10 percent about you. Everyone seems to break that rule, including myself. But social media is all about sharing, and if you are perceived as someone who has valuable information to share, people will be more apt to take notice of what you are promoting about yourself.

VANIE POYEY

poyeyphotos.com
Started career in 2000

Career Summary Based in Los Angeles, Poyey specializes in headshots, both in-studio and on location. Professional clients are actors and corporate portraits.

Control

My business went up because I was able to fully control the presentation, the proof sheets, the web gallery, or the PDF proof sheets. It wasn't until I took control of postprocessing and doing all my own color balancing and retouching and all of that, that

my business shot up. Because that's the product people look at. When they look at that and think, "Oh wow, this looks great," they're going to keep coming back, or refer people, or people who see it are going to be attracted to it, versus the lab's mediocre work.

What I do for actors, because a lot of them don't understand how to resize a file for upload, we resize all the files for them, for the five directories that they use, which all require different sizes. There's no standardized sizing. It has really gotten rid of the whole "come to the photographer for help on that." And then if people still want us to resize a high-res file, we charge for that.

New Business Models

After losing a lot of corporate jobs for the reason that I charged too much, I decided to create a "package" structure with three different price points for corporate clients to choose from. From what I learned at ASMP's SB3 conference, each price point took something away as it got cheaper. This immediately had me booking more. Rather than losing out to the under-cutters, I was able to give my clients a package that suits their budget without the guesswork involved. Most clients won't volunteer their budget even when asked.

Social Media

I use social media daily to continue branding my company, though I still spend the same amount of money on traditional advertising. I don't think I have seen a considerable difference in the way that I get my clients. There's still a very traditional base of referrals coming from agents, from the usual advertising venues that actors go to. Ranking on Google helps. But the Google people are the bottom feeders usually, so you book maybe two out of ten calls from Google. You don't have the credibility of a referral or a trusted source.

We have a Facebook page. And Facebook has made it easy to tweet and post, only on a professional page, not on a personal one. But it's actually linked to Twitter. So we post and tweet at the same time. We're going to link every single client to the post so that it shows up on their wall. The post they're in shows up on their wall and it gets tweeted at the same time.

When people come in here the day of their shoot, what happens is it says, "So-and-so checked in at Vanie Poyey Photography" on their wall. So they're advertising for me and they're getting something in return. They get a free high-res file for instance.

Every now and then I'll actually get a client from Twitter or from Yelp. I have a million fans on Facebook but I don't really see people saying, "Oh I found you on Facebook." But just like any other form of advertising, the idea is to get your brand name out, right? So when people know your name and somebody mentions it, they're more than likely to come to you versus someone whose name they've never seen. So that's really why I do it.

SAVERIO TRUGLIA

saveriotruglia.com, saveriotruglia.blogspot.com
Started career in 1997

Career Summary After graduating from photography school, moved into editorial, and then commercial work and advertising in 2004.

Branding

We do retouching now—we never did retouching before—I make a little bit of money on that. I now do some corporate-type jobs with my own spin. I've done a lot of corporate work in this last year and it has actually all been fun. I always try to keep my brand on top of whatever I do.

Sometimes I am able to sell myself as an art director for my own retouching projects. I will say to a client, "I am including my time to help direct this, or I will do retouching." I make it a point to get a cut of some of the retouching, because I have to be on top of it. I have surrounded myself with people that are better at retouching than me and I have learned from them.

Bidding

There are times in the life of a self-employed person where you start saying, "You know what? I am going to change the way that I am doing my business." Bidding used to take me two days to put a bid together, and then I would do all the sketches and try to solve the problem, and I would even show the client how I would solve the problem.

I would put in the bid and then I'd wait, and I'd wait, and then I'd hear nothing. I'd ask my rep, "Have you heard anything?" You know, it's just a lot of anxiety. It may be the product of getting older, but lately I bid, and I forget, and I just move on, because there's nothing I can do after I bid on a job to make it so that I get it. That has probably been the biggest lightbulb.

It hasn't turned into lots of money for me, but it has changed the amount of anxiety that I have around me. There is enough anxiety around getting a job that you know you only have a 30 percent chance of getting. I try to just relax a bit and step back from it, and not worry so much about the ultimate success all the time, because staring at the ball does not ensure that you are going to hit it out of the park all the time.

Blogging

That's something where a lot of our personal voice can come through in the writing.

That's something really new to photography. I like to write, I like to read, I like to communicate through words, so the blog was a natural fit for me. The stories I tell on my blog are different than the story somebody else tells on their blog. I think one of the bigger changes, which never really gets talked about, is how a visual artist needs to be a good writer and craft a message.

Are you, in your blog, an irreverent person, or are you always showing process behind what you do, or do you share your inspiration you're getting from other places? That becomes part of your brand, and I think you have to be conscious of it and also true to yourself.

On my blog, I tend to talk about projects that I do. I might show some behind-the-scenes, I might show a little video, I might talk about who was there and why I enjoyed it. So my brand is positivity on my blog. I never slam anybody. I never talk down to anybody. That's the last thing that photographers or artists or people in competitive businesses like ours ever want to come off as being. I also tell about what I do that I don't make money on. I talk a lot about editorial work and the things that I do for my passion and my love.

Facebook is a complement to my blog, in that if somebody really wants to know what's going on in my life, they can go to my Facebook account and they might read that my cat died last week. From that, they know I'm an animal lover. It paints a bigger picture if somebody really wants to know. Honestly, I get a lot of traffic to my blog through Facebook, because when I post to my blog, I'll link to Facebook and almost all of my blog traffic comes from Facebook. A number of my Facebook friends are former clients.

I'll use Google analytics and it can be up, it can be down. It's useful to know when people have posted about me. If I see a spike on my blog or on my website, I'll go and see where that spike came from. Apparently it's well-read if it's spiked my website, so I'll get in touch with them and thank them, create a little relationship with them, and sometimes it leads on to other editorial stories.

Do the thing that motivates you. Don't compare yourself to other people, that's death. Once you've done that, the person that you're comparing yourself to has already moved on to something else. Never try to repeat somebody else, and that's the biggest challenge, because we all fall into that. It's not a natural human thing to do, to innovate all the time.

NEW BUSINESS/ PHOTOGRAPHER IDENTITY

BY BARRY SCHWARTZ

One of the most important tasks clients have to accomplish is gauging how a photographer's persona connects with their work. Photographers worry about the same thing, but with a twist: what is it about themselves that connects to the persona and needs of the client? The goal is to produce work that satisfies everyone, and it's inherently a sloppy business, potentially fraught.

For some, there is a certain amount of theatre involved: a performance. Others strive for genuine, honest behavior. Usually, it's a mixture of the two. In the end, everyone wants this: what you see is what you got.

TIMOTHY ARCHIBALD

timothyarchibald.com
Started career in 1996

Career Summary After college, where he got an art degree, was a staff newspaper photographer. After going out on his own, clients are editorial, advertising, and nonprofits. Portraits, documentary, lifestyle, and fine art.

Personal Projects

I always have a personal project that I'm working on. In 2005 I had a book called *Sex Machines: Photographs and Interviews*, a documentary project about this suburban sexual subculture. That was the first thing I did that really seemed to get a lot of attention. For obvious reasons, it opened doors and closed doors simultaneously.

Many of the photographs had these penises in them. You know, fake penises, but still...

It was something that gained me this artistic cred and spoke to certain creative directors, and a lot of the doors that are open now, couldn't have been opened if I didn't do that project. It just made people think of me differently. I always felt like I needed to do something with my skills that was more than just doing assignments. I felt that I wanted to show the world what I could do; what my brain could do. It did establish me as someone who has certain ambitions and a certain way of thinking, another way of storytelling.

I think it led people to think of me as a thinking person's photographer. Then in 2010, my son and I did a project together, Echolilia, and that eclipsed *Sex Machine*. I mean, that got more attention that anything.

You get attention for the stuff that you are passionate about, and for better or worse, my personal projects are the things that have opened the doors for me. Unfortunately they're not utterly commercial, so they may have closed doors as well. But you have to use what you're best at.

Letting Go

When I first started there was a magazine that hired me a lot. There was some little thing I was doing for them and suddenly they thought I was too big for that. So they wouldn't give me these little things. And I was like, oh wait a minute, no, I can do the little things and the big things...

Then I realized, well, this freelancing thing, it's about this flux and this redefinition of yourself. There's times when you need to let things

go, you need to take on new things. It's a natural thing. It is like Darwinism or something like that. I feel like these cycles have always been present.

I'm more like an optimist, and I don't know if that has always served me well. But it allows me to put one foot in front of the other.

Social Media

The social media stuff has been very rewarding to me. It's probably made 30 percent of an economic difference. It isn't like massive jobs have come from that, but in general I think the blog and Facebook has allowed creatives to get a feel for my sensibility, my personality, and my value system.

When you look at a website, you're just looking at work. And you might get a feeling for someone's aesthetics, but you don't feel their personality as much. Over the past couple of years I can definitely point to people who have acknowledged me on Facebook and got the feeling that I was A: nice, B: passionate about photography, C: workable and generous.

Some people can demonstrate or create a persona through social media better than others. I have friends who are great to work with but they hate the whole social media thing of being behind the computer. And so they aren't being able to create a persona, a reflective persona in the written word.

I wanted to create a persona. I was able to, via the phone, before the Internet: "You're going to want to work with me, I'm nice and I'm cool and I want to work with you, too." It was easier to do when the economy was strong. But I never wanted to put myself in that position of "please hire me." I wanted it to be the other way round.

When the social media thing came up I was able to use that to my advantage. I wanted to create a persona of someone who loves photography, likes to be busy, and was generous and loved other people's work too. It wasn't just about me. It was other work I loved, you know. And that's served me well.

ELIZABETH CARMEL

elizabethcarmel.com
Started career in 2000

Career Summary Landscape, environmental, and conservation. After
a few years opened a gallery with her husband, also a photographer.
Has self-published two books.

Workshops

I've partnered with Mountain Light Gallery—Galen Rowell's gallery—
I like working with them, they do a good job with the logistics. You
can make a good income for four days worth of work, and it's really
enjoyable, meeting people who are into landscape photography, and
it's always educational for me as an instructor. You can see how
people see a space differently, and you learn a lot from your clients.
I've had people who have nicer equipment than I do at these things,
and show me some of the latest gadgets that I haven't bought.
It's essentially a two-way street.

We had a little bit of savings, and we decided to invest it in a
downtown commercial property in downtown Truckee, and now we're
doing the same thing in another little downtown in the wine country.

I do 95 percent retail and 5 percent professional buyers. Primarily,
I sell prints for the home decor market, and it's a very hands-on
business. It requires people coming in the gallery, and it requires
a whole sales progression with people; it's not as easy as waiting
for people to order your prints online, because I don't think
that happens.

A very small percentage of what I do is photography, it's mostly
managing a business, managing a retail storefront. I'm primarily
a retail business owner, and I've got to make sure I carve out
time to make my photography production happen. I do all my
own printing, with my own large-format printer, and have a lot
of direct client contact. I don't sell a whole lot of prints
through the Internet.

Social Media

The most important for me has been the Facebook page for our gallery, because that's the one that actually connects with customers. All my other social media connects with other photographers, who are interested in what I do, and maybe trying to duplicate some of what I do, maybe are interested in some of my workshops. The people who check it out that are good for me are corporate sponsors; it keeps me on their radar.

Books

Those have been a really good way to make people aware of my work, and also to get an important message out; I feel strongly about the need for landscape photographers to educate the public about threats to the natural world, and my last book was about climate change impacts in the Sierra, and I worked with a couple of wonderful scientists who helped me with the text.

Self-publishing has been great. They're coffee-table books, they're art books. I have a distributor, that's the most critical part of it. It's very difficult for self-publishers to get a distributor for their books. Amazon sells them and all the big bookstores and a lot of independent bookstores. Once you have a distributor you can get anywhere.

I always encourage people who want to do what I do to start in their local neighborhood, their local communities. Most people go to the big, iconic national park locations, and people need to focus on what's beautiful in their communities, and develop their own client-base wherever they live.

GRACE CHON

gracechon.com
Started career in 2008

Career Summary Transitioned out of an award-winning career as an advertising agency art director after photographing pets after-hours. Her work includes advertising, editorial, corporate-direct, TV shows, individuals, and nonprofits.

Dogs

I just have this crazy connection with dogs that I can't really explain in words, and I think it comes through in the images, which I'm so grateful for.

I thought "Hey, I should take pictures of these homeless dogs and help them get adopted and hopefully people see the images, and they come to meet the dogs and then adopt them." Being an art director and coming from advertising, I know how strong visuals hook people and get them interested. Carol Pearson is the name of the founder of this group called "The Dawg Squad" and she was shocked: "All of the photos of the dogs you take, people are so interested. We get emails. People are coming from San Diego. They were so interested."

This was in late 2007. By February '08, I decided, "Hey, why don't I put together a little website and see if I can do this as a little weekend hobby." And so I started my retail business called Shine Pet Photos and it just exploded. Advertising is already a very stressful job where you're working a lot of hours; but nights and weekends now, I started working as a pet photographer. I was booked two months in advance because I could only work on weekends. It got to the point where I had to make a decision; I can't keep working at this pace.

So I decided to quit my job. It was at the very beginning of the recession in '08 in the fall. I had just launched a TV campaign that was so well received. My partner and I had just received raises and people thought I was nuts. They were like, "You realize everyone is losing their jobs right now. The economy is going to shit and

you're going to quit your job after you just launched a TV campaign and got a raise? Are you kidding?!" But I did it because I'll never know unless I try. If I'm turning down opportunities in photography because I have a day job, I have to know what happens if I don't have that day job anymore. So I quit my job and I've been doing this full time ever since. That's my story.

In advertising, I learned how to build brands, how to build awareness, how to build companies, how to build brand perception; all of these things that I did for national, multimillion dollar clients, I had to do for my own business now. I had to do for myself. And when I did it for myself, it was so much more fun that doing it for a car company!

I am utilizing email promos quite a bit, in tandem with sending our print promotions. But my entire promo schedule is based around clicks and leads from my email promos. I also haven't had to send out any print books at all! Everyone is viewing my work purely online and they're OK with that.

JENNA CLOSE

p2photography.net
Started career in 2007

Career Summary After photography school, Close worked as an assistant and did editorial work after an earlier career as a professional actress. Her areas are lifestyle, corporate, aerial, and portraits. After partnering up with Jon Held, a major focus became industrial photography, with a particular specialty on large-scale alternative energy. Their work is editorial, advertising, and client-direct.

Remote Aerial

A few years ago we realized that all these solar panels we were shooting would look a lot more dramatic from 200 feet off the ground. We incorporated a remotely controlled helicopter into our business. It took a year of our time and a decent financial investment, but our clients love it. They also love the spectacle of being part of something unique. If they use us for a shoot, they often tell their colleagues or shoot

a video of the helicopter with their phone to show their friends. This helps with word of mouth. What I find interesting is that our clients didn't even know they wanted low-altitude aerial shots until we intro-duced it to them. Now, it makes up a huge part of our business.

Our main response to the "new economy" was to specialize. Having such a targeted market (alternative energy) really helped us carve a name for ourselves without much in the way of competition. The main thing we will all have to keep dealing with is progress... I know my clients have been asking more frequently if we shoot video. As technology keeps racing onward, we will have to pick and choose which outlets work best for us and learn to use them. I think the constant evolution of our industry will continue for quite awhile.

Trade Shows

One of our most successful marketing models involves going to a trade show every year. Since we specialize in alternative energy, we rent a booth at a trade show catering to that industry. While this does take up a fair amount of our yearly marketing budget, it also allows us to meet current and prospective clients face-to-face. We are the only photography company at this trade show, and people are generally surprised to see us there. We hang our pictures up and... it is like a huge portfolio review for us. People who don't know us come up and we can point out fifteen different booths that have our images all around the show.

To go there and be forced to do something that was out of our comfort range... eventually it was comfortable and I did not think that was going to happen. You stand in the booth for four days and you say the same thing fifteen billion times. Now it's gotten to the point where I actually enjoy talking to the people who come up; it took a couple of years, but practice really makes perfect for that kind of thing.

After every trade show we add new contacts to our list, and then remind them of our presence through more traditional marketing techniques, such as mailers and emailers. I think this is particularly effective because the recipients of the mailers have already seen our work and met us in person.

ROBERT DURELL

robertdurellphoto.com
Started career in 1985

Career Summary Worked as an assistant while also a staff photographer at a small weekly paper, and after twenty years on staff for the *Los Angeles Times*, became a freelancer. Clients are corporate, political, and editorial.

Employee to Entrepreneur

The biggest skill by far that I got from journalism… everybody is a cold call, you have to walk up to strangers, introduce yourself and immediately be on the same wavelength they are. That's the skill that a lot of young photographers do not have. They come at it from being an artist and don't know how to talk to people. It's constant, the number of clients that keep calling me back and say, "oh my goodness, you know how to dress for the situation, you can come up to the CEO and talk to him, other photographers can't do that, they are just kind of tongue-tied or have nothing to talk about." They know composition, they know beautiful pictures, but when you need to interact with strangers, the best training is being a journalist, being a photojournalist.

The other thing about a photojournalist is you're adaptable. You previsualize, you think about an assignment, you go in, but you can look around and you don't have to have blinders on, you can use what's there. You can be creative. A lot of people can't; they have to come in with their lights and their certain way of doing things, they can't think on their feet. In photojournalism you learn to think on your feet quickly.

The hardest thing, that I still fight everyday, is coming up with a rate schedule—a creative fee—and making sure that I do not lose money. That's a constant battle; you go from an employee with a salary to an entrepreneur businessman and it's extremely difficult to do. When I started out I was undercharging—I was way undercharging. But I have a rate structure that I can live with and

I would rather see stuff go out the door before I work for half of what that rate structure is.

BETSY HANSEN

betsyhansen.com
Started career in 2004

Career Summary After graduating with a photography degree, there were few assisting jobs available where she lived, so she started freelancing with editorial portraits and added fashion and beauty. Clients are editorial and advertising.

Doing Something More

Four or five years into photographing numerous doctors in white lab coats, I had an unbelievable urge to do something more creative with my business. Growing up as a female meant that I always had access to glamorous magazines with beautiful models and beautiful clothes. It was, and still is, a craft I much admire, especially in some of the markets overseas. I began photographing fashion, strictly as personal work. I only promoted the work as personal, but after a short time the work was strong enough that I was picking up new clients from it. Even new portrait clients would book me because they enjoyed how strong my studio lighting techniques were in the images. I've established my portfolio now where I am promoting a fashion body of work, and a beauty body of work, in addition to my portraiture. My beauty work currently is my strong point.

One of the things I offer my clients, which I get rave reviews for, is retouching. I come across so many clients who, because of budgets and cutbacks, do not have a person in-house for this or are lacking the time because they have so many other things on their plate. Even one of my biggest clients, Walmart, leaves the retouching in my hands. Retouching is huge, and the creatives I work with all seem to know and understand how much retouching can improve an image. It just puts it on the next level. It's also easier for them to receive

the image as a final product, ready to be dropped in somewhere. Budget isn't usually a problem for this, either, because it's worked in as an expense, not part of the photography fee.

Online

I believe strongly that in order to compete with the droves of photographers out there that you have to stay current. Not so far as photography trends or styles, but within your business itself. Your website has to be current, user friendly, SEO optimized, and the quality of your work must be top-notch. I am a big advocate for shooting personal work in addition to everything else. My personal work is what has propelled my business to where it is today. It keeps my mind fresh, my creativity flowing, and it puts new work that I am passionate about in my portfolio. A photographer should never stop trying to improve themselves or their work. If you stop, you'll end up behind.

Approximately six months ago I spent a bit of time researching the ever-changing world of SEO. I implemented multiple things from that research into my website, and miraculously ended up at the number two spot for "Orlando Fashion Photographers" after a few months. The number one and number three spots both were taken by local wedding photographers, which by default put me at number two. My daily unique site hits went from approximately five per day to thirty per day, and my workload has more than doubled. It's definitely worth it to stay current!

WALT JONES

waltjones.com (personal), *rhythm.com (employee)*
Started career in 2001

Career Summary Was on the lighting crew for a Kiss tour at age sixteen, has a degree in computer science, but feels it's a secondary skill in his present job. Does fine art and architectural photography, is a supervisor at Rhythm & Hues Studios doing CGI, and was on the team that won an Oscar for their work on *The Golden Compass*.

Architecture

The architecture work is on both sides of the fence. I've done a fair amount of architectural rendering which is mostly about previsualization; it's creating images of things that don't actually exist yet. The flip side of that is I've also done architectural photography where it's about documenting that building after it's been created, though it's important to note there's not a lot of crossover between those two worlds yet.

CGI: Computer-Generated Imagery

The kind of business I was doing back in the late 1990s and early 2000s is very different from what I'm doing now. With the proliferation of cheaper hardware, better software, and, in general, more public knowledge of the capabilities of these tools, I now have to compete with a kid living in his parent's basement who's downloaded cracked software for free off the Internet. As such, I've tried to shift my focus away from the toolset and sell people more on the design aspect of the work.

What makes me unique to clients is the vision I bring to the table, not what hardware or software I'm using. That can be a hard sell at first, but once you get people hooked on the idea that you're amazing to work with and will find a unique way to visually communicate their message, they tend to keep coming back. Oh yeah... and my pricing still has to be in line with the rest of the market, whatever that may be.

Photographer to CGI Producer

The photographer—the former photographer shall we say— becomes the producer, the creative director, what have you. At that point, they're basically manipulating the imagery to create what they're after in very much the same way they would have done it with a more traditional process. It's just that the tools happen to be different.

CGI can't exist without photography, straight and simple. The reality is that any CG image has more photography in it than you could

probably imagine, in the sense that there are photographs being used in the actual final image.

The fundamentals haven't really changed. I've had to continually court new clients, leverage those I have already, and constantly sanity-check my price points. Mostly things boil down to big-picture items like creative fees, shooting fees, and so on. Approaching things this way often requires reeducating clients, particularly those used to granular invoices, as to why I do things this way.

Collaboration

For our industry in particular—dealing with postproduction visual effects, creating images mostly in the computer—it really is about the process and it's very much collaboration. On my crew right now, I've got 31 people that I'm directly responsible for. My responsibilities mostly involve giving them artistic and technical direction, as well as overseeing the overall vision of the project and ensuring things are consistent across our work. We have close to 400 people working on the current project.

You may look at this and say, "Okay, what the hell does this have to do with someone being hired as a photographer?" It's not necessarily the same kind of collaboration, but at the end of the day, it's something where you are being hired to work with the client.

It needs to be a collaborative, creative process, regardless of whether you're working with 2 people or if you're working with 100 people.

Creator

I've worked hard to get people to see me as simply a creator of images, not as a photographer or a CGI-producer. In the end, I'm going to use whatever tools are appropriate to the task at hand, so I try not to pigeonhole myself.

It's about the experience of working with people, and obviously the product that you get at the end of the day is important as well. The image is sort of the culmination, the proof that they had a good time through all of this experience, as opposed to the image standing literally on its own.

My experience overall is that if you sell people on connecting emotions and a clear understanding of abstract ideas, they care far less about what the actual price tag is, provided it's ballparked within their budget. In the past few years, I've been hired by several people who literally said they hadn't spent money on this kind of stuff in years, but they felt like I got things in a way that no one else did. Hard to put a price tag on that.

MARK KATZMAN

markkatzman.com
Started career in 1985

Career Summary After assisting for two years, shot editorial for another two years, then added corporate for the next fifteen years; now, primarily advertising and some motion.

Licensing

Buyers don't know where they're going to use the pictures. So they can't necessarily tell you what specific rights they're going to need; as a result they're asking for more blanket rights. We still limit a period of time and we try to negotiate a fair usage that works for them.

Website

These days it's as much about personality as anything. "You've seen my work, you know what I can do. Now, do you want to hang out with me?"

I think the site is the most important marketing tool. It's not only an opportunity to show your work, but also much more. For example, you are fun to work with and professional and reliable. Do you want it hip and cool, or do you want to be the easy-going guy, or do you want to be the fun guy? Who do you want to be? You've got be appealing in addition to whatever else you're serving up, and it's all really important. It's a very deliberate strategy.

The strategy behind my site is based on feedback from art buyers, keeping my ear to the industry, and also watching my competitors and seeing what they're doing. Feedback from actual clients— how they use my pictures in presentations—is also a factor. "This has to be, first and foremost, fast. Second, easy to navigate. Third, I like the photography. Fourth, deep."

I had a partner for twenty-five years and we marketed ourselves as the name of the company. When we broke up, I started marketing under my own name, which was easier to associate with my personal vision. Every year has been good but when it really got good was when I was marketing my name with my work, instead of our company's name. It strengthened that long-held theory that you have to have a brand. You have to have an identifiable personal vision.

I will go to my grave in this industry claiming that personal vision is the most important thing to success. If you can tap into your personal vision, present it, and it's marketable, I think chances are you will get work. And it will then feed on itself and you will have a business.

CLAUDIA KUNIN

claudiakunin.com
Started career in 1976

Career Summary Began as an editorial photographer, added advertising, fashion, stock, portraits, then weddings, always doing fine-art "on the side." In 2004, she began to work exclusively as a fine artist, focusing on 3D and recently, animations. Her work is in galleries, museums, and institutions.

Ghost Stories

I was doing a series called The Holy Ghost Stories, which were symbols of western civilization: mythology and saints and sinners. I felt very accomplished when I was doing that series, because they looked like paintings. A curator that I respect said to me, "I don't know about these holy ghosts, Claudia. Who is your audience anyway? Mid-westerners?" I was so hurt. I felt like she was calling

me the Thomas Kinkade of art photographers and I just—I was reeling. I really felt like I'd been slapped in the face.

It took me a little while to get a grip, and then I called her back and I said, "Well what are you trying to tell me, really?" and she said, "Don't you think it might be more worthwhile for you to explore what your own personal symbols are?" I thought it was really good criticism. It was very hard to take at the time. Then I just said, "I don't care what people think. Here I have these photographs of me growing up, and I'm going to do something with them, and I don't care who looks at it; it's just for me. What do I care what people think?" That ended up being the series that's gotten the most attention from curators, because I've gone to some portfolio reviews and I would take the Family Ghosts, and ironically enough, when I stopped trying to be great and started just doing something that was personally satisfying, then I seemed to hit a cord that resonated with everybody.

I'd always wanted to do animation and I didn't know how. I guess it would have been 2010, I just decided I don't care how hard it was, I was going to go for it. So I spent the next year making animations. My passion has to be great enough to overcome the obstacles— and there are lots of obstacles. It's not for wimps. Man, oh man.

Planning for the Future

The Smithsonian National Museum of American History had contacted me because they were doing a survey of their 3D collection and they realized they had no contemporary artists working in 3D. So they reached out to me and asked if I would donate a few pieces to them. Hello?! You think I'd say no? I didn't say no; I said yes. They said, "You choose two from each series." So I sent them two images from all four series that I had done up to that point.

I wrote a letter. I said, "I'm considering end of life issues. I'm looking for a home for my archive. I'm considering an institution such as yourself and I don't know how to go about it, and I don't know what your policy is. So let me know your thoughts." They sent me back a sample letter of how you make a donation to the Smithsonian of your archive. I wasn't sure if they were saying,

"this is a sample letter of how you would do it to any institution"
or if they were saying they wanted my archive. It wasn't clear.

Well I was kind of in a hyped-up state of disbelief and so after two
weeks, I screwed up my courage and I made a list of things and I said,
"Would you want my journals? Would you want my father's pictures
of us growing up? Do you want my source material? Do you want my
negatives? Do you want my..." listing everything that would be part
of my archive. And they wrote back and said, "We want it all!"

So the first place I asked—I can't believe it! It's the National
Museum of American History, their photography collection. Hello?!
I don't have to worry about dying now; I can die and know where
it's going. Because I never had children. I made photographs;
that was my choice.

I've had a lot of failure in pursuit of developing new ways of seeing
things. I've had a lot of failure that way, difficulty overcoming obsta-
cles with my ideas and how to accomplish them, but I've not had
obstacles in the way of getting a gallery or even getting into museums.
Of course, my goal is to get into the Getty before I die. They have
a few of my little handmade books and that's it, but I can say I'm
in the collection, you know? I'm in the collection. But the important
thing is that I'm still striving. I still have a hunger.

ED MCDONALD

edmcdonald.com
Started career in 1989

Career Summary Worked as a full-time assistant for several
years, then as a freelance assistant before becoming a full-time
photographer. Areas are corporate direct, advertising, event,
editorial, and portraits.

Events

I had a client who approached me about shooting something that
was outside the realm of what I did as a photographer; I said "no"

because my basic premise was I did annual reports, I did corporate identity pieces, I did advertising, but I didn't do PR and events.

So even though this was a client of mine for years—and a very good client... they finally called me and said, "Listen, you have to help us. This first event is going to happen in two weeks and we have no one for it and we desperately need you." It turned out this event I thought was going to be a yearly event turned out to be monthly event.

That was kind of a little ah-hah moment, but I still didn't see the beauty of it or the virtue of it. It turned out to be in the $2,500 range for the studio, and it just became a comfortable income.

In 2009 this client came to me and said their budgets had been cut and that if I wanted to continue to do this job, that I would need to completely fund this and self-monetize. This was about the time the bottom was dropping out of the economy. I had already noticed that I had a 40 percent decrease in sales... mostly due to the fact that my annual reports had just basically ceased to exist in 2008, due to the crash of the market.

I partnered up with Pictage, a lab out of California where the images would be put up and sold via the web. We went from $1,500 and grew to $2,500 in the first month of self-monetizing... and that was with me barely getting my act together on it. Within the first six months, I tripled the numbers and every month since then has been at least double and several months have tripled... and now it's a job that, in present day, has sustained this studio.

When I monetized it, I said it had to become very structured, very regimented. It had to be high quality. The product had to be something that people were willing to pay for. Otherwise I didn't think it was going to work. And that's exactly what happened.

Secondary Licensing from Editorial

Once we've cleared the threshold of first rights of publication for a magazine, we email the subject with the link to the online gallery, and in almost every editorial assignment that I've done since then, we have gotten orders from the actual subjects for reprint licensing.

It opened the discussion for usage in their website or a brochure. So this actually brought in new income that I probably would not have seen otherwise.

Approaches

I have maintained my personal page on Facebook since almost day one as a business page. Even though my personal site on Facebook has a lot about me personally, I don't divulge any more on that site than I would tell a client in a face-to-face meeting.

I think that all things being equal on quality, style, and price, what is that thing that separates me from my competitors? I have been told many times by my clients that it's the fact they enjoy working with me, that we get along, that I have a good personality, that I'm easy to talk to. I think that's the thing that social media brings to the table. It's a soft sell. It's a way for your clients to be able to see who you are over a long period of time and be able to tell that you have a family life and what kind of person you are.

Reinvention

For years I had a vision in my own mind of who I was, and the kind of work I did, and what I would and wouldn't do, and I think that was limiting me in what possibilities were out there.

We have to understand that there's a business side to what we do, and I think that sometimes when you say "no" to one thing, you limit yourself to so much more. So I think that really the point of my story is that the new economy is in multiple streams, not just one.

I keep reinventing myself, and that's why I've had some success; because I understood early that times change constantly, and if we didn't do that ourselves—particularly this creative business that we're in—you were not around long, and you were left behind pretty quickly. So I've always been reinventing and looking for new things to do, and been an early adopter of all that is new in our industry, like it or not, because time waits for no man.

MATTHEW MILLMAN

matthewmillman.com
Started career in 1997

Career Summary After assisting for several years, Millman began
working full time as an architectural photographer, in addition
to producing long-term personal documentary projects outside the
area of architecture. Clients are architects, interior designers,
books and editorial.

Digital Business

The level of complexity from film to digital seems to translate to
business environments. It's more fluid and you have to be agile and
more creative on the business side, and you have to be ever more
expressive and articulate in being able to explain and interact with
clients to create a really successful working environment.

Marketing

Word of mouth is still quite good for me. I presently don't utilize
social media, social networking, Facebook and Twitter and so forth
because they haven't represented themselves to me as valuable
tools for me to reach the really specific clientele I'm trying to reach.
It's actually a fairly narrow bandwidth of architects and designers
that I would be enthusiastic to work with. It's probably better for
me to identify them and reach out to them, or hope they reach
out to me directly.

I'm fortunate enough to have gotten to the point where I end up
declining a good bit of work, and I can only imagine that if I really
engaged social media to a greater extent, what I would be doing is
increasing that bandwidth of work I'm declining anyway right now,
instead of reaching the people I really want to reach.

Competition with Clients

Architecture design students are using Photoshop not so much with photography in mind, but as part of their rendering services they learn in school. They develop some level of competency, and then you put a camera in their hands, and the shots come out looking decent, you know, they're not bad.

To have somebody in the firm that has some level of photographic competency is of great value to a firm. On the other hand, your work will most likely be significantly better than anything a firm can produce themselves. You have to draw a distinction between their photographs and yours, and really highlight the value of excellent representation. I think that architects can understand this, because they have to make these sort of creative pitches to their clients. You know, why am I worth it? Why would you hire me as an architect over that guy?

You have to be able to articulate that top-level architectural photography is really its own thing and it's an additive experience to a project. For most firms these projects, they're going to be seen almost exclusively through photography. So it's extremely important that you present it in an impactful way and you wouldn't want to leave that representation in the hands of a skilled amateur; that it's really best served when they profoundly and creatively connect with a photographer who they think represents their work in a really strong way.

Tools of Representation

When designers and architects bemoan the changes in the editorial and publishing world, I say to them, what you have to do is publish your own work, in one way or another. You have to embody some of that editorial mechanism yourself. Previously, you had this nicely set up experience where you had a curator present your work in the editorial world in the form of these stories, and along with that came all this credibility and this value that got added on to your project.

Even if that is as simple as your own website or something like a Facebook page, people now have really profound ways to

self-publishing their own book. Tools of representation are now much more in their grasp than they used to be before.

YVETTE ROMAN

yrphoto.com
Career started in 1992

Career Summary After graduating from Art Center College of Design and working as a studio manager for Gary McGuire, then as a free-lance producer, Roman transitioned from a successful career doing advertising and editorial work, primarily in the world of music, to weddings in 1997, though she still does some commercial work.

Quality

I only carry the highest end products, and yes, they are very pricey. I have always been of the mind that money spent on quality is never ever wasted, and that has carried me through the whole way. People want a tremendous value for their dollars spent. Selling a substandard product that is posing as an heirloom which is supposed to last for generations—but doesn't—is just money thrown away.

Usage

If the photos are used for profit, I license them. However, being published is a huge part of my business, and is a major reason I have come this far. Editorial is *everything*, and in the wedding world, "real wedding" content submitted to magazines and published is usually not paid for by the magazines or by blogs; of course, all my work is credited and linked, and that is great. But anyone who hijacks my work and uses it without permission, all I have to say is... beware the wrath.

Promotion, Vendors, Referrals

I always make sure that my vendors get images for their portfolios. Most of my business comes from referrals, and if you treat your referrers well—and be nice to them, be friends with them, for

God's sake—they will keep sending you work. I always shoot with them in mind as well as my clients themselves, because, in the end, they are also my client.

I use social media a bit, but I am more old-school, and my business has always prospered from being slightly "under the radar" instead of in everyone's face every second. I appreciate all of the forms of advertising out there, from Facebook to Twitter, to Pinterest—but I don't use Pinterest. Really, it can take your time and energy away from the most important thing... your *work*. I am an avid believer in the power of a beautiful print, and it is how I want my work to be seen.

In years past, I spent a *lot* of time living without the cash to do fancy advertising and promotions, so I made everything by hand. I still do those kinds of promos all the time, even as recently as last week. It is very, very tempting to put all my eggs into cyber-marketing—it is everywhere, and it makes you question if you shouldn't play along with the crowd. But to me, the thing that resonates the most is to be as against the crowd as I possibly can, even if that crowd is made up of the top photographers in the nation. I mean, who really needs to read another tweet or to get another mass email?

I'd rather concentrate my promotional dollars, and my time and effort, making something with my hands that is truly my own. I target just a few people at a time, even though I have the most extensive mailing list you ever saw. I'll pick maybe twenty companies a year to go for, make something truly exceptional, and send it via snail mail in a lovely box. Yes, it is a huge load of work and is crazy-time-consuming! True. But...it is truly personal...I want people to feel special, and I want to make my time spent to be special as well. As much as I love my Mac, any time spent *not* in front of the computer these days is a total gift. I am an artist, and I love making things.

There are certain jobs that come up that I'll cut my fee for because I know it's going to be something special that I can parlay into something else. For instance, I know a wedding is going to be amazing, and I know it'll get published, and I know I can make it go and go and go. I know that it'll be the book next year. There's something to be said for that, but you just have to be smart about it.

NICK VEDROS

vedros.com
Started career in 1977

Career Summary Vedros's degree is in photojournalism (1976) but he very quickly transitioned to commercial work, almost entirely advertising, client direct, some editorial and motion.

Digital

As soon as I saw my client base was accepting digital, I started to sell my big studio because I wasn't going to need six spaces any longer. It was going to be important for me to downsize to a smaller, more efficient studio that's all digital.

Everything is smoother now. We upload completed projects via FTP sites and don't have to charge sales tax when delivered electronically. My belief is that we're in an ever-changing universe of photography and it's not going to stand still; it's always going to be morphing into something else.

Motion

It stands to reason now that there is more and more motion now than there was ten to fifteen years ago. And so it's opened up some opportunities for photographers of course.

I love being a DP where I'll be in charge of the lighting, the look, and what focal length, where to shoot from.

Licensing

Sometimes they ask for motion in the same day but we price that out as a separate shoot. You don't just pull out the motion cameras and use them on the same set. It doesn't really work that way because strobe is still different from hot lights.

Value

If a project is not right for me I see if my associate photographer wants to shoot it. We are at two different rate structures and if a client is price conscious they may want to shoot with him— he is quite good. When I bid a job I emphasize value, not price. Things are still going strong after thirty-four years.

We deliver great imagery and are a premium brand. I try to stay in the upper realm where they don't nickel and dime a project to death.

Some clients hire me now to do what is called a library shoot. They want a bunch of images shot of a two-day period and I hand them off a hard drive of images when complete. My pricing has remained strong; we are worth every penny.

Personal Work

I've always done the personal work because that's really the driving force behind my assignment work; it's not the other way around. I have to do personal work to feed the assignments. It's really what has steered my career as well, because I'll run a lot of those images and people will go, "Oh man, Nick. You get all the great assignments," and I'm like, "No, you've got to create your own assignments."

I don't really do any social media. My market is usually larger advertising agencies or very sophisticated buyers of photography. I really don't load up assignment work and try to make that into a marketing tool. That's just not me.

You need to differentiate yourself from everybody else; you need to create something that is unique so that you stand out and you're considered the expert in that one arena. For instance, I've taken humor and tried to hone that skill over the course of three decades. I take my humor very seriously and it's something that people brand me for nationally.

Everybody in the marketplace wants your attention and the best way to inform people is usually to entertain them and so humor is a great instrument for that.

DAN WINTERS

danwintersphoto.com
Started career in 1985

Career Summary After college, worked at a daily newspaper for two years, then assisted Chris Callis for a year and went on his own, shooting stills, videos, and commercials. Areas are editorial and advertising, illustrations, constructions, portraiture, photojournalism, science.

Books and Passion

I'm working with University of Texas Press. I have a five-to-seven book deal with them right now, and I've got two books coming out this year, and Dave Hamrick, the director of the UT Press, is just obsessed with photography, and he's producing some insanely high-end photo books. It's great having someone that's so passionate and in your court and wants a really long-term relationship, and that's a rare, rare, rare thing in publishing.

Voice

The thing that is changing the way the photography world functions is less a product of technology and more a product of the massive amounts of people that are attempting to enter the field and are willing to work for nothing. And I think that because money is of concern to magazines and advertising, both... the thing about an advertising campaign, 90 percent of advertising, there's a thousand people that can do the job. They can pick anybody to do it, so if I give a bid that I would have been able to give even ten years ago on a job, they would laugh at it and say, why? There's fifty million people that can do this job.

What I do when I shoot for magazines is I don't give options. Even if I missed the mark, still, at that point in my life, that's the picture. If I shoot a portrait for someone and there are two that I like, they get those two. They never see contacts. They never see anything.

How many pictures do you need? We need three. We need an opener. We need a turn page and we need another one. Okay, so maybe I'll give you five, or maybe I'll give you three, or maybe I'll give you one for a cover, one picture. That was really, really hard to do when I started. And I say, well you said you only needed one picture and this was my favorite one, so here it is.

The voice of the photographer is in the edit. I'm not going to turn my film over to someone. So once again that comes back to the way that someone works, not the technology.

Why does anybody's image resonate the way they do? Because they have a vision. They have a sensibility. Because they have a command of their craft. Not only of their craft, but also of their consciousness about what they're doing, and that has nothing to do with exposure or focus. So, yeah, more people can take pictures. It's your whole sensibility. It's the way you—it's your makeup. You know, you're hired for your opinion.

AFTERWORD

BY SUSAN CARR

You did not arrive at these final thoughts unless you love the medium of photography period, end of story. A personal satisfaction in using still or motion imagery to visually communicate facts, emotion, or both must be a large part of who you are as a person.

It is that drive that leads you to this ASMP book and it's industry contributors. Both are dedicated to the business side of what you do as an independent artist. Both want you to find your unique business direction and run with it toward a successful conclusion. We have covered our recent past as an industry, discussed the myriad of opportunities now available to us, drawn a careful path to developing success and highlighted tools for dealing with continual change. This combined with your artistic talents is what you need to take those first steps in this changed business landscape.

Here you are at the end of this book, but at the beginning or revitalization of your career. Seize inspiration where you find it, constantly push yourself toward excellence in your area of expertise, and build a product or service buyers need and want. Celebrate your success. And, in ASMP's grandest tradition, share your wisdom with those coming up the hill. Photographers helping photographers.

NOTES

1 Seth Godin, *Free Prize Inside*, © 2004, published by Portfolio, a member of Penguin Group (USA) Inc.

2 Godin, *Free Prize Inside*, p. 5

3 Chris Anderson, *The Long Tail*, © 2006, Hyperion, New York, New York

4 Stephanie Clifford, *The New York Times*, March 29, 2010, "For Photographers, the Image of a Shrinking Path"

5 Charles Abel, *Professional Photography For Profit*, © 1946, Greenberg, New York

6 Getty Images and Flickr,™ a division of Yahoo, press release, July 8, 2008

7 Chris Anderson, *Free, The Future of a Radical Price*, © 2009, Hyperion, New York, New York

8 Godin, *Meatball Sundae*, © 2007, The Penguin Group, New York, New York.

9 Judy Herrmann, ASMP *Strictly Business* blog, © 2009

10 "Remembering Who We Are," last modified July 9, 2009, http://societymatters.org/2009/07/05/remembering-who-we-are/

11 Marshall McLuhan and Lewis H. Lapham, *Understanding Media: The Extensions of Man*, 1967, Penguin, New York, p. 63.

12 Clay Shirky, *Cognitive Surplus: Creativity and Generosity in a Connected Age*, New York, The Penguin Press HC, pp. 54–55

13 "Steady growth for Flickr as it reaches 6 billion photos," last modified August 18, 2011, http://www.kullin.net/2011/08/flickr-reaches-6-billion-photos/

14 The Latest Crazy Instagram Stats: 150 Million Photos, 15 Per Second, 80% Filtered, last modified August 9, 2011, http://techcrunch.com/2011/08/03/instagram-150-million/

15 The State of the News Media 2011— Overview, published March 14, 2011, http://stateofthemedia.org/2011/overview-2/

16 iPad 2 tablet launched by Apple's Steve Jobs, last modified March 2, 2011, http://www.bbc.co.uk/news/technology-12620077

17 The State of the News Media 2011, Survey: Mobile News & Paying Online, published March 14, 2011, http://stateofthemedia.org/2011/mobile-survey/

18 John Hagel III, John Seely Brown, and Lang Davison, *The Power of Pull: How Small Moves, Smartly Made, Can Set Big Things in Motion*, 2010, Basic Books, New York, pp. 21–22

19 Henry Jenkins, *Convergence Culture: Where Old and New Media Collide*, 2006, NYU Press, New York and London, p. 140

20 Jenkins, *Convergence Culture: Where Old and New Media Collide*, p. 18

21 Jenkins, *Convergence Culture: Where Old and New Media Collide*, p. 14

22 "Key Global Telecom Indicators for the World Telecommunication Service Sector," last modified November 16, 2011, http://www.itu.int/ITU-D/ict/statistics/at_glance/KeyTelecom.html

23 "Internet Users in the World," last modified December 31, 2011, http://www.internetworldstats.com/stats.htm

24 Geoffrey Moore, *Crossing the Chasm: Marketing and Selling High-Tech Products to Mainstream Customers*, 2002, Harper Collins, New York

25 Panel Discussion ASMP Copyright Symposium, http://asmp.org/articles/copyright-symposium-panel-discussion.html

26 Xerox Corporate History, http://www.xerox.com/about-xerox/history-timeline/enus.html

27 Sony Corporate History, http://www.sony.net/SonyInfo/CorporateInfo/History/sony history-d.html#sl-6300

28 Sony Corp. Of America v. Universal City Studio, Inc., http://scholar.google.com/scholar_case?case=5876335373788447272&hl=en&as_sdt=2,39

29 Title 17 of the United States Copyright Act, http://www.copyright.gov/title17/92chap1.html#106

30 The American Society of Media Photographers (ASMP) History 1951, Paragraph 13, http://asmp.org/articles/history-asmp.html

31 Google Ad Sense, http://www.google.com/intl/en/ads/publisher/#subid=ww-en-et-adsense-pubsollink

32 YouTube Partner Program, http://www.youtube.com/creators/partner-program-policies.html

33 UPI, "YouTube buys RightsFlow" December 10, 2011, http://www.upi.com/Business_News/2011/12/10/YouTube-buys-RightsFlow/UPI-86381323535948/

34 U.S. Copyright Act, Public Domain, http://www.copyright.gov/circs/circ03.pdf

35 Digital Millennium Copyright Act (DMCA), http://www.copyright.gov/title17/92chap5.html

36 Jay Kinghorn, ASMP SB3 *Strictly Business*, The Agile Photographer seminar, January 2011, Agile Photographer Manifesto, p. 10

37 The PLUS Coalition Plus Glossary, http://www.useplus.com/useplus/glossary.asp

38 U.S. Copyright Works Made for Hire, http://www.copyright.gov/circs/circ09.pdf

39 Lawrence Lessig, *Remix: Making Art and Commerce Thrive in the Hybrid Economy*, 2008, Penguin, New York, p. 244

40 *U.S. Small Business Administration Advocacy Small Business Statistics and Research*, "FAQ's: Frequently Asked Questions," accessed February 15, 2012, http://web.sba.gov/faqs/faqIndexAll.cfm?areaid=24.

41 Nick Bilton, *New York Times Bits Blog*, "Study Shows People Ignore Generic Photos Online," November 2, 2010, accessed February 19, 2012, http://bits.blogs.nytimes.com/2010/11/02study-shows-people-ignore-generic-photos-online/

42 Dave Itzkoff, *New York Times Arts Beat Blog*, "Online Sales for Louis C.K. Special Cross $1 Million Mark," December 22, 2011, accessed February 19, 2012, http://artsbeat.blogs.nytimes.com/2011/12/22/online-sales-of-louis-c-k-special-cross-1-million-mark/

43 Ze Frank, "jon benet,"™ The Show with Ze Frank, August 29, 2006, http://www.zefrank.com/theshow/archives/2006/08/082906.html

44 Anne Lamott, *Bird by Bird: Some Instructions on Writing and Life*, 1995, Random House/Anchor Books edition, New York, pp. 21–27

45 Colleen Wainwright, communicatrix, "You, amplified" (a poem about marketing), http://www.communicatrix.com/2009/08/you-amplified/

46 Wikipedia, "Diffusion of Innovations," last modified March 1, 2012 http://en.wikipedia.org/wiki/Diffusion_of_innovations

47 Michael Collins, Marc André Kamel and Kristine Miller, Bain Brief, "Growing Beyond Your Core in Retail," March 28, 2006, http://www.bain.com/publications/articles/growing-beyond-your-core-in-retail.aspx

48 Joe Weikert (General Manager & Publisher, O'Reilly Media), interview by Chris Kenneally, The Future of Art & Commerce, ASMP Video Library, "Examining Compensation Models for Visual Content," January 8, 2012, http://asmp.org/articles/future-art-commerce-compensation-models.html.

INDEX

innovation, 113, 191–192
 platform development, 32–33, 43–45
telephone skills, 178–181
television, 17, 44
testimonials, 184
TextExpander, 158
Time-Warner, 14
touch screens, 44–45
trade shows, 252
Truglia, Saverio, 240–242
Twelve Hours in a City, 229–230
Twitter, 162–163, 229

U

unique product marketing, 10, 11, 16
Universal City Studio, Sony Corp.
 of America v., 54–55
universal license, 70–71
User eXperience (UX), 146
user interface (UI), 146

V

Values Analysis, 84–85
Values List, 87–93
Vedros, Nick, 268–269
video
 amateur, 21
 defined, xv
 licensing issues, 221
 producer, xv
 WMFH contracts, 73
Video Cassette Recorders (VCRs), 54–55
Virgin America, 135
visual communication
 broadcasting via digital media, 20–22
 and collaboration,
 24–25, 27–28, 212–213, 257
 and marketing, 22–23, 116
 new media landscape in, 14–15
 prevalence of, 19–20
 prevalence of, via technology, 114–115
 providing content to new media, 26–28
 timeliness in delivering to consumers,
 21–22
visual identity, 131–132, 145–146
 see also brand identity

W

Wainwright, Colleen, xxi, 131–148, 151–168
Walmart, 37
websites
 750words.com, 145
 building, 146–147
 goal-setting and, 99, 102, 126

landing page, 141, 159
 as marketing tool, 258–259
 SCORE.org, 82
 and social media, 154–155
 and testimonials, 184
 www.asmp.org/herrmann6, 103
Weikert, Joe, 199
Weisberg, Jackie, 204
Wiegold, David, 130
winner-take-all economics, 37–39
Winters, Dan, 270–271
Work Made For Hire (WMFH) clause
 and copyright law, 57, 72–74, 207
 increase in, 66–67
 misuse of, 74
Working Business Plan
 adjustment phase, 127
 assessment phase of, 107–119
 and audiences, 115–116
 and competitors, 122, 124
 creation phase of, 121–126
 drafting, 123–126
 financial aspect, 121, 122–123, 126
 five steps to develop a, 105
 focus areas of, 121–126
 geographical boundaries, 122, 124
 implementation of, 127
 marketing, 122, 125–126
 opportunities, 118–119
 the PEST analysis, 107–116, 191.
 see also PEST analysis
 planning, and resistance to, 106–107
 and prospective clients, 122, 124–125
 research phase of, 119–120
 strengths, 117–118
 the SWOT analysis, 116–119, 191
 threats, 119
 weaknesses, 118
writing skills, 144–145, 241

Y

Yahoo! Inc., 8, 19, 38
YouTube, 44, 60
Yuskoff, Claudia, 165

Z

Zuckerberg, Mark, 19

Books from Allworth Press

Allworth Press is an imprint of Skyhorse Publishing, Inc. Selected titles are listed below

The Art and Business of Photography
by Susan Carr (6 x 9, 224 pages, paperback, $24.95)

ASMP Professional Business Practices in Photography, Seventh Edition
by American Society of Media Photographers (6 x 9, 480 pages, paperback, $35.00)

Pricing Photography: The Complete Guide to Assignment and Stock Prices, Fourth Edition
by Michal Heron and David McTavish (11 x 8 ½, 160 pages, paperback, $29.95)

Top Ten Secrets for Perfect Baby and Child Portraits
by Clay Blackmore (5 ½ x 8 ½, 112 pages, paperback, $16.95)

Top Ten Travel Photo Tips: From Ten Pro Photographers
by Chuck DeLaney (5 ½ x 8 ½, 112 pages, paperback, $16.95)

Start Your Career as a Photo Stylist: A Comprehensive Guide to Photo Shoots, Marketing, Business, Fashion, Wardrobe, Off-Figure, Product, Prop, Room Sets, and Food Styling
by Susan Linnet Cox (6 x 9, 280 pages, paperback, $19.95)

How to Create a Successful Photography Business
by Elizabeth Etienne (6 x 9, 240 pages, paperback, $19.95)

Profitable Wedding Photography
by Elizabeth Etienne (6 x 9, 224 pages, paperback, $24.95)

The Business of Studio Photography, Third Edition
by Edward R. Lilley (6 x 9, 432 pages, paperback, $27.95)

The Real Business of Photography
by Richard Weisgrau (6 x 9, 224 pages, paperback, $19.95)

Digital Stock Photography: How to Shoot and Sell
by Michal Heron (6 x 9, 288 pages, paperback, $21.95)

The Photographer's Guide to Marketing and Self-Promotion
by Maria Piscopo (6 x 9, 256 pagers, paperback, $24.95)

Selling Your Photography: How to Make Money in New and Traditional Markets
by Richard Weisgrau (6 x 9, 224 pages, paperback, $24.95)

How to Succeed in Commercial Photography: Insights from a Leading Consultant
by Selina Matreiya (6 x 9, 240 pages, paperback, $19.95)

Licensing Photography
by Richard Weisgrau and Victor S. Perlman (6 x 9, 208 pages, paperback, $19.95)

Business and Legal Forms for Photographers, Fourth Edition
by Tad Crawford (8 ½ x 11, 208 pages, paperback, $29.95)

Legal Guide for the Visual Artist, Fifth Edition
by Tad Crawford (8 ½ x 11, 280 pages, paperback, $29.95)

The Law (in Plain English) for Photographers, Third Edition
by Leonard D. DuBoff and Christy O. King (6 x 9, 256 pages, paperback, $24.95)

The Professional Photographer's Legal Handbook
by Nancy E. Wolff (6 x 9, 256 pages, paperback, $24.95)

To see our complete catalog or to order online, please visit www.allworth.com.